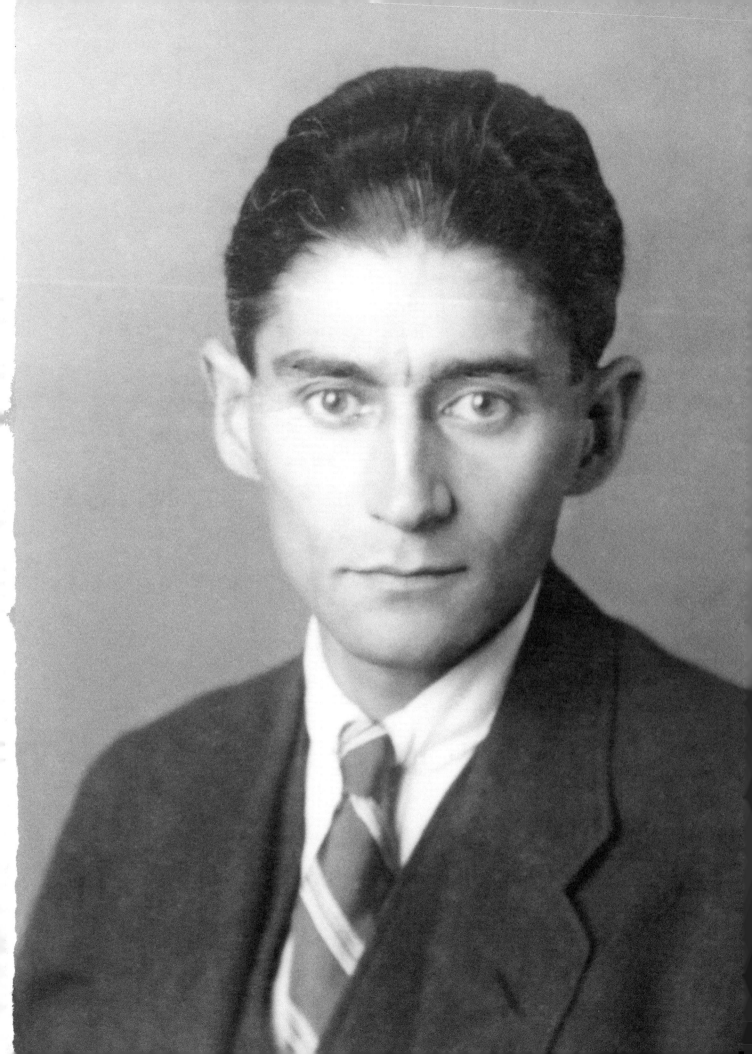

1 Photograph of Franz Kafka,
 Berlin, ca. 1923–1924.
 Bildarchiv Klaus Wagenbach.

KANT
GALLERY OF WEST BOHEMIA IN PILSEN

THROUGH THE EYES OF FRANZ KAFKA

BETWEEN IMAGE AND LANGUAGE

Marie Rakušanová and Nicholas Sawicki, eds. 2024

Concept © Marie Rakušanová
Text © Miroslav Haľák, Zuzana Jürgens, Alexander Klee,
Roman Musil, Marek Nekula, Marie Rakušanová, Nicholas Sawicki, 2024
© KANT – Karel Kerlický, Gallery of West Bohemia in Pilsen, 2024

ISBN: 978-80-7437-426-5

TABLE OF CONTENTS

	FOREWORD	8
Marie Rakušanová	THROUGH THE EYES OF FRANZ K.: BETWEEN IMAGE AND LANGUAGE	14
Alexander Klee	KAFKA GOES TO SCHOOL: DRAWING AS OBLIGATION AND FORMATIVE INFLUENCE	110
Nicholas Sawicki	FRANZ KAFKA'S DRAWINGS: FORM, FIGURE, CONTEXT	122
Marek Nekula	FRANZ KAFKA: THE LANGUAGES AND IMAGES OF (PRAGUE'S) PUBLIC SPACE	166
Miroslav Haľák	HETEROCHRONIC MODERNITY IN A HETEROTOPIC PRAGUE	200
	INDEX OF NAMES	219

FOREWORD

One hundred years ago, on June 3, 1924, Franz Kafka, a Prague Jewish author writing in German, died in the Austrian sanatorium of Kierling. At that time, he was far less known than he is today, when his writing—novels, stories, diaries, correspondence—has been translated into nearly all major languages. Through the years, Kafka's life and work have inspired many other writers and have been the subject of countless books and studies.

It seems that everything that can be said about Kafka has already been written, and that his life and even his most personal thoughts and views have been examined to the very last detail. We know about his complicated relations with women, his disagreements with his father, his interest in diet and exercise, and his sense of never fully belonging to the communities of which he was a part.

In 1982, Frankfurt's S. Fischer Verlag began publishing the first critical editions of Kafka's writings that presented his work free of the earlier textual interventions of his close friend Max Brod—who, after Kafka's death, gathered and edited many of his writings for publication. From the work of Hanns Zischler, author of the 1996 monograph *Kafka Goes to the Movies*, we know of the important role that film had in Kafka's life, and thanks to Reiner Stach and his monumental three-volume biography of Kafka, completed in 2014, we have detailed information about Kafka's life and the historical context of the era in which he lived. The year 2021 saw the first comprehensive publication of Kafka's drawings, under the editorship of Andreas Kilcher, including a newly discovered group of more than one hundred previously unknown drawings that had until then been stored in a bank vault in Zurich. Kafka's work continues to inspire today. Our own experience of contemporary life and society resonates with his perception of the world, perhaps because, like us, he lived at a time marked by change and upheaval, new artistic tendencies, a mixing of cultures, and surging nationalism.

On the centennial of Kafka's death, the Adalbert Stifter Verein in Munich and the Gallery of West Bohemia in Pilsen have decided to commemorate this anniversary with an exhibition and accompanying publication addressing Kafka's relationship to the visual arts and how his perception of visual culture shaped his work.

The idea for the exhibition grew out of conversations with Steffen Höhne and Manfred Weinberg during preparations for the conference *Franz Kafka Intermedial: Appropriations and Influences between Image, Sound, and Word*, held June 3–6, 2024, at Charles University in Prague, and from subsequent discussions among the authors of this preface.

FOREWORD

There is a logic behind the decision to organize an exhibition on this subject at the Gallery of West Bohemia in Pilsen. For one, this institution houses an exceptionally valuable collection of early and interwar modernist art, including works by Czech, Bohemian-German, and Jewish artists who were Kafka's contemporaries. Additionally, in its research and exhibition activities, the Gallery has long focused on new and international bodies of work previously overlooked by Czech art historiography, and on a multidisciplinary approach to the study and presentation of such materials. Likewise, it was here that an international team recently came together under the leadership of the Gallery's longstanding collaborator Marie Rakušanová, professor of art history at the Faculty of Arts of Charles University in Prague, to organize the exhibition *Kubišta – Filla: The Founding Figures of Modern Czech Art in the Field of Cultural Production* (2019), which focused on the generation of artists whose work introduced Kafka and Max Brod to the world of modern art.

The present publication and exhibition, *Through the Eyes of Franz Kafka: Between Image and Language*, trace Kafka's interests in modern visual culture, mapping not only his relations to traditional forms of art but also to film, cabaret, and popular culture in general. The book is a collective project, with contributions by a range of scholars, and its English edition is edited by Marie Rakušanová and the American art historian Nicholas Sawicki.

In her chapter, Rakušanová examines the diverse languages of visual images in early-twentieth-century Prague, as well as the ways in which Kafka engaged with them in his life and work. Alexander Klee, curator at the Belvedere Museum in Vienna, outlines the historical context of drawing education at primary and secondary schools in the Habsburg monarchy, reflecting on the possible implications of this curriculum for Kafka's own drawings. Thanks to the recent discovery of previously unknown drawings by Kafka from Max Brod's personal holdings, we today know more about Kafka's artistic practice, although the topic has yet to be explored more extensively in scholarship. In his contribution to this volume, Nicholas Sawicki, professor of modern art history at Lehigh University, probes Kafka's drawings in detail. Marek Nekula, professor of Czech language and literature at Regensburg University and a leading expert on Kafka's relationship to Prague, writes about how Kafka experienced the city's public space, which in his time witnessed the nationalist use and abuse of both images and language. The book concludes with the philosophical reflections of Miroslav Haľák, art historian and curator at the Belvedere.

For assistance and support in preparing the exhibition and publication, we would like to thank Andreas Kilcher, who supplied reproductions of several works, and Hana Klínková, for her help with archival research. Our heartfelt gratitude goes as well to the Jewish Museum in Prague, which worked closely with us throughout the project, in particular its director Pavla Niklová and the museum's curators.

The exhibition is part of the larger international project *Kafka 2024*, which brings together institutions in the Czech Republic, Germany, Austria, and other countries. It has been organized under the patronage of Martin Baxa, Minister of Culture of the Czech Republic, and Claudia Roth, attaché of the Federal Republic of Germany for culture and media.

Zuzana Jürgens, Adalbert Stifter Verein
Roman Musil, Gallery of West Bohemia in Pilsen

so weit war dass ich
... konnte und wo ich
... letzten Stufe meiner
... ruhig auf dem Rücken
... Wand. Aber was für
... Wand! Und doch
drückten sie mein Fr...
hoben sie meine Füße

Dne 18. února 1911.

Poncův Royal: Bioskop, Žižkov, Husova 70.

Dnes, 17. února již na programu

Bílá otrokyně.

Tento sensační dramatický snímek jest zhotoven na popud spolku pro potírání obchodu s děvčaty. Obsahuje 60.000 fotogr. snímků a potrvá na scéně plnou hodinu. Denně představení o 5. a 8. hod. več.

...ožna na Smíchově

...stvo s ručením obmezeným

bude míti

1911 o půl 10. hodině dopoledne

...na Smíchově, Kinského tř. č. 29 n.

...ční valnou hromadu.

PROGRAM:

...lné hromady od 28. prosince 1910.
... výboru v roce 1910 a zpráva účetní.
...ny a o revisi účtů za rok 1910.
...revisi a usnesení o zprávě revisní dle § 3. zák.
... 133 a udělení absolutoria.
...revisora na 3 roky.
... v roce 1910 výborem povolených za rozličnými
... 50.
...žití se má se správním výtěžkem.
... 7. stanov.
...ou v místnostech kanceláře k volnému nahlédnutí.
...adě potřebný počet členů, koná se druhá valná
... tentýž den, v týchž místnostech o půl 11. hodině
...přítomných členů rozhoduje (čl. 13. stanov).

SPRÁVNÍ VÝBOR.

THROUGH THE EYES OF FRANZ K.: BETWEEN IMAGE AND LANGUAGE

Marie Rakušanová

We can approach the work of Franz Kafka "by any point whatsoever; none matters more than another, and no entrance is more privileged," to cite the words of the French philosophers Gilles Deleuze and Félix Guattari, writing in 1975.[1] The present volume, *Through the Eyes of Franz Kafka: Between Image and Language,* focuses on Kafka's relation toward the fine arts and visual culture. It also brings to attention the author's own artistic activity, specifically in the chapters that follow by Nicholas Sawicki on Kafka's own drawings, and by Alexander Klee on Kafka's artistic education. → **FIG. 1**

As revealed by many literary and cultural historians and theorists, Kafka as a viewer of images took an interest not only in the fine arts but also in popular culture, ranging from illustrated magazines and posters, film, photography, and dance, to the circus and cabaret.[2] Yet, with only a few exceptions, scholars have tended to discuss each of these visual realms separately, focusing on Kafka's own relation to individual aspects of the visuality of his era, without trying to establish a complex view of the possibilities and varieties of his visual experience.[3] In the heterogeneity of the images that surrounded Kafka in his quotidian life, we can perhaps perceive a parallel to the multilingualism that marked Prague, and indeed all of Central and Eastern Europe, in his time. Some scholars have presented the hypothesis that an essential aspect of Kafka's writing was his personal experience with this linguistic diversity. In the present volume, this hypothesis is addressed by Marek Nekula, who also examines previous research into this question.[4] As he walked through his home city, Kafka was indeed confronted with a tangle of languages: Czech, German, the distinct German of the Jewish bourgeoisie and intellectual classes, the German spoken by the Czech cooks and servants who worked for German-speaking families,[5] and, after 1914, the Yiddish spoken by Jewish refugees from the east.

[1] Gilles Deleuze and Félix Guattari, *Kafka: Toward a Minor Literature*, trans. Dana Polan (Minneapolis: University of Minnesota Press, 1986), 3.

[2] Andreas Kilcher, "Kafka's Drawing and Writing," in *Franz Kafka: The Drawings*, ed. Andreas Kilcher (New Haven: Yale, 2022); Heinz Ladendorf, "Kafka und die Kunstgeschichte I; II," *Wallraf-Richartz-Jahrbuch* 22 (1961) and *Wallraf-Richartz-Jahrbuch* 25 (1963); Hartmut Binder, "Anschauung des ersehntes Lebens: Kafkas Verständnis bildender Künste und ihrer Werke," in *Was bleibt von Franz Kafka*, ed. Wendelin Schmidt-Dengler (Vienna: Studienreihe der Franz-Kafka-Gesellschaft, 1985); Detlev Schöttker, "Vielfältiges Sehen: Franz Kafka und der Kubismus in Prag," *Zeitschrift für Ideengeschichte* 4 (2010); Gerhard Naumann, "Überschreibung und Überzeichnung: Franz Kafkas Poetologie auf der Grenze zwischen Schrift und Bild," in *Öffnungen*, ed. Friedrich Teja Bach and Wolfram Pichler (Paderborn: Fink, 2009); Jiří Kotalík "Franz Kafka und die bildende Kunst," in *Kafka und Prag: Colloquium im Goethe-Institut Prag*, ed. Kurt Krolop and Hans Dieter Zimmermann (Berlin: De Gruyter, 1994); Hanns Zischler, *Kafka Goes to the Movies*, trans. Susan Gillespie (Chicago: University of Chicago Press, 2002); Hartmut Binder, *Wo Kafka und seine Freunde zu Gast waren* (Prague: Vitalis, 2000); Carolin Duttlinger, *Kafka and Photography* (Oxford: Oxford University Press, 2007).

[3] See, for example, Jacqueline Sudaka-Bénazéraf, *Le regard de Franz Kafka, dessin d'un écrivain* (Paris: Maisonneuve & Larose, 2001); Leena Eilittä, "Kafka and Visuality," *KulturPoetik* 6 (2006).

[4] See also Marek Nekula, *Franz Kafka and His Prague Contexts* (Prague: Karolinum, 2016), 71–150.

[5] Reiner Stach refers to this as "Kuchelböhmisch" in *Franz Kafka: The Early Years* (Princeton: Princeton University Press, 2017), 138.

No less diverse were the visual stimuli that Kafka encountered in Prague. He was, in his own words, an "observer of the ground floor" and the streets, and he was aware of the uniqueness of this interest.[6] At street level, the walls and corners of Prague's buildings were covered with posters on which the aesthetic styles of historical eclecticism and academicism met and clashed with secessionist ornamentation and fin-de-siècle Japonisme, later also with echoes of cubism, a style with exceptional influence in Prague.[7] At the exhibitions organized in Prague by the Mánes Association of Fine Artists, Kafka could encounter French impressionism and postimpressionism, Czech secessionist symbolism, cubism, and Scandinavian symbolist expressionism. At the exhibitions of the more conservative, bilingual Krasoumná jednota, or Kunstverein für Böhmen (Art Association for Bohemia), and of the Verein deutscher bildender Künstler in Böhmen (Association of German Artists in Bohemia), Kafka could view salon painting from the main centers of art in Germany as well as works of *Freilichtmalerei*, Czech-German spiritualism, and German expressionism. Meanwhile, the Klub deutscher Künstlerinnen (Club of German Women Artists) displayed the work of women painters and sculptors, not only from Prague, but also from Olomouc, Brno, Vienna, Munich, and other German-speaking centers of artistic culture, often conservative and conformist in orientation but occasionally artistically innovative. At Prague's cinemas, Kafka could witness the exaggerated gestures and images of European and American silent films; at its theaters, he attended performances of Russian and French ballet; and at the city's cabarets, he observed the body language and movement that accompanied dancing, singing, and recitation by variété artists from Prague, Vienna, Munich, Berlin, and Lviv.

The images that surrounded Kafka spoke various languages of aesthetic and expressive form. It is my aim in this study to attempt a characterization of these various contemporary visual languages, using methods similar to those previously deployed by other scholars to define the significance of multilingualism for Kafka's writing. When Deleuze and Guattari attempted to grasp the specific experience of Kafka within a multilingual Prague as a provincial city of the Austro-Hungarian monarchy, they borrowed from the linguist Henri Gobard, employing his "tetralinguistic model." Gobard's model arranges language into four categories: (1) "vernacular, maternal, or territorial language, used in rural communities or rural in its origins"; (2) "a vehicular, urban, governmental … language of business, commercial exchange, bureaucratic transmission, and so on"; (3) "referential language, language of sense and of culture"; and (4) "mythic language … caught up in [the] spiritual or religious."[8] For Prague Jews who "have come from a rural milieu," the vernacular language was often Czech, gradually losing its importance and becoming forgotten as they urbanized, and indeed Kafka was one of the few German-Jewish Prague authors of his generation who understood, spoke, and even occasionally wrote in Czech. According to Deleuze and Guattari, German was the vehicular language of the towns, "a bureaucratic language of the state, a commercial language of exchange."[9] Additionally, the German of Goethe, *Hochdeutsch*, had a cultural and referential function. Hebrew was a "mythic language," in the sense of biblical myth as well as modern Zionist mythology. Beyond the tetralinguistic model, Deleuze and Guattari also emphasize Kafka's complicated and sometimes disparaging relationship to Yiddish, which to him was "a language that frightens more than it invites disdain, 'dread mingled with a certain fundamental distaste' … lacking a grammar and … filled with vocables that are fleeting, mobilized, emigrating, and turned into nomads."[10]

6 "Ich, nur ich bin der Beobachter des Parterres [I, only I, am the observer of the ground floor]," Kafka wrote in his diary on September 23, 1912, comparing his writing to the literary achievements of his friends after writing the short story "The Judgment" in one night. Franz Kafka, *Tagebücher,* ed. Hans-Gerd Koch, Michael Müller and Malcolm Pasley (Frankfurt am Main: S. Fischer, 1990), 461. See the new English translation and edition, Franz Kafka, *The Diaries*, trans. Ross Benjamin (New York: Schocken, 2022), 242.

7 See Josef Kroutvor, "Polemická nároží," in Hana Rousová et al., *Mezery v historii 1890–1938. Polemický duch střední Evropy – Němci, Židé, Češi* (Prague: Galerie hlavního města Prahy, 1994).

8 Deleuze and Guattari, *Kafka*, 23. See also Henri Gobard, *L'aliénation linguistique: Analyse tétraglossique*. Gilles Deleuze's introduction (Paris: Flammarion, 1976).

9 Deleuze and Guattari, *Kafka*, 25. Nevertheless, with the Badeni language reforms in 1897, Czech gained equal status in Bohemia and Moravia alongside German, and by the late-nineteenth-century many businesses and trades in Prague were already Czech-owned. What is more, Czech had already been made the official language of the Prague municipality in 1861. In fact, Deleuze and Guattari's application of Gobard's tetralinguistic model to the Prague context of Kafka's time is most problematic precisely when it comes to defining the role of Czech. In the Prague of that era, it was not so much a vernacular, rural language than it was the language of the Czech middle-class elites who not only kept pace with their German-speaking counterparts in the city's political, educational, and cultural institutions, but were successfully displacing them.

10 Deleuze and Guattari, *Kafka*, 25.

Like Deleuze and Guattari in their investigation of Kafka's languages, in my analysis of the diverse languages of visual images, I too plan to focus on the sign-systems and their autonomous function more than on the normative idea that languages merely transmit "information." Deleuze and Guattari approach Kafka's literary oeuvre from the position of post-structuralist philosophy, avoiding any literary-historical interpretation of Kafka's texts, and they stress the fleeting and ephemeral meanings created in his works through the endlessly shifting relations between linguistic signs. For Deleuze and Guattari, deferral of meaning is linked to the concept of desire, to a certain extent colored by Lacanian psychoanalysis.[11] At the same time, they show an awareness of the power of visual images in Kafka's texts, which they closely link to their discourse analysis of the unstable mutual interaction of signs.[12] The way in which Kafka works in his stories and novels with the presence of images such as paintings or photographs, with descriptions of the distinctive physical gestures of actors, animals, other individuals, and statues that seem to come to life, has nothing in common with the direct functioning of narrative structures.[13] Indeed, as Walter Benjamin noted as early as 1934, Kafka in his texts replaces plot with gesture.[14] Kafka was an exceptionally perceptive observer, with an almost obsessive reliance on precise written records of the seen image. The more precise this description, however, the more fleeting, the more resistant to desire, the visual experience seemed.[15]

In mentioning the elusiveness of meaning and avoiding a definitive interpretation of pictorial and linguistic signs, I reference the final chapter in this volume, in which Miroslav Haľák attempts a deliberate disruption of the seemingly documentary synchronic framework of Kafka's relation to artistic and visual culture. Haľák places Kafka's language and images into the context of Prague as a topographically uncertain and polysemic place, which he associates with the phenomenon of modernist heterochrony—the diversity of chronological layers and the shattering of linear causal orders. Haľák applies the poststructuralist or Foucaultian concept of "heterochrony and heterotopia" to an examination of the myths that have been built up not only by Kafka's writing but also by the vast scholarship on his work. For my own study, it is also essential to grapple with the fact that the various mythologies surrounding Kafka have generally prevented a precise topographic or historical anchoring of his experience with visual arts and culture and have even involved the invention of fictitious events beyond time and place. In particular, Gustav Janouch's fabrication of purported conversations with Kafka has led to a number of dubious subsequent claims about Kafka's encounters with art.[16] There are many more myths surrounding Kafka, including, in the Czech context, the falsified testimonies of the anarchist Michal Mareš. These legends are today inseparable from Kafka's image. The ambivalence of the place where he lived, the many visual and linguistic worlds that Kafka encountered or may have encountered in turn-of-the-century Prague cannot be mapped with any absolute truthfulness. In this study, I will not attempt to infer the influence of specific artists and works on Kafka, but will rather focus on the specific nature of Kafka's relationship to images and to visuality in general. Kafka had a propensity to devour the diverse images that surrounded him and to observe and describe them in detail, but he never categorized or subjected them to aesthetic judgment. At the same time, he had a certain distrust of visual sensations. In his diaries and letters, he spoke of the longing that images awakened in him and how they failed to give him satisfaction. The crisis

11 Ibid., 80–98. The psychoanalytic interpretation of Kafka has been consistently pursued by the French writer Marthe Robert. See also Duttlinger, *Kafka and Photography*, 132–56. For this study, however, the main inspiration is Lacan's idea of the image attracting the gaze but constantly eluding it, as presented in his lecture "What is a Picture," in *The Seminar of Jacques Lacan, Book XI: The Four Fundamental Concepts of Psych-Analysis*, ed. Jacques-Alain Miller, trans. Alan Sheridan (New York: W. W. Norton, 1998), 105–22.

12 Deleuze and Guattari, *Kafka*, 7–16.

13 That is why the theory of intermedial narratology, in other cases functional, does not seem to be a suitable methodological tool for the analysis of Kafka's relationship to image and text. Werner Wolf, "Das Problem der Narrativität in Literatur, bildender Kunst und Musik," in *Erzähltheorie transgenerisch, intermedial, interdisziplinär*, ed. Vera and Ansgar Nünning (Trier: Wissenschaftlicher Verlag, 2002), 23–104; Stanislava Fedrová and Alice Jedličková, "Teorie intemediality," in Richard Müller, Tomáš Chudý et al., *Za obrysy média. Literatura a medialita* (Prague: Karolinum, 2020), 501–62.

14 Walter Benjamin, "Franz Kafka. On the Tenth Anniversary of His Death" (1934), in *Illuminations*, ed. Hannah Arendt, trans. Harry Zohn (New York: Schocken, 1969), 121.

15 Deleuze and Guattari, *Kafka*, 97.

16 In his alleged conversations with Janouch, Kafka purportedly expressed interest in specific personalities such as Paul Gauguin, Vincent van Gogh, Pablo Picasso, Josef Čapek, George Grosz, Charlie Chaplin, Oskar Kokoschka, and Vladimír Sychra. Gustav Janouch, *Conversations with Kafka*, trans. Goronwy Rees (New York: Frederick A. Praeger, 1953). The falsity of Janouch's records has been documented by, among others Eduard Goldstücker, "Kafkas Eckermann? Zu Gustav Janouchs 'Gespräche mit Kafka,'" in *Franz Kafka. Themen und Probleme*, ed. Claude David (Göttingen: Vandenhoeck und Ruprecht,1980), 238–55; and Josef Čermák, *Franz Kafka. Výmysly a mystifikace* (Prague: Gutenberg, 2005).

of representation in visual signs also penetrated into the domain of Kafka's writing. In what follows, I will explore his ambivalent feelings towards visuality, which are also manifest in some of his writings, and which draw their power from the tension between image and language.

TOWARD A MINOR ART: CZECH MODERNISM AND THE KLUB DEUTSCHER KÜNSTLERINNEN

In their discussion of Kafka, Deleuze and Guattari speak of the experience of a "minor" (though "minority" would perhaps be more accurate) language and culture. In their view, the language of Kafka's prose subverted German as the language of the majority, as the language of great canonical authors. By making visible the minority otherness of Prague German, Kafka's writings uncover the previously unanticipated creative potential of the language.[17] As an observer of images, Kafka in Prague at the start of the twentieth century also encountered a wide range and large number of minority, or "minoritized," visual phenomena: Czech modern art, which had been gaining increasing self-awareness and self-confidence from the middle of the nineteenth century onward, in part through its links to France and Paris; the art of Prague's German-speaking artists, who stood in ambivalence to the centers of the German empire; and the art of Prague's German and Jewish women artists, who, overlooked within their own cultures, sought support through the network of women's associations in German-speaking Central Europe.

Indeed, Kafka himself, writing in his diaries in 1911, associated the idea of minor literatures to the Jewish as well as Czech literary environments.[18] Starting in the mid-nineteenth century, Czech cultural life intensified at an ever-growing pace, a development that German-speaking cultural circles viewed with no small disquiet. Kafka was compelled by the aspiring national culture of the Czechs to reflect on, among other aspects, its function in the process of "the detailed spiritualization of the extensive public life" and "the restriction of the nation's attention to its own circle and admission of the foreign only in reflection."[19] In the domain of the fine arts, Kafka could hardly have missed the 1902 exhibition in Prague of the work of August Rodin. Organized by the Mánes Association, it was as much a political as it was a cultural event for the Czech organization and its supporters. → FIG. 2 The municipal government of Prague, by this point representing exclusively Czech national interests, framed the visit of the great French sculptor to Prague in unambiguously nationalist terms. Kafka himself would have also been well aware of the political connotations of the sculptural forms and principles adopted from Rodin by the Czech sculptors Stanislav Sucharda and Josef Mařatka in their monument to František Palacký, or by Ladislav Šaloun in his monument to Jan Hus.[20] A later encounter with Rodin and nationalist discourse may also have come for Kafka if he read the sculptor's treatise on Gothic cathedrals, which Rodin claimed as the embodiment of the "most French" of all styles.[21]

The orientation of Czech culture before the First World War was indeed largely Francophile, as evidenced by the Mánes Association's subsequent exhibitions of modern French art: one later in 1902, and others in 1907, 1910, and 1914.[22] Art historians have, to a large extent justifiably, ascribed great importance to French modernism in the shaping of Czech aesthetic culture while at the same time dismissing how organizations such as the Mánes

[17] Deleuze and Guattari, *Kafka*, 29–51. The confidence with which Deleuze and Guattari assume the existence of a stabilized urban German speech in Prague at the time has also been the subject of criticism by many linguists.

[18] Kafka, *The Diaries*, 161–68. See also the chapter by Marek Nekula in the present volume.

[19] Ibid., 162.

[20] Franz Kafka to Max Brod, July 30, 1922, in Franz Kafka, *Letters to Friends, Family, and Editors*, trans. Richard and Clara Winston (New York: Schocken, 1977), 433. See also the chapter by Marek Nekula in the present volume.

[21] Rodin's book *Les cathédrales de France* was translated into German by Max Brod. August Rodin, *Die Kathedralen Frankreichs* (Leipzig: Kurt Wolff, 1917).

[22] *Moderní francouzské umění* (Modern French Art), 1902; *Francouzští impresionisté* (French Impressionists), 1907; *Les Indépendants* (The Independents), 1910; *Moderní umění* (Modern Art), 1914.

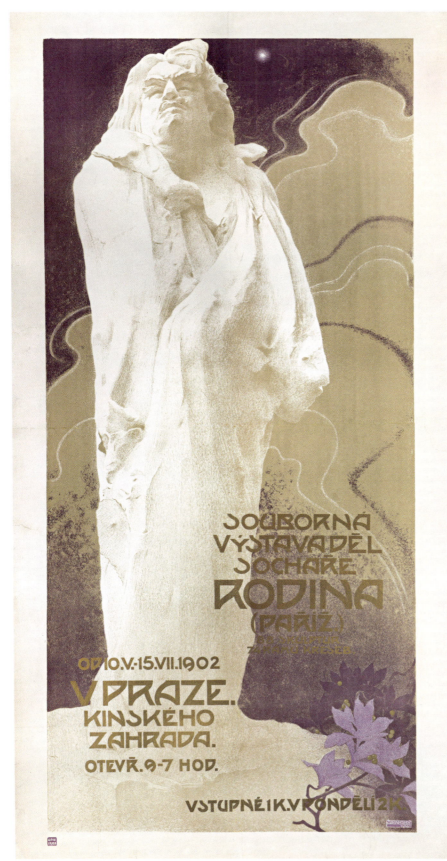

2 Vladimír Županský, poster for exhibition by Auguste Rodin, Mánes Association of Fine Artists, Prague, 1902. Color lithograph, 160×85 cm. National Gallery in Prague.

3 Jan Preisler, poster for exhibition by the Worpswede artists, Mánes Association of Fine Artists, Prague, 1903. Color lithograph. 79×111 cm. Museum of Decorative Arts in Prague.

4 Jan Preisler, poster for exhibition by Ludwig von Hofmann, Mánes Association of Fine Artists, Prague, 1908. Color lithograph, 110×94 cm. Museum of Decorative Arts in Prague.

5 Emil Orlik, poster for the lecture "French Painting in the 19th Century," Urania, Prague, 1901. Color lithograph, 110×82 cm. Museum of Decorative Arts in Prague.

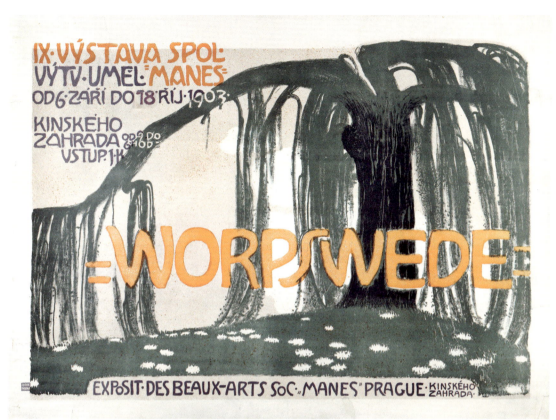

3

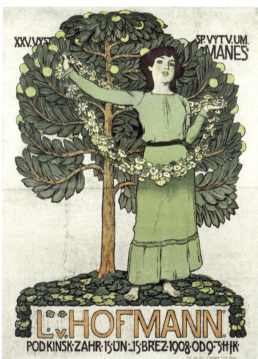

4

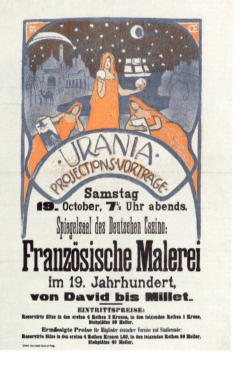

5

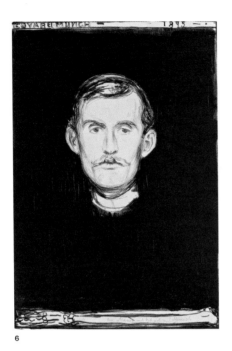

6 Edvard Munch, *Self-Portrait with Skeleton Arm*, 1895. Lithograph, 45.8×31.9 cm. National Gallery in Prague.

23 Note, for example, the condescending tone of the review by Emil Utitz, "Zwei Weihnachts-Ausstellungen deutscher Künstlerinnen," *Deutsche Arbeit* 9, no. 4 (January 1910): 239–41.

Association also brought German art to the awareness of Czech audiences, including the landscape painting school and artists' colony of Worpswede (1903) or the prominent secessionist Ludwig von Hofmann (1908). → FIG. 3, 4 Contemporary audiences undoubtedly would have noticed that the work of German landscape and figural painters such as these resonated strongly with the work of many members of the Mánes Association. In turn, French art sparked interest not only among Czech modernists, but among Prague's German-speaking artists as well. → FIG. 5

In 1905, the Mánes Association held an exhibition of the Norwegian painter Edvard Munch, which was greeted with particular enthusiasm by the Bohemian, Moravian, Bohemian-German, and Jewish artists of the Prague group Osma, or Die Acht (the Eight). → FIG. 6 This group emerged onto the artistic scene in 1907, and Kafka was personally close to three of its members: Max Horb, a fellow student of law; Friedrich Feigl, whom Kafka knew from the Altstädter Gymnasium in Prague; and Willi Nowak, whom Kafka met through his own closest friend, the writer and critic Max Brod. → FIG. 7, 8 It was through these German-speaking artist friends that Kafka was introduced to the art of their Czech-speaking counterparts in Osma: Emil Filla, Bohumil Kubišta, Antonín Procházka, Linka Scheithauerová-Procházková, Otakar Kubín, Emil Artur Pittermann-Longen, and Vincenc Beneš. → FIG. 9–14 In Czech art, these figures represent the early avant-garde generation which adapted the language of the modernist tendencies of Europe's larger cultural centers, among which Paris was then gaining in significance.

But Kafka's Prague was home to another minority group that German-speaking intellectual circles regarded with critical skepticism. Texts by the era's critics and memoirs of the period often show a somewhat dismissive attitude toward the literary and artistic output of women artists associated with the Klub deutscher Künstlerinnen.[23] Kafka, on the other hand, on various occasions

showed genuine interest in the artistic activity of the women in his wider circle. For instance, he assisted Irene Bugsch, who was from the German-speaking Zips (Spiš) region of Slovakia and whom he met while convalescing in Tatranské Matliare, in her efforts to apply to the Kunstgewerbeakademie in Dresden, and he also provided a recommendation for her to contact the Hellerau artists' colony.[24] In his letters, Kafka took a lively interest in the paintings of the cousin of his Hungarian friend Robert Klopstock, Rószi Szilard, who briefly studied in Berlin.[25] His letters similarly show an unforced interest in the amateur photography of Minze Eisner, whom Kafka met during his stay in Schelesen (Želízy).[26] It must also be said that Kafka took some time to fully develop the sensitivity he showed in his later years toward the work of women artists and writers among his friends and acquaintances. At one early point in his life, Kafka blamed a "bad woman painter" who taught him academic drawing lessons for wasting his early talent in drawing.[27] In a letter to his friend Paul Kisch upon his first meeting with his mentor Ida Freund in the salon of her sister Berta Fanta, Kafka described the women artists he met there as captivating in their self-regard but insufficient in their training; one sang, a second wrote verses, and a third painted pictures.[28] Although Kafka was not an enthusiastic or frequent guest among the group of German-speaking Jewish intellectuals who met at the Fantas' salon,[29] the painter Ida Freund quickly became his advisor in artistic matters, probably soon after their first meeting.[30] → FIG. 15, 16 A, B

Freund was active in the Deutscher Verein "Frauenfortschritt" (German Association for Women's Progress), a Prague organization in which she headed the department of arts and crafts.[31] She co-founded the Klub deutscher Künstlerinnen in 1906, and she had a significant influence on the planning of its lectures and exhibitions.[32] Unfortunately, not a single of her artworks is known to have survived. Her work as an organizer was nevertheless quite significant and reveals much about how even minority groups such as female and German-speaking Jewish artists found ways of providing mutual support. The Klub arranged public presentations of several of Kafka's acquaintances in art and literature, including Emil Utitz, Max Brod, Felix Weltsch, and Friedrich Feigl. Later, during the First World War, it even organized a presentation of Kafka's own writings.[33] In March 1911, Kafka attended a dance performance at the Rudolfinum to which Émile Jaques-Dalcroze, founder of the Hellerau school of rhythm, music, and exercise, had been invited by the Klub to demonstrate his innovative teaching methods.[34] Later, in April 1913, Kafka attended a literary evening hosted by the Klub dedicated to the work of the Berlin poet Else Lasker-Schüler.[35] It is known that he also attended some of the exhibitions organized by the Klub. In February 1912, for example, he met with Ida Freund

[24] Franz Kafka to Robert Klopstock, September 21 and December 6, 1921, in Kafka, *Letters to Friends, Family, and Editors*, 379–83, 389.

[25] Franz Kafka to Robert Klopstock, early December 1921 (and references in other letters), in ibid., 392.

[26] Franz Kafka to Minze Eisner, December 1919, in ibid., 221.

[27] Franz Kafka to Felice Bauer, February 11–12, 1913, in Franz Kafka, ed. Erich Heller and Jürgen Born, *Letters to Felice*, trans. James Stern and Elisabeth Duckworth (New York: Schocken, 1973), 189. See further the text by Nicholas Sawicki in the present volume.

[28] Franz Kafka to Paul Kisch, February 7, 1903, in Franz Kafka, *Briefe, 1900–1912*, Kritische Ausgabe, ed. Hans-Gerd Koch (Frankfurt am Main: S. Fischer, 1999), 21.

[29] Franz Kafka to Max Brod, February 6, 1914, in Kafka, *Letters to Friends, Family, and Editors*, 136. See also Klaus Wagenbach, *Franz Kafka: Eine Biographie seiner Jugend 1883–1912* (Bern: Francke, 1958).

[30] The importance of Ida Freund for Kafka's drawing practice has already been highlighted by Reiner Stach and Andreas Kilcher: Stach, *Franz Kafka: The Early Years*, 255, 257; Kilcher, "Kafka's Drawing and Writing," 220. See also, for example, Ida Freund's inscription on Kafka's drawing of a figure with a half dog, reproduced in the present volume. "Delightful!!! It is a pity that the lady is gone. Otty says that she was there and was ripped away. But one can be content with the gentleman, because he is lovely. I have never seen a more beautiful man (except one). (He is certainly a dandy.)" Kafka added to the drawing: "misslungene Dame / wohlgelungener Herr" [unsuccessful lady, successful gentleman]. See also Pavel Schmidt, "Catalogue Raisonné," in Kilcher, *Franz Kafka*, 311.

[31] Wilma A. Iggers, *Frauenleben in Prag. Ethnische Vielfalt und kultureller Wandel seit dem 18. Jahrhundert* (Vienna: Böhlau, 2000), 161–62, 171.

[32] Stefan Benedik Karner, *Versuch einer Fallstudie zu Gender und Nation im Prag der Zwischenkriegszeit*, MA thesis (Graz: Karl-Franzens-Universität, 2007), 80.

[33] Hartmut Binder, "Der Klub deutscher Künstlerinnen in Prag 1906–1918," *Sudetenland. Europäische Kulturzeitschrift* 52, no. 4 (2010): 394–420.

[34] Franz Kafka to Felice Bauer, January 17–18, 1913, in Kafka, *Letters to Felice*, 159. Even in a letter written two years after the fact, Kafka gives an enthusiastic description of the dance of Dalcroze's pupils.

[35] Hartmut Binder, "Else Lasker-Schüler in Prag," *Wirkendes Wort* 44, no. 3 (1994): 405–38.

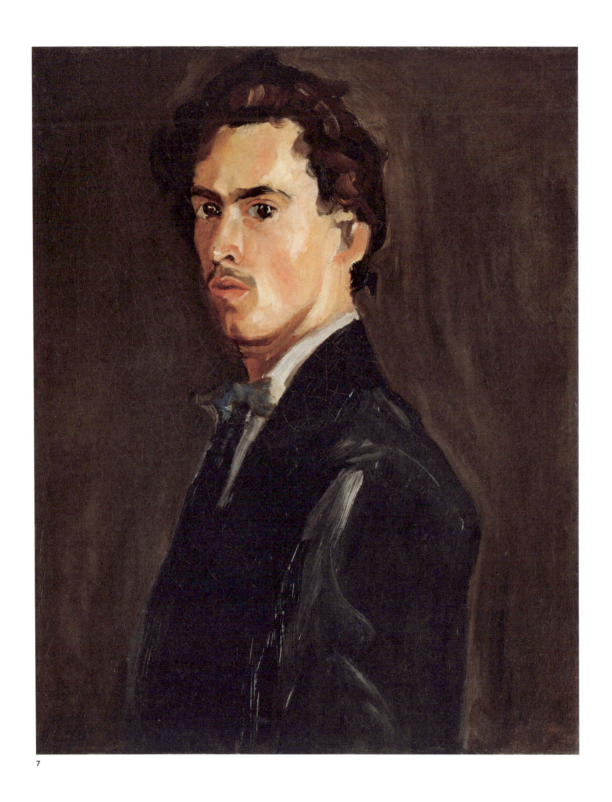

7 Friedrich Feigl, *Self-Portrait*, ca. 1905. Oil on canvas, 55×44.5cm. Jewish Museum in Prague.

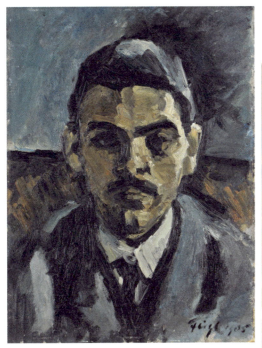

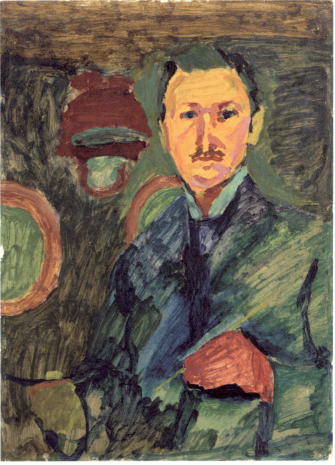

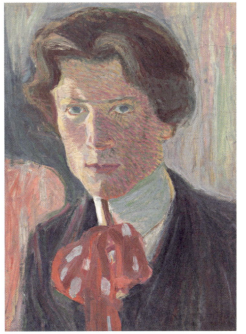

8 Friedrich Feigl, *Portrait of Willi Nowak*, 1905. Oil on paperboard, 45×34.5 cm. Liberec Regional Gallery.

9 Emil Filla, *Self-Portrait*, 1907. Oil on paperboard, 66×49 cm. GASK – Gallery of the Central Bohemian Region.

10 Bohumil Kubišta, *Self-Portrait with Polka-Dot Necktie*, 1904–1905. Oil on paperboard, 40×30 cm. Gallery of West Bohemia in Pilsen.

THROUGH THE EYES OF FRANZ K.: BETWEEN IMAGE AND LANGUAGE

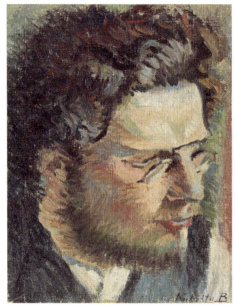

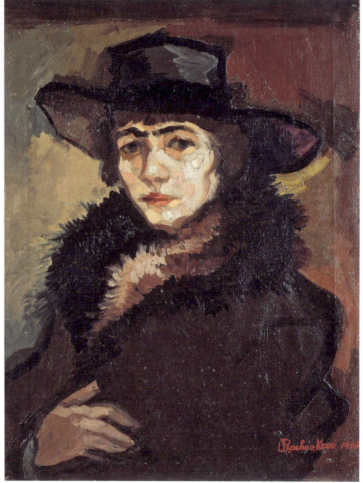

11 Bohumil Kubišta, *Portrait of Antonín Procházka*, 1905. Oil on canvas, 23×19 cm. COLLETT Prague | Munich.

12 Linka Scheithauerová-Procházková, *Self-Portrait*, 1910. Oil on canvas, 65×50 cm. Moravian Gallery in Brno.

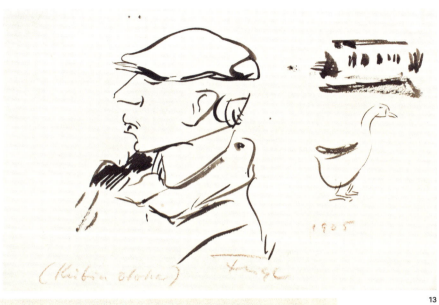

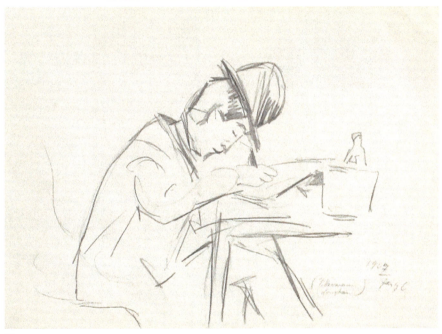

13 Friedrich Feigl, *Otakar Kubín*, 1905. India ink on paper, 15.6×25.1 cm. Moravian Gallery in Brno.

14 Friedrich Feigl, *Emil Artur Pittermann Longen*, 1907. Pencil on paper, 21×29 cm. Moravian Gallery in Brno.

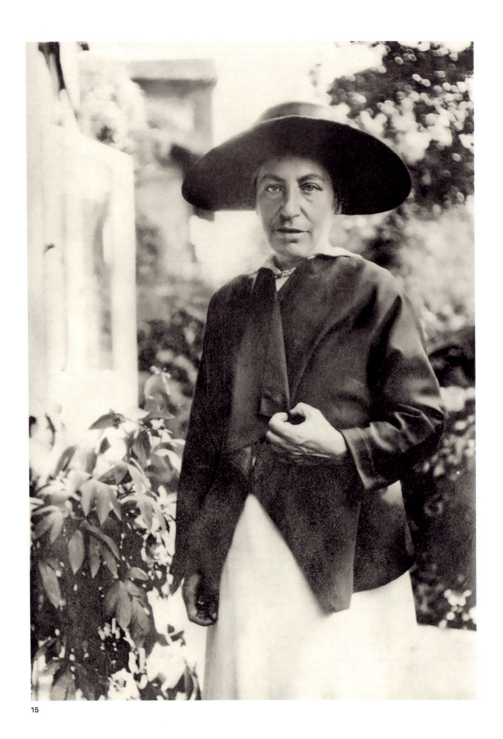

15

15 Photograph of Ida Freund from an application for a passport, 1917. National Archives, Prague.

at an exhibition of the Klub titled *The Laden Table*,[36] which showed still-life works by Bohemian-German, Austrian, and German women artists.[37]

In February 1910, the Klub held an exhibition for the Viennese association Die Neukunstgruppe, which included a set of sketches and paintings of nudes by Egon Schiele alongside works by Tony Faistauer, Hans Ehrlich, Franz Wiegele, Rudolf Kalvach, Albert Paris Gütersloh, and others. → FIG. 17–19 The exhibition was partially a reprise of an earlier exhibition by the group, which, though founded in 1909 exclusively by men, invited several women artists to its first exhibition at Vienna's Salon Pisko, mostly graduates of Vienna's Kunstschule für Frauen und Mädchen (School of Art for Women and Girls).[38] The Vienna exhibition also contained works by the Czech artist Minka Podhajská,[39] but her name is absent from the catalogue for the reprise showing in Prague.[40] → FIG. 20–22 Maria Vera Brunner and Luise Horovitz, two women artists who showed their works in Vienna were in Prague represented by sketches, prints, and paintings. Since reviewers of the Prague exhibition mention the names of several artists, both men and women, who are not listed in the catalogue,[41] it can be assumed that the actual exhibition was more varied and may have included not only Podhajská but also another artist who showed in the earlier Vienna exhibition, Fanny Harlfinger-Zakucka. → FIG. 23, 24 These two artists jointly produced an album of graphic patterns that reflected reformist efforts in applied graphics founded on the aesthetics of the Wiener Werkstätte. → FIG. 25A–C Indeed, the Neukunstgruppe was generally regarded by Prague reviewers as overly dependent on Viennese models, specifically on the work of Gustav Klimt.[42]

36 *Der gedeckte Tisch.* Kafka, *The Diaries*, 197.

37 "Výstava Der gedeckte Tisch měla velký úspěch," *Bohemia*, February 20, 1912, 9.

38 Tobias G. Natter and Thomas Trummer, eds., *Die Tafelrunde: Egon Schiele und sein Kreis* (Cologne: DuMont, 2006), 86–132.

39 *Minka Podhajská* (Prague: Arthouse Hejtmánek, 2021), 25.

40 *Katalog der Austellung der Neukunstgruppe* (Prague: Klub deutscher Künstlerinnen, 1910).

41 See, for example, Emi Utitz, "Die 'Neukunstgruppe Wien 1910' im Klub deutscher Künstlerinnen zu Prag," *Deutsche Arbeit* 9, no. 6 (March 1910): 391.

42 Pá, "Neukunstgruppe," *Dílo* 8 (1910): 55.

 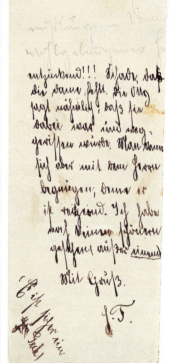

16 A, B Franz Kafka, man walking a dog. The verso side of the drawing contains a note addressed to Kafka, signed "I. F." Pencil on paper, 12.3×5.5 cm. National Library of Israel, Jerusalem.

There is no evidence that Kafka visited the exhibition, although he was certainly aware of it. For one, an extensive review appeared in the journal *Deutsche Arbeit*, written by a former classmate of his, the Brentano-oriented art critic and scholar of aesthetics Emil Utitz.[43] The exhibition also precipitated a major scandal that was heavily debated in Prague. On the day of the exhibition's opening, the Prague police confiscated the entire collection of Schiele's paintings and drawings on the grounds that their depiction of the nude human body threatened morality. → FIG. 26, 27, 33 The early presentation in Prague of the work of this future paragon of Viennese expressionism, and the events surrounding it, clearly deserve more attention than they have received in Czech art historical scholarship.[44] → FIG. 28–30 Significantly, the Neukunstgruppe exhibition in Prague was overshadowed by another event that scholarship on Czech modern art has always regarded as foundational: *Les Indépendants*. Hosted by the Mánes Association, this exhibition showed artworks by the French fauvists and proto-cubists that had been selected in Paris by the painter Bohumil Kubišta and the young Czech art historian Antonín Matějček. → FIG. 31, 32 Two distinct exhibitions of artworks and artists that would become crucial to the canon of Western modernism thus overlapped in Prague at precisely the same time. While the Mánes Association continued to emphasize the artistic currents of Paris as an ideal model for Czech artists, thanks to its ties to a Central European network of women artists, the Klub deutscher Künstlerinnen was able to bring to Prague an exhibit of works by young men and women artists working to develop a specific artistic position within Central European culture.[45] Although Czech art history tends to only view *Les Indépendants* as significant, the Czech cultural press of the time did not ignore the exhibition of the Viennese modernists and in fact interpreted the police intervention against Schiele's nudes as evidence of Prague's backwardness.[46] Kafka's Prague—a city accustomed to multilingualism—thus resounded with various languages of modernism, a fact that has been somewhat obscured in Czech scholarship, which has generally excluded the German-inflected variants of modernism from its narratives of the history of art in Prague at the start of the twentieth century.

THE REFERENTIAL LANGUAGE OF GERMAN, AND PAINTINGS FROM GERMAN-SPEAKING CENTERS OF ART

Within the structure of Gobard's tetralinguistic model, an exceptional position is held by the language of high culture, the one to which the speaking group relates and which references in its foremost cultural achievements.[47] The German and German-Jewish minority in multilingual Prague regarded as its reference language the *Hochdeutsch* of the intellectual centers of Germanic Central Europe.[48] In turn, the visual arts looked to the same centers as models for the pictorial language of stylistic form.

In the case of the Neukunstgruppe exhibition, Prague audiences could encounter a Viennese lineage of painting that had begun to experiment with different ways of depicting figures and objects. Kafka himself had previously encountered Viennese visuality through literature.[49] For instance, he will surely have noticed the illustrations of fourteen erotic nudes by Gustav Klimt in *Lucian's Conversations with the Hetaerae*, which Kafka and Max Brod read together in 1907.[50] Schiele's nudes came as such a shock at the Prague

[43] Utitz, "Die 'Neukunstgruppe Wien 1910,'" 391–92.

[44] Austrian art history, by comparison, has explored the subject on numerous occasions. See, for example, Natter and Trummer, *Die Tafelrunde: Egon Schiele und sein Kreis*, 106–8; Tobias G. Natter et al., *Fantastisch! Rudolf Kalvach: Wien und Triest um 1900* (Vienna: Leopold Museum, 2012), 67–79.

[45] *Stadt der Frauen. Künstlerinnen in Wien 1900–1938* (Munich: Prestel, 2019); Julie Marie Johnson, *The Art of the Women: Women's Art Exhibitions in Fin-de-Siècle Vienna*, Ph.D. thesis (Chicago: University of Chicago Press, 1998).

[46] *Čas*, February 3, 1910, 4; *Čas*, February 18, 1910, 6. The article's author repeatedly points out that "the same paintings were exhibited harmlessly … at the Pisko Salon in Vienna."

[47] Deleuze and Guattari, *Kafka*, 44–45. See also Gobard, *L'aliénation linguistique: Analyse tétraglossique*.

[48] The issue of the linguistic inclinations of the Jewish population in Bohemia in the late nineteenth and early twentieth centuries has been thoroughly addressed by Hillel Kieval, *The Making of Czech Jewry: National Conflict and Jewish Society in Bohemia, 1870–1918* (New York: Oxford University Press, 1988).

[49] On Kafka's relationship to Vienna in general, see Hartmut Binder, *Kafkas Wien. Potrait einer schwierigen Beziehung* (Mitterfels: Vitalis, 2013).

[50] Franz Kafka to Max Brod, autumn 1907, in Kafka, *Letters to Friends, Family, and Editors*, 51. *Die Hetärengespräche des Lukian*, trans. Franz Blei (Leipzig: Julius Zeitler, 1907).

exhibition because, in a city accustomed to the more commonly decorous nudity calculated to tickle the fancy of the bourgeois viewer, they brought a provocatively subjectivized portrayal of the human body similar to the one with which Schiele's teacher Klimt had challenged Vienna almost a decade earlier. Beyond this, Schiele's male nudes could also be interpreted as self-portraits. → FIG. 33 Not only in Prague but in Vienna or Munich as well, the era's definition of pornography often included any difficult-to-interpret depictions of the body that defied the heteronormative male gaze. In Munich at the start of the century, Kafka's friend Franz Blei had become a social outcast after a scandal over his publication of several issues of the erotic magazines *Der Amethyst* and *Die Opale*. Kafka subscribed to the magazines, and in addition to the texts published therein, he would undoubtedly also have been interested in the drawings that the magazines reproduced, including works by Aubrey Beardsley, Alfred Kubin, Félicien Rops, and other leading European artists.[51] In the first issues of *Der Amethyst*, Blei published Beardsley's illustrations relating to Lucian, including one depicting the muscular calf of a man seemingly giving birth to a child.[52] → FIG. 34 This image is characteristic of Blei's selection of reproductions for his magazines. Even over a century later, some scholars still view Blei's magazines as sinisterly pornographic and appear shocked at the knowledge that Kafka was a subscriber and reader.[53] This titillation arises in part from the tradition of describing Kafka, largely due to how Max Brod portrayed him, as a puritanical ascetic with a distaste for all aspects of bodily physicality.[54] Kafka's correspondence suggests that, despite his deep love for women, he mostly avoided sexual contact in his closest relationships, an element present in his relations with both Felice Bauer and Milena Jesenská. As a visual observer, however, Kafka was notably interested in images with nudity and sexual content, as evidenced by some passages in his stories and books, as well as in his diary entries.

In 1911, the Munich art collector and author Anton Max Pachinger visited Prague, where, at the recommendation of Alfred Kubin, he sought out Brod and Kafka as guides to the city's nightlife.[55] In several passages in his diaries, Kafka records with great fascination the over-sexed hedonist Pachinger's boasts of his large number of sexual partners and his erotic desires and provides detailed descriptions of the photographs that Pachinger showed to Kafka and Brod of his half-naked mistresses. The encounter did not lead Kafka to issue any moral judgments, although his description of Pachinger's behavior is revealing. Indeed, the encounter with Pachinger's vulgarity led Kafka to reproduce, in words, the following visually resonant image in his diaries:

> On women: The stories about his potency make one think about how he must slowly stuff his large member into the women. His trick in earlier days was to exhaust women until they couldn't go on. Then they were without a soul, animals. Yes this submissiveness I can imagine.[56]

Further, it was Pachinger who informed both Brod and Kafka of the revulsion that Franz Blei had provoked in Munich through the publication of *Der Amethyst* and *Die Opale*. Kafka's descriptions of Pachinger, moreover, clearly reveal where true pornographers made their existence in Europe at the time: hiding behind the expertise of publicly cultured activities such as art collecting.[57] Elsewhere in his diaries, Kafka notes with apt brevity that Pachinger's

[51] *Der Amethyst* (1905–1906); *Die Opale* (1907). Max Brod published his short stories and poems in both magazines and in 1909 dedicated his novel *Ein tschechisches Dienstmädchen* to Blei, presumably because Blei liked Prague so much.

[52] See *Der Amethyst* 1 (1905), 46. See also Aubrey Beardsley, *An Issue of Five Drawings Illustrative of Juvenal and Lucian* (London: Leonard Smithers, 1906).

[53] James Hawes, *Excavating Kafka* (London: Quercus 2008), 61.

[54] Max Brod, *Franz Kafka: A Biography*, trans. G. Humphreys Roberts and Richard Winston (New York: Schocken, 1960); Max Brod, *Zauberreich der Liebe* (Berlin: Paul Zsolnay Verlag, 1928); Max Brod, *Streitbares Leben: Autobiographie* (Munich: Kindler Verlag, 1960), 238–39.

[55] Alfred Kubin was born in Litoměřice, but his family soon moved to Salzburg. He studied at the Academy of Fine Arts in Munich, where he also became a member of the group Der Blaue Reiter. In 1906 he settled in Zwickledt in Upper Austria. He corresponded with Brod from 1909 and began to meet him and Kafka in person in 1911.

[56] This passage was omitted from earlier English translations of Kafka's diaries, based on the original German editions edited by Max Brod. It has been restored in the new English translation by Ross Benjamin, see Kafka, *The Diaries*, 189.

[57] In his diaries, Kafka also mentions that Pachinger published a book titled *Motherhood in Art* and that "he considers the pregnant body the most beautiful, for him it's also the most pleasant to screw." Kafka, *The Diaries*, 140. Anton Max Pachinger, *Die Mutterschaft in der Malerei und Graphik* (Munich: G. Müller, 1906).

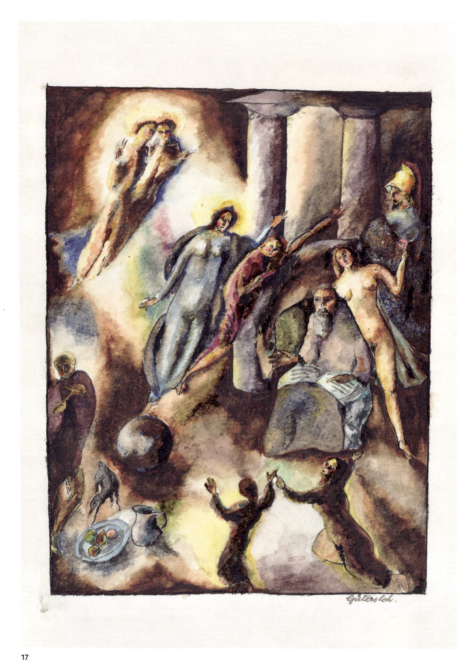

17 Albert Paris Gütersloh, *The Temptation of St. Anthony*, ca. 1910. Gouache on paper, 30×20 cm. Albertina, Vienna.

18 Rudolf Kalvach, *Harbor Life in Trieste*, 1907–1908. Woodcut with watercolor, 19.7×16.8 cm. Kunstsammlung und Archiv der Universität für angewandte Kunst Wien.

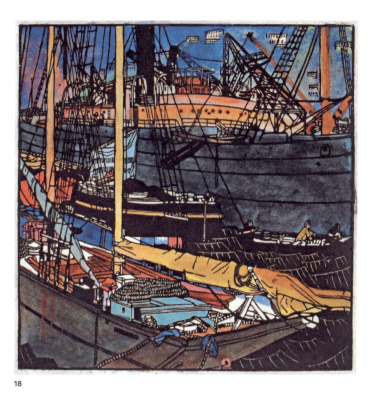

18

58 Kafka, *The Diaries*, 140.

59 Ulrich Bach, "'Das Formierte der Erotik': Franz Blei und der erotische Buchhandel," in *Erotisch-pornografische Lesestoffe*, ed. Christine Haug, Johannes Frimmel, and Anke Vogel (Wiesbaden: Harrassowitz Verlag, 2015), 147–48.

60 Kafka, *The Diaries*, 186.

61 See James Whitlark, *Behind the Great Wall: A Post-Jungian Approach to Kafkaesque Literature* (Rutherford: Fairleigh Dickinson University Press, 1991), 72, 92; Sander L. Gilman, *Franz Kafka, the Jewish Patient* (New York: Routledge, 1995), 160.

62 Franz Kafka, *The Trial*, trans. Breon Mitchell (New York: Schocken, 1998), 131–50. Evelyn Beck speculated whether the phrase "sich malen lassen" meant a sexual episode in the contemporary slang of homosexuals. See Whitlark, *Behind the Great Wall*, 72.

"relationship to art has a bad clarity attainable only through collecting."[58] The literary historian Ulrich Bach quotes Blei as stating that the point of his magazines was to "contrast the coarse materiality of pornography with the formal essence of the erotic." Indeed, Blei's publications were a social critique attacking the hypocritical way that all erotic manifestations at the time were relegated to the private sphere, and manifested a utopian yearning for a change in social structures.[59]

Various examples of Kafka's relationship to images indicate not only that he avoided narrow moralizing about "the formal essence of the erotic" and steered clear of condemning pornography, but moreover, that he did not even see any real difference between depictions of the nude body and other genres of representational art. The image of the human body, particularly any depiction of his own likeness, unnerved him and was felt as a potential threat to his dignity. In 1912, Kafka laconically noted in his diaries that "I'm supposed to serve as a nude model for a Saint Sebastian."[60] This saint was a popular subject in painting of the time, a motif that was often interpreted as a typical allegory of (homo)sexual masochistic victimization.[61] In Kafka's case, the event he describes probably never came to be, although he knew the artist in question: Ernst Ascher. Kafka's contact with Ascher left an impression on his imagination, and he returned to these impressions in the chapter "The Painter" in *The Trial*, where Josef K. makes his way into a dubious neighborhood to see a painter named Titorelli, justifying his visit to curious ears by his intention to "have himself painted," a phrase which clearly connotes the humiliating act of exposing oneself.[62] → **FIG. 35–39**

Franz Blei subsequently brought his artistic tastes, though slightly moderated to fit more closely with social norms, to the new journal *Hyperion*, where Kafka published his very first short stories in 1908, under the title "Contemplation."[63] The same issue featured reproductions of artworks by Jules Pascin, Francisco Goya, and Thomas Theodor Heine; further short prose of Kafka's appeared in the same journal in years following. → FIG. 40A–C, 41

Kafka and his friend Brod looked for inspiration not only to Munich but also to other centers of art in the German Reich. One crucial personality who informed them of the high cultural standards of Berlin's intellectual milieu was Oscar Bie, chief editor of the literary revue *Die neue Rundschau*. An art historian by training, Bie was also the author of *The Modern Art of Drawing*, which Kafka probably read.[64]

Max Brod, in his memoir *Embattled Life*, states that he was raised within German culture and felt a "cultural resonance" with German identity. At the same time, however, his relationship to the intellectual achievements of great German minds such as Goethe remained limited to what he called "love at a distance."[65] Prague's Jews, many of whom were part of the city's German-speaking minority, were also in various contexts excluded from it. More strongly than their non-Jewish German-speaking counterparts, they understood that German, apart from being a minority language in Prague, was also the language of an oppressive minority, a language separated from the people.[66]

In the arena of the visual arts, the reference language of high culture (the German of Goethe) stimulated precisely this "type of dialectical relation" invoked by Brod.[67] Kafka as well as Brod maintained a respect for the type of artwork favored by the traditions and legacy of Goethe. Throughout the second half of the nineteenth century, the classical ideals as embodied by the large

63 Franz Kafka, "Betrachtung," *Hyperion* 1, no. 1 (1908): 91–94. Paul Raabe, "Franz Kafka und Franz Blei," in *Franz Kafka. Ein Symposium. Datierung, Funde, Materialien* (Berlin: Verlag Klaus Wagenbach, 1965), 7–20.

64 Oscar Bie, *Die moderne Zeichenkunst* (Berlin: Bard, 1906). See also Jürgen Born, *Kafkas Bibliothek. Ein beschreibendes Verzeichnis* (Frankfurt am Main: S. Fischer, 1990), 133.

65 Brod, *Streitbares Leben,* 52, 74. Brod addresses this issue in many other texts.

66 See Deleuze and Guattari, *Kafka*, 30.

67 Brod, *Streitbares Leben*, 52.

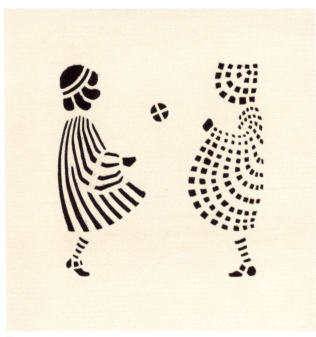

19 Maria Vera Brunner, *Children Playing with a Ball*, 1902. Stencil print, 22.5×22.5 cm. Kunstsammlung und Archiv der Universität für angewandte Kunst Wien.

20 Catalogue for the exhibition of the Neukunstgruppe at the Klub deutscher Künstlerinnen in Prague, 1910. Private collection.

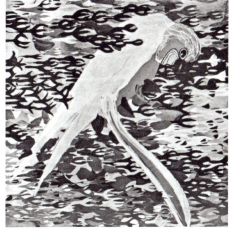

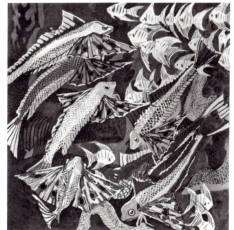

21 Minka Podhajská, *Parrot*, 1909. Tempera on paper. Location unknown. Shown at the exhibition of the Neukunstgruppe at the Salon Pisko in Vienna in 1909.

22 Minka Podhajská, *Fish*, 1909. Tempera on paper. Location unknown. Shown at the exhibition of the Neukunstgruppe at the Salon Pisko in Vienna in 1909.

23 Fanny Harlfinger-Zakucka, *Willows*, ca. 1908. Oil on canvas, 57×57 cm. Private collection.

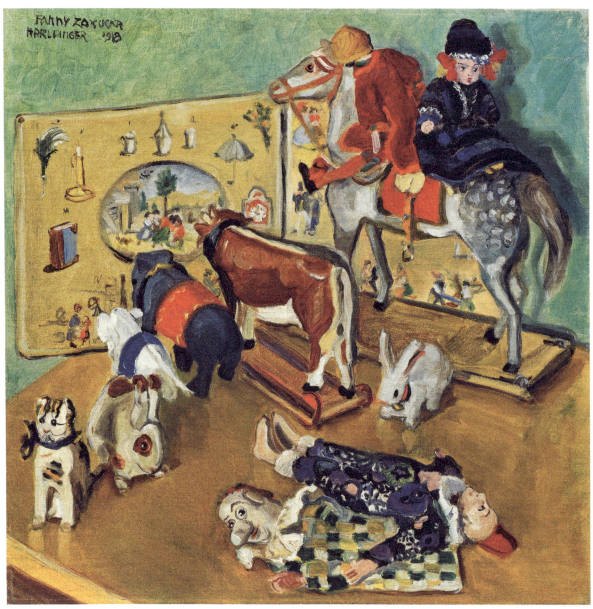

24 Fanny Harlfinger-Zakucka, *Toys*, 1918. Oil on canvas, 50×50 cm. Belvedere, Vienna.

25A–C

25A–C Minka Podhajská and Fanny Harlfinger-Zakucka, album of stencil prints, 1902–1905, 25×23 cm. Arthouse Hejtmánek, Prague.

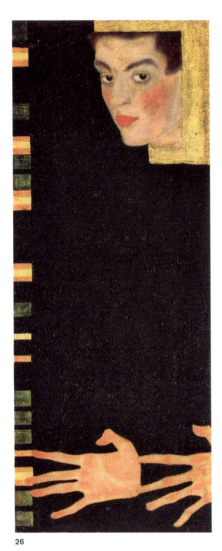

26

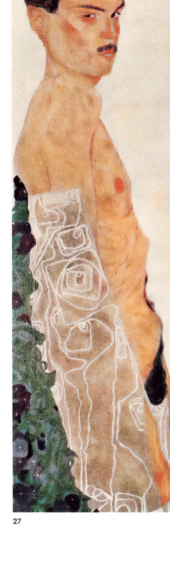

27

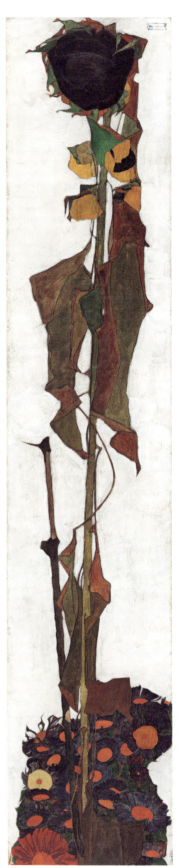

28

26 Egon Schiele, *Self-Portrait with Spread Fingers*, 1909. Oil and metallic paint on canvas, 71.5×27.5 cm. Private collection.

27 Egon Schiele, *Nude Self-Portrait with Ornamental Drapery*, 1909. Oil and metallic paint on canvas, 110×35.5 cm. Private collection.

28 Egon Schiele, *Sunflower II*, 1909. Oil on canvas, 150×29.8 cm. Wien Museum, Vienna.

THROUGH THE EYES OF FRANZ K.: BETWEEN IMAGE AND LANGUAGE

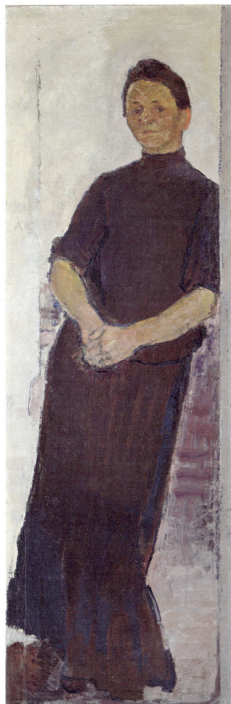

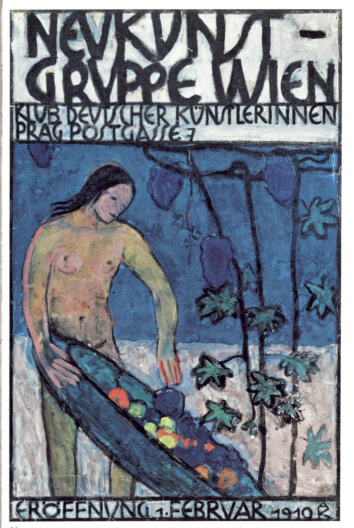

30

29 Anton Kolig, *Quiet Woman (Portrait of the Artist's Mother)*, 1909. Oil on canvas, 168.5×56 cm. Leopold Museum, Vienna.

30 Anton Kolig, maquette for a poster for the exhibition of the Neukunstgruppe at the Klub deutscher Künstlerinnen, Prague, 1910. Mixed media on paper, 55.5×37 cm. Private collection.

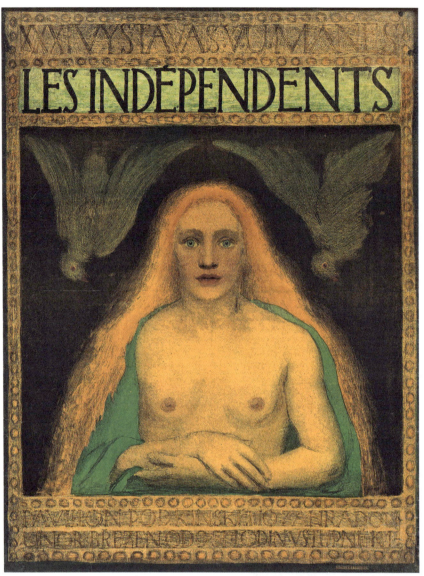

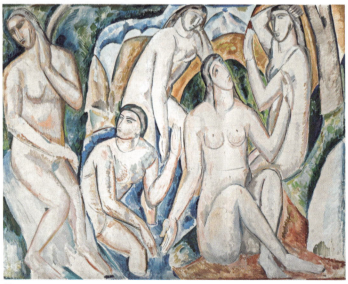

31 Vratislav Nechleba, poster for the exhibition *Les Indépendants*, Mánes Association of Fine Artists, Prague, 1910. Color lithograph, 125×96 cm. Moravian Gallery in Brno.

32 André Derain, *Bathers*, 1908. Oil on canvas, 180×230 cm. National Gallery in Prague.

bust of the Juno Ludovisi at Goethe's house in Weimar[68] were a reference point for the collections and interior decorations of many German-speaking Central European intellectuals. → **FIG. 42** Sigmund Freud owned a cast of a relief of Gradiva,[69] → **FIG. 43** while in spring 1903 Kafka himself ordered a "dancing maenad," a cast of an original antique relief from the collections of the British Museum, from the catalogue of a Munich decorating firm.[70] → **FIG. 44** Max Brod placed a similar relief in the room of Richard Garta, one of the characters in his 1928 autobiographical novel *The Kingdom of Love*. Brod conceived Garta as a reflection of Kafka, though in place of the study of law the hero of the novel "was fully devoted to the fine arts."[71] In addition to this cast of a classical relief, Garta's room described by Brod contained another artwork—a lithograph.[72] In fact, Kafka's friend and former classmate Paul Kisch, who was studying German literature in Munich, acquired at Kafka's request not only the dancing maenad but also a reproduction of *The Ploughman* by Hans Thoma from the Munich journal *Der Kunstwart*.[73] → **FIG. 45**

Both artworks are relatively conventional, and *Der Kunstwart* generally provided readers an unchallenging visual experience. → **FIG. 46** The magazine introduced Kafka not only to Thoma but also to the Biedermeier painter Ludwig Richter. → **FIG. 47** As concerns the journal, Brod noted in his memoirs that it "valued only certain, albeit great authors" and that Kafka, under its influence "suffered occasional bouts of Germanophilia."[74] This German nationalist orientation, combined with the journal's mission to present a classical understanding of art to its culturally uncertain middle-class readers,[75] evidently left Kafka undisturbed, since he read the magazine throughout his gymnasium years and even later into adulthood. German culture, in Kafka's imagination, was consciously framed through the sentimentally regarded traditions most ideally embodied by the illustrated family periodicals popular in the later decades of the nineteenth century. In a 1913 letter to Felice Bauer, Kafka wrote of his emotional response to perusing an old issue (from 1863) of a German magazine of this kind, *Die Gartenlaube*:

> I didn't read anything in particular, but slowly thumbed through … the illustrations. … I always like reading old newspapers and periodicals. And then there is this ancient, heart-stirring, expectant Germany of the middle of the last century. The confined conditions, the proximity each felt to the other, editor to subscriber, author to reader, the reader to the great poets of the time.[76]

THE VEHICULAR LANGUAGE OF PRAGUE GERMAN, AND IMAGES OF JAPAN AT THE PERIPHERY OF COLONIAL EUROPE

In a 1921 letter to Brod, Kafka shared his views on Jewish authors writing in German:

> [I]n this German-Jewish world hardly anyone can do anything else [than this] bumptious, tacit, or self-pitying appropriation of someone else's property, something not earned, but stolen by means of a relatively casual gesture. Yet it remains someone else's property, even though there is no evidence of a single solecism.[77]

68. Jochen Klauss, ed., *Goethe als Sammler. Kunst aus dem Haus am Frauenplan in Weimar* (Zurich: Strauhof, 1989), 19.

69. Harald Leupold-Löwenthal, ed., *Sigmund Freud Museum* (Vienna: Verlag Christian Brandstätter, 1999), 44.

70. Franz Kafka to Paul Kisch, February 7, 1903, in Kafka, *Briefe*, 22. Classical sculpture interested Kafka. During his visit to the Louvre, he was captivated by, among others, the *Venus de Milo* and the *Borghese Gladiator*. See also Franz Kafka, *The Diaries*, 539.

71. Brod, *Zauberreich der Liebe*, 48.

72. Ibid.

73. Brod, *Franz Kafka: A Biography*, 53–54. See also Kilcher, "Kafka's Drawing and Writing," 215–17. Paul Kisch was the brother of the journalist Egon Erwin Kisch.

74. Brod, *Streitbares Leben*, 278.

75. Stach, *Franz Kafka: The Early Years*, 195–98. Kafka was introduced to the magazine by his classmate Oskar Pollak, who later became an art historian with a focus on the baroque. Like Pollak, Max Horb's brother Felix also studied art history in Vienna.

76. Franz Kafka to Felice Bauer, January 17–18, 1913, in Kafka, *Letters to Felice*, 158.

77. Franz Kafka to Max Brod, June 1921, in Kafka, *Letters to Friends, Family and Editors*, 360.

The previous section of this chapter discussed the significance that the high culture of German centers had for Prague's German-speaking authors, art lovers, and artists. What, however, happened to these same artistic and pictorial signs when they were removed from their original context in Munich, Berlin, or Vienna, and shifted to Prague's ateliers and exhibition spaces? Did they remain "someone else's property" in the eyes of local or international viewers? What actions did the local community of German-speaking artists and patrons in Prague take to ensure that this "appropriated" property became firmly bound to the new place and claimed there at a deep level?

The artwork of German-speaking artists in Bohemia, which expressed itself in an artistic language borrowed from German centers, was something that Kafka knew well from Prague exhibitions and from the pages of Prague's German-language journals. In 1900–1901 the poet Paul Leppin → **FIG. 48** published the journal *Frühling*, followed in 1906 by another called *Wir*, both of which devoted space to reproductions of artworks by Hugo Steiner, Richard Teschner, Alois Wierer, and Kafka's own friend Max Horb. → **FIG. 49, 50** Steiner, Teschner, and Wierer all occasionally illustrated books of fairy-tales, and this was also reflected in their artwork: fantastic motifs given a stylized secessionist-symbolist treatment in the vein of the painters and printmakers of Munich or Vienna. They brought these aesthetic styles to Prague and further enriched them with illustrative accents of the city's own mythic geography. → **FIG. 51–53**

For the young Kafka, the key personality among the German-speaking Jewish artists of Prague was the painter and graphic artist Emil Orlik. In November 1902, Max Horb, then still a law student, delivered a lecture on Orlik for the liberally-minded Prague German students of the Lese- und Redehalle der deutschen Studenten in Prag (Reading and Lecture Group of German Students in Prague). The lecture was associated with an exhibition of Orlik's work in Prague, which also presented a significant number of pieces inspired by Japanese woodcuts.[78] → **FIG. 54–56** Orlik's paraphrasing of Japanese art was admired not only in Prague but also in the era's German-speaking centers of art.

Some two weeks after Horb's lecture, Oskar Pollak, a student of art history and a friend of Kafka's who had an intellectual influence on him, gave a presentation to the same student organization on Japanese culture in its own right, asserting it to be more developed and sensitive than that of the West. From the minutes that were recorded of the lecture, it would appear that it stimulated debate among the listeners, with one of the participants being the previously mentioned painter Ida Freund. At the end of the evening, Kafka announced to the audience that he would soon be providing his own lecture under the title "Japan and Us." From what we know, however, this lecture was never delivered.[79]

"Japonisme" fascinated artists and audiences across Europe and, from the mid-nineteenth century at the latest, significantly shaped the development of modern culture. For the German-speaking circles of Prague, it gained special force thanks precisely to Orlik. Even before his Prague exhibition, in late December 1901 he gave two lectures in the sold-out Hall of Mirrors at the Deutsches Haus (German House) in Prague on the subject of life and art in Japan, where he had just spent over a year. The presentation was accompanied by a projection of slides.[80]

Why did the young Kafka find the aesthetics of the Japanese printmakers Utamaro, Hiroshige, and Hokusai and their creative paraphrasing in the works

[78] *Výstava Emila Orlika* (Prague: Krasoumná jednota, 1902).

[79] Minutes of the lecture taken from Stach, *Franz Kafka: The Early Years*, 217. Kafka's other involvement in the association is worth mentioning as well: at the beginning of the fifth semester, he was elected fine art reporter there. See also Hartmut Binder, "Kafka in der Lese- und Redehalle," *Else-Lasker-Schüler-Jahrbuch zur klassischen Moderne* 2 (2003): 160–207.

[80] *Bohemia*, December, 12, 1901, 12.

of Orlik so captivating? → **FIG. 57, 58** Scholars have already identified, in Kafka's stories and novels, the inspiration that he gleaned from literary models in Japan and China, India, and the Arab world.[81] What, however, motivated Kafka's fascination with the visual imagery, real or stereotypical, of Japan? Reiner Stach has hypothesized that Kafka was gripped by the extreme simplicity with which Japanese artists could, in a single movement, express the essence of a figure or a landscape. The unusual flatness of their pictorial space was an example of the refinement of this extreme form of pictorial reduction.[82] Similarly, as noted by Andreas Kilcher, Kafka could have been aware of the close link in both Japanese and Chinese culture between writing, drawing, and painting. In Kilcher's view, a Japanese tendency toward abstraction may thus have found expression not only in Kafka's drawings but in Kafka's approach to writing as well.[83]

Throughout his life, Kafka approached the study of Japanese and Chinese art with great seriousness. In 1923, he ordered Otto Fischer's *Chinese Landscape Painting* and Ludwig Bachhofer's *The Art of the Japanese Woodcut Masters* for his personal library.[84] Max Brod shared this interest, and in autumn 1908 Kafka sent him a postcard—"the most beautiful I have"—featuring a reproduction of a woodcut by Hiroshige Utagawa.[85] → **FIG. 59** Kafka also had an interest in more popular imagery of Japan and its stereotypical exoticism. Back in Prague after being forced to return early from a October 1910 trip to Paris with Brod by an attack of furunculosis, Kafka sent his friend a postcard with a photograph of a Japanese girl in traditional dress. Both sides of the card are thickly covered with Kafka's writing, describing among other things his medical condition.[86] → **FIG. 60** Perhaps the choice of subject for the postcard was no accident: Kafka, in Prague, sent his friend traveling in prosaic western Europe an image that, viewed from the standpoint of the periphery of colonial Europe, evoked the "truly exotic."[87] In the course of his own life in Prague, Kafka regularly encountered the massive popularity of the Japanese aesthetic, which had been taken up at the turn of the century by advertising design, → **FIG. 61** and during his regular visits to the cabaret or cinema at the Lucerna Palace, he would certainly have noticed the opening in 1909 of a café named "Jokohama," featuring a pseudo-Japanese interior and waitresses dressed in kimonos.[88] → **FIG. 62** Performances by Japanese acrobats similarly garnered the attention of a broad sector of the public. → **FIG. 63** Well-known today is Kafka's sketch made in response to a performance by the Mitsutas ensemble that he witnessed in November 1909 at Prague's Théâtre Variété. → **FIG. 64** The Japanese performers' dangerous stunts[89] inspired Kafka not only to attempt to capture their compelling gestures in drawings but also to formulate parallels between the performers and his own writing:

> For whatever things occur to me occur not from the root, but beginning somewhere toward their middle. Just let someone try to hold them, let someone try to hold and cling to a blade of grass that only starts growing in the middle. Perhaps some can, Japanese acrobats, for example, who climb a ladder that isn't resting on the ground but on the upturned soles of a partner lying on his back and isn't leaning against a wall but goes straight up into the air.[90]

[81] Walter Benjamin had already spoken of the "Chineseness," the Taoist character of Kafka's thought. See Benjamin, "Franz Kafka," 279, 295. See also Rolf J. Goebel, *Constructing China: Kafka's Orientalist Discourse* (Columbia: Camden House, 1997); Weiyan Meng, *Kafka und China* (Munich: Iudicium, 1986); Ralf R. Nicolai, *Kafkas "Beim Bau der Chinesischen Mauer" im Lichte themenverwandter Texte* (Würzburg: Königshausen & Neumann, 1991); Michael P. Ryan, "Samsa and Samsara: Suffering, Death, and Rebirth in 'The Metamorphosis,'" *The German Quarterly* 72, no. 2 (Spring 1999), 133–52.

[82] Stach, *Franz Kafka: The Early Years*, 218. See also the text by Nicholas Sawicki in the present volume.

[83] Kilcher, "Kafka's Drawing and Writing," 222.

[84] Otto Fischer, *Chinesische Landschaftsmalerei* (Munich: Kurt Wolff Verlag, 1921); Ludwig Bachhofer, *Die Kunst der japanischen Holzschnittmeister* (Munich: Kurt Wolff Verlag, 1922). See Born, *Kafkas Bibliothek*, 187.

[85] Kafka, *Letters to Friends, Family, and Editors,* 47.

[86] Ibid., 89–90. Kafka sent the postcard together with two other, related ones.

[87] John Zilcosky, *Kafka's Travels. Exoticism, Colonialism, and the Traffic of Writing* (New York: Palgrave Macmillan, 2003), especially the chapter "Transcending the Exotic: Nostalgia, Exoticism, and Kafka's Early Travel Novel, *Richard and Samuel*."

[88] "Jokohama v Lucerně," *Český svět*, October 22, 1909, 83. See also Binder, *Wo Kafka und seine Freunde zu Gast waren*, 103.

[89] *Bohemia*, November 17, 1909, 7.

[90] Kafka, *The Diaries*, 6.

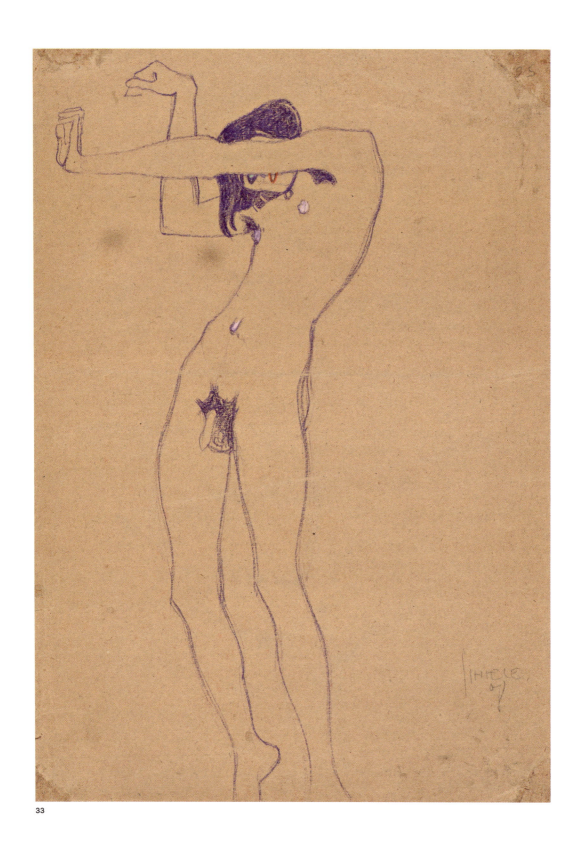

33

33 Egon Schiele, *Male Nude*, 1908. Colored chalk on paper, 44.2×32.3 cm. Wien Museum, Vienna.

BETWEEN LANGUAGES AND WITHOUT LANGUAGE

Prague at the start of the twentieth century was a place where languages clashed in polemics, passed each other in indifference, or creatively overlapped and supplemented one another. In the streets, it was possible to see the same image accompanied in one instance by Czech text and in another by German. This was the case for the posters of the exhibition *Das schöne Prag*, or *Krásná Praha*, which Kafka likely visited in February 1906.[91] → **FIG. 65, 66** Organized by the consistently bilingual Krasoumná jednota, it won the attention of both the German- and Czech-language press.[92] The reviewer in the Czech weekly *Zvon* wrote that the "historic beauty of Prague" is an "inalienable part [of an] immaculate nation," implying of course the nation to be Czech.[93] The exhibition's "modern section," nevertheless also included "German" painters and graphic artists, with representation for both linguistic groups guaranteed by a bilingual jury consisting of "Bárta, Braunerová, Jakesch, Jansa, K. D. Mráz, Staegr, and Stretti."[94] Kafka even considered purchasing one of the artworks from this showing.[95] The exhibition presented its viewers with images of Prague that protested, through clearly legible form, against the insensitive destruction of the historic fabric of the city, at the time under threat from modernizing projects of urban renewal.

By the turn of the century, nationalist conflict and linguistic resentments had increased within the Krasoumná jednota, which dates its founding back to 1835. Aesthetic culture, artistic traditions, and contemporary creativity

[91] Franz Kafka to Max Brod, February 19, 1906, in Kafka, *Letters to Friends, Family, and Editors*, 19.

[92] Oskar Wiener, "Das schöne Prag," *Wir* 1 (1906). Quoted from Kurt Krolop, "Zur Geschichte und Vorgeschichte der Prager deutschen Literatur des 'expressionistischen Jahrzehnts,'" in *Weltfreunde. Konferenz über die Prager deutsche Literatur*, ed. Eduard Goldstücker (Prague: Academia, 1967), 53; J. H.-a, "Krásná Praha," *Pražská lidová revue* 2, no. 1 (1906): 26.

[93] "Krásná Praha. Zvláštní výstava," *Zvon* 6, no. 23 (1906): 367.

[94] J. H.-a, "Krásná Praha," 26.

[95] Kafka, *Letters to Friends, Family, and Editors*, 19.

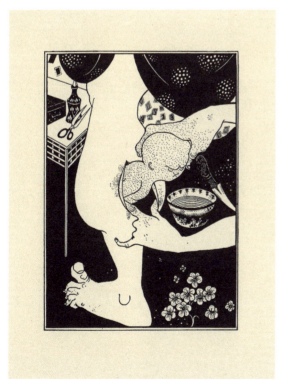

34 *Der Amethyst*, vol. 1, no. 1, 1905. Reproduction of an illustration by Aubrey Beardsley for Lucian's *True History*. Private collection.

35

36

37

35 August Brömse, *St. Sebastian*, ca. 1915. Black pastel on paper, 19.5×15.6 cm. Liberec Regional Gallery.

36 Alfred Kubin, *St. Sebastian*, 1920s. India ink on paper with backing, 23.5×15.5 cm. Liberec Regional Gallery.

37 Bohumil Kubišta, *St. Sebastian*, 1912. Pencil on paper, 94.8×73.7 cm. National Gallery in Prague.

THROUGH THE EYES OF FRANZ K.: BETWEEN IMAGE AND LANGUAGE

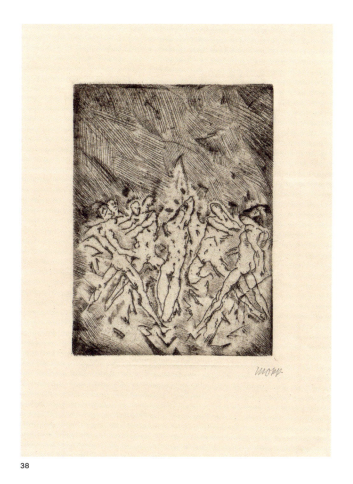

38 Max Oppenheimer, *Flogging*, 1913. Drypoint, 11.4×8.5 cm. Jewish Museum in Prague.

39 Detail from a letter from Franz Kafka to Milena Jesenská, October 9, 1920, with drawing of torture scene. Ink on paper, 8.7×22.7 cm. Deutsches Literaturarchiv Marbach.

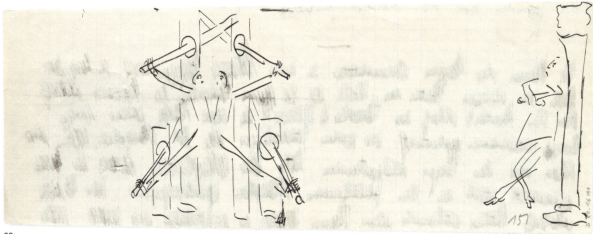

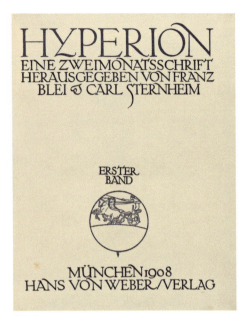

40 A–C

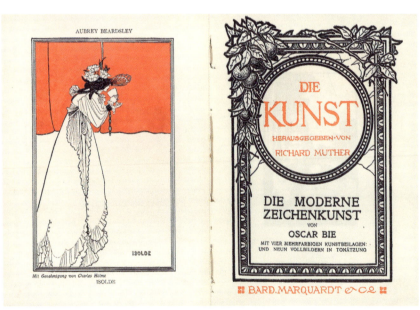

41

40 A–C *Hyperion*, vol. 1, no. 1, 1908. Issue with Kafka's "Betrachtung" and reproduction of Jules Pascin's *Doll Fairy*. Library of the National Museum in Prague.

41 Oscar Bie, *Die moderne Zeichenkunst* (Berlin: Bard, 1906). Library of the Moravian Gallery in Brno.

THROUGH THE EYES OF FRANZ K.: BETWEEN IMAGE AND LANGUAGE

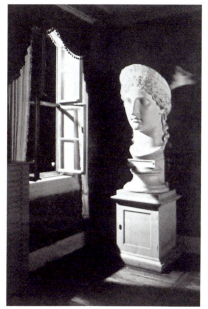
42

43

44

42 Photograph of the "Junozimmer" in Johann Wolfgang von Goethe's house in Weimar.

43 Cast of classical relief from the Chiaramonti Museum in Rome (*Gradiva*, original from the second half of the 4th century BCE). From the former collection of Sigmund Freud.

44 *Dancing Maenad*, Roman copy of a lost Greek original from the 5th century BCE. Marble relief, h. 43cm. British Museum, London.

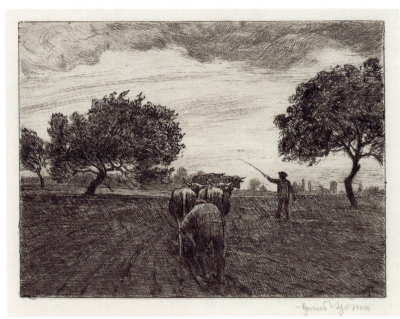

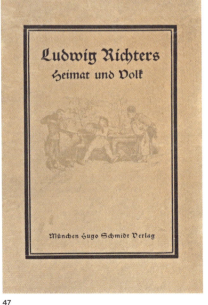

45　Hans Thoma, *Plowman*, 1897. Etching, 17.7×23 cm. Private collection.

46　*Der Kunstwart*, vol. 15, no. 17, 1902. T. G. Masaryk Library, Masaryk Institute and Archives of the Czech Academy of Sciences.

47　*Ludwig Richters Heimat und Volk*, edited by Ernst Wilhelm Bredt (Munich: Hugo Schmidt Verlag, 1917). Library of the Museum of Decorative Arts in Prague.

all became a part of the political agenda. Kafka nevertheless also encountered another sphere of visual imagery, not only in Prague, that in its newness offered a more democratic form of entertainment, outside all disputes over nation or language.[96] In October 1907, the Oeser brothers opened the Grand-Kinematograph Orient on Prague's Hybernská street, where Kafka watched many films in the ensuing years. In the press of that era, we find cinema advertisements and announcements presented in identical German and Czech versions; both languages were also used equally for the intertitles of the silent films of the period. → FIG. 67, 68 Interestingly, the film *Daddy Long Legs*, which Max Brod in his memoir claimed was Kafka's favorite, was seen by Kafka in 1919 at the Lucerna cinema with Czech titles.[97] This American film, produced by Mary Pickford, who also played its main character, has several somewhat bizarre scenes, including Pickford playing the title character both as an adult and as an orphaned child fighting against the structures of the orphanage.[98]

In *Kafka Goes to the Movies,* Hans Zischler calls attention to a clear reference to the film *The White Slave*[99] in Kafka's unfinished novel *Richard and Samuel*, conceived in collaboration with Max Brod and inspired by their journey together in 1911 from Prague via Pilsen, Munich, Lugano, Milan, Sankt Moritz, Montreux, Lausanne, and Dijon to Paris.[100] *The White Slave*, a popular Danish film of the time, relates the story of an impoverished young woman who falls into the cross-hairs of a gang of human traffickers. After a dramatic search, she is rescued by her suitor, but the shadow of suspicion that her virtue has been taken from her hangs over their relationship. In the unfinished *Richard and Samuel,* Brod and Kafka directly invoke a scene from the film in which the innocent heroine, upon exiting the train station, is manipulated into getting into a car and is taken away. → FIG. 69 Richard, Kafka's alter ego, recalls the scene at the moment when Samuel, who stands in for Max Brod, initiates a taxi ride through Munich in the company of a young woman whom they met by chance while on the train.[101] Kafka's diary reveals that the figure of the girl was inspired by their real-life acquaintance Alice Rehberger, who joined them in their train compartment in Pilsen.[102] Like the heroine of Kafka and Brod's novel, Rehberger worked in an office, which inspired the authors to engage in a broader critique of the employment of women in similar conditions:

> And think of a poor girl sitting in an office, her very skirt isn't made for the job, what a strain is put upon it having to shift to and fro all the time for hours on a hard wooden chair. And so these round bottoms are galled, and the breasts too against the edge of the desk.[103]

For Zischler, the daring and perhaps even socially unacceptable taxi ride with two young men that the woman in the novel takes through un unknown city represents the authors' attempt to free her from the hated office setting and "entrust her to the realm of pure, cinematic fiction." The reference to a specific, compelling, and suspenseful scene from a popular silent film was meant to aid in this effort.[104] Kafka removed the visual language from its original cinematic context and assigned it an entirely new function—in defiance of the general criticism of cinematic kitsch motivated either by conservative prudery or by the superiority of the educated middle classes.[105]

[96] Ines Koeltzsch, *Geteilte Kulturen. Eine Geschichte der tschechisch-jüdisch-deutschen Beziehungen in Prag* (Munich: Oldenbourg Wissenschaftsverlag, 2012), 288–330.

[97] Brod, *Streitbares Leben*, 274.

[98] *Daddy Long Legs*, USA, 1919, directed by Marshall Neilan.

[99] *Die weiße Sklavin*, Denmark, 1911, directed by August Blom.

[100] Hans Zischler, *Kafka Goes to the Movies*, 34.

[101] Max Brod and Franz Kafka, "The First Long Train Journey," in Franz Kafka, *The Penal Colony: Stories and Short Pieces*, trans. Willa and Edwin Muir (New York: Schocken, 1948), 286–87.

[102] Kafka, *The Diaries*, 503.

[103] Brod and Kafka, "The First Long Train Journey," 286.

[104] Zischler, *Kafka Goes to the Movies*, 37.

[105] Zischler quotes a lengthy, caustic critique of the film by Jiří Mahen, published on March 3, 1911, in *Lidové noviny*. Ibid., 126–27.

THROUGH THE EYES OF FRANZ K.: BETWEEN IMAGE AND LANGUAGE

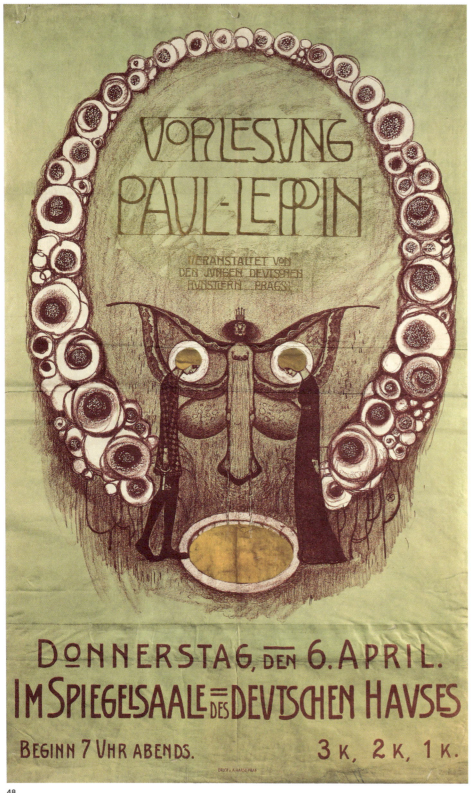

48

49

48 Richard Teschner, poster for a lecture by Paul Leppin, Prague, 1900. Color lithograph, 129×79 cm. Museum of Decorative Arts in Prague.

49 *Frühling*, vol. 1, no. 1, 1900. Reproduction of artwork by Hugo Steiner. National Library of the Czech Republic, Prague.

50 *Wir*, vol. 1, no. 1, 1906. Reproduction of artwork by Richard Teschner. National Library of the Czech Republic, Prague.

50

51

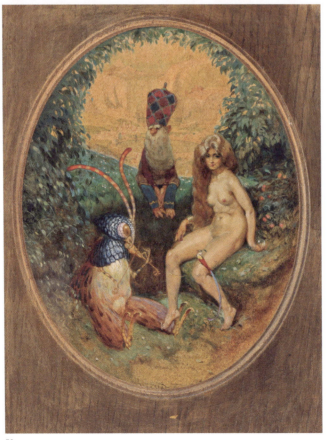

52

51　Richard Teschner, poster for a masquerade ball of German writers and artists in Prague, 1904. Lithograph, 116×182 cm. Museum of Decorative Arts in Prague.

52　Richard Teschner, *Fairytale Scene*, 1907. Oil and watercolor on paper, 30.5×23.3 cm. National Gallery in Prague.

THROUGH THE EYES OF FRANZ K.: BETWEEN IMAGE AND LANGUAGE

53

53 Hugo Steiner-Prag, from the cycle *The Golem*, 1916. Lithograph, 19×12.3 cm. Gallery of West Bohemia in Pilsen.

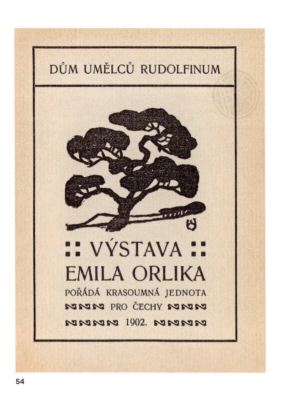

54 Catalogue for Emil Orlik's exhibition organized by Krasoumná jednota at the Rudolfinum, Prague, 1902. Library of the Museum of Decorative Arts in Prague.

55A–C Emil Orlik, *Painter, Engraver, Printmaker: Creating a Woodblock Print*, 1901. Offset prints, 19.4×15.7 cm, triptych. Magazine inserts in *Die Graphischen Künste*, vol. 25, 1902. National Gallery in Prague.

56 Emil Orlik, *Girl and Willow*, 1900. Color woodcut, 19.5×38.2 cm. Shown at Orlik's 1902 exhibition in Prague. Jewish Museum in Prague.

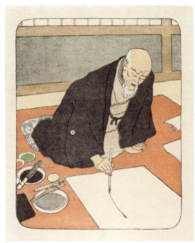

55A–C

56

57

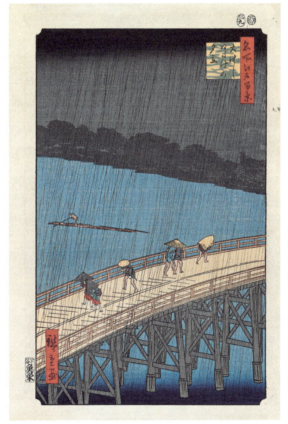

58

59

60

57 Kitagawa Utamaro, *New Year's Print with Five Cranes*, ca. 1790. Color woodblock print (nishiki-e), 16.5×37.7cm. From the former collection of Emil Orlik. National Gallery in Prague.

58 Hiroshige Utagawa, *Sudden Shower over Shin-Ōhashi Bridge and Atake*, from the series *One Hundred Famous Views of Edo*, 1857. Color woodblock print (nishiki-e), 37.5×26cm. Olomouc Museum of Art.

59 Postcard with reproduction of woodblock print by Hiroshige Utagawa, sent by Franz Kafka to Max Brod on November 21, 1908. National Library of Israel, Jerusalem.

60 Postcard with photograph of a Japanese woman, sent by Franz Kafka to Max and Otto Brod on October 20, 1910. Private collection.

THROUGH THE EYES OF FRANZ K.: BETWEEN IMAGE AND LANGUAGE

61

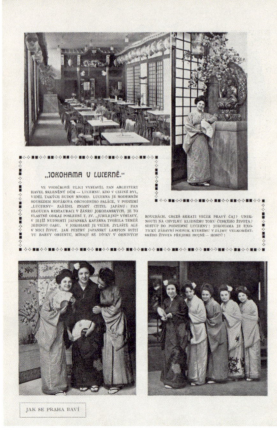

62

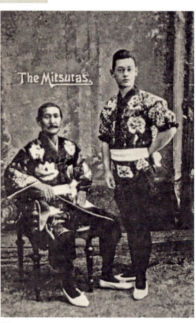

63

61 Karel Šimůnek, poster for *Panorama Gea*, an exhibition of travel images, Prague, 1899. Chromolithograph, 93×126 cm. Museum of Decorative Arts in Prague.

62 *Český svět*, October 22, 1909. Article about the Jokohama restaurant at the Lucerna Palace, Prague. National Library of the Czech Republic, Prague.

63 Period photograph of the Japanese acrobats the Mitsutas. Private collection.

64 Franz Kafka, diary entry about Japanese acrobats, mid-November 1909. The Bodleian Libraries, University of Oxford.

The White Slave belongs to the genre of films that allow the viewer a bashful yet unashamed peek into a brothel. The interest that Kafka displayed in this film, returning to it even in his correspondence, confirms Zischler's view that, for Kafka, cinema was among the "various escapades" he pursued in his free time: "coffeehouse, cinema, cabaret, bordello."[106]

Contrary to the above, Zischler paradoxically associates Kafka's cinematic experiences with existential questions of life: "For Kafka … the almost demonic technological element [of cinema] challenges the way we have learned to see, confronts the author's powers of sight and writing with very great, agonizing demands."[107] Even from Kafka's own words it is clear that the cinematic image confronted him with urgent questions of human existence and artistic creation. When Prague cinemas showed the film *The Other*[108] with Kafka's favorite theater actor Albert Bassermann, whom he had seen as Hamlet in Berlin, he reflected in a letter to Felice on what the definitive permanence of the filmic image does to the actor's performance and personality in the course of time:

> This is how I imagine the situation: the satisfaction of acting is over; the film is made; B. himself can no longer influence it in any way; he need not even realize that he had allowed himself to be taken advantage of. … He grows older, weak, gets pushed aside in his armchair, and vanishes somewhere into the mists of time.[109]

Kafka saw film images as detached from the body, indeed torturing the physical body into confrontation with its own immortality. But the fleeting nature of the moving image also provoked in Kafka an unquenchable desire for something that was lacking. In September 1913, he wrote to Felice Bauer from his travels: "nothing happens to me to stir my inmost self. This applies even if I weep, as I did yesterday in a cinematographic theater in Verona. I am capable of enjoying human relationships, but not experiencing them."[110] In yet another letter to Felice, Kafka also describes how this sense of absence and desire can be alleviated through the enjoyment of images:

> My need for pleasure and distraction feeds on posters; when looking at posters I derive some relief from my habitual inner uneasiness, that everlasting feeling of impermanence; whenever I returned to the city after the summer vacation …
> I felt a great thirst for posters, and, from the tram on my way home, swiftly and with some effort I used to read fragmentary snatches of the posters we were passing.[111]

Most of these posters were evidently for films being shown at the time or for the planned film programs of Prague's movie houses, as indicated by the sentence immediately preceding the quotation: "although I myself rarely go to the cinematographic theater, I usually know by heart almost all the weekly programs in every one of them." → FIG. 70

As early as 1911, before he was an accustomed moviegoer, Kafka compared the lifelike qualities of the cinematic image with those evoked through stereophotography. Since the mid-nineteenth century, stereoscopy had drawn on the discovery that each of a person's eyes perceives a different image

106 Ibid., 10.
107 Ibid., 16.
108 *Der Andere*, Germany, 1913, directed by Max Mack.
109 Franz Kafka to Felice Bauer, March 4–5, 1913, in Kafka, *Letters to Felice*, 213.
110 Franz Kafka to Felice Bauer, September 21, 1913 (included with letter from November 6, 1913), in ibid., 459. The films that brought Kafka to tears were *Lolotte* and *Catastrophe at the Dock*. See Zischler, *Kafka Goes to the Movies*, 104.
111 Franz Kafka to Felice Bauer, March 13–14, 1913, in Kafka, *Letters to Felice*, 221.

from the other, and that the brain composes a spatial impression from these two images. Stereophotography places together two photographs taken at the same moment through lenses placed at precisely the same distance apart as human eyes. When viewed through a stereoscope, each eye sees the respective photograph, and the brain then unifies them into a seemingly three-dimensional image. While on a business trip to Friedland (Frýdlant) in February 1911, Kafka visited the "Kaiserpanorama," which contained inside its circular structure places for viewers to sit in front of individual stereoscopes. "I had forgotten the setup of the panoramas and was afraid for a moment that I would have to go from one chair to the next," Kafka wrote in his diary.[112] Viewers needed only to take a seat, and before their eyes, their gaze fixed by the stereoscope's eyepieces, the entire display of stereophotographs was set in motion. Franchises of the Kaiserpanorama spread throughout towns across Bohemia; their distribution through Austro-Hungary was arranged by the Weltpanorama Photoplastikon company in Vienna, and the negatives were purchased from the Paris firm of Lévy Fils et Cie.[113] → FIG. 71, 72 The photographs of monuments and landscapes in these panoramas were limited to the boundaries of the Habsburg empire, or respectively Austria, which before 1859 reached even further into northeastern Italy. A verbal commentary was not necessary for the stereoscopic display; at most, the viewers, Kafka among them, could hear mechanically produced music from an "ariston," a predecessor of the gramophone. "Brescia, Cremona, Verona," Kafka wrote in his diaries. "The pictures more alive than in the cinematograph, because they allow the gaze the repose of reality. The cinematograph gives what is viewed the restlessness of its movement, the repose of the gaze seems more important. Smooth floor of the cathedrals in front of our tongue."[114]

It seems odd that Kafka linked his impression from the panorama to the tongue, the transmitter of taste, as the lifelike aspect of stereophotography was more commonly ascribed to its ability to convey the optical illusion of three-dimensional volumes and spatial depth. "People in there like wax dolls fastened to the ground to the pavement by their soles," Kafka adds. "Monument to the hero Tito Speri: the clothes flutter neglected and enthusiastic around his body. Blouse, broad-brimmed hat." Kafka's description of the stereoscope images recalls his evocative portrayals of the stances and gestures of singers, cabaret artists, and dancers. It is as if Kafka wished to capture the acts of the performers he enjoyed the most (such as the Austrian chansonnières Mella Mars and Lucie König, the Russian dancer Eugenie Eduardova, the Viennese dancer Gusti Odys, or the Czech singer Rudolf Vašata) through a textual effect similar to the three-dimensional illusion of stereophotography. "Odys dancer. Stiff hips. Real fleshlessness. To me red knees suit the dance 'Moods of Spring.'"[115] → FIG. 73

For his cabaret visits, Kafka usually selected programs in German,[116] though he is known to have attended Czech operetta performances and even at the Lucerna he did not exclusively follow the German programming.[117] In view of the fact that Kafka is known not to have been very acoustically perceptive,[118] his choice of which performances to attend was made primarily on the basis of the visual attractiveness. In Kafka's youth, the intermingling of Prague's two linguistic spheres happened on visits to nightlife venues and houses of ill repute. → FIG. 74–76 In spite of, or perhaps precisely because of, the city's multilingualism, the visual imagery of nocturnal Prague functioned on a plane entirely outside of speech.

112 Kafka, *The Diaries*, 500.

113 See, for example, "Císařská panorama," *Lidové noviny*, September 5, 1909, 7.

114 Kafka, *The Diaries*, 500.

115 Ibid., 22.

116 Binder, *Wo Kafka und seine Freunde zu Gast waren*, 99–113.

117 See Antonín Měšťan, "Slované u Franze Kafky," in *Česká literatura mezi Němci a Slovany* (Prague: Academia, 2002), 50.

118 Stach, *Franz Kafka: The Early Years*, 342. See also Steffen Höhne and Alice Stašková, eds., *Franz Kafka und die Musik* (Cologne: Böhlau Verlag, 2017).

THE VERNACULAR LANGUAGE OF CZECH, AND IMAGES BETWEEN COUNTRYSIDE AND METROPOLIS

Judging from his diaries and correspondence, as well as from the testimony of his contemporaries, Kafka's immediate circle of friends included five professional artists: Ernst Ascher, Alfred Kubin, Max Horb, Willi Nowak, and Friedrich Feigl. The three latter painters managed to break the barrier between the German- and Czech-speaking artistic scenes in Prague; along with their Czech counterparts from the Academy of Fine Arts, they founded the previously mentioned group Osma. At least indirectly, Kafka would have learned from these three artists about the works of Czech modernist and early avant-garde art, soon to be associated with terms such as expressionism, fauvism, cubism, and futurism.

In the early history of Osma, the group's German members played a truly irreplaceable role in organizing its collective activities. The Czech members either came from poor rural families, as was the case with Bohumil Kubišta, Antonín Procházka, and Otakar Kubín, or at best from the world of provincial small towns, in this case Emil Filla and Emil Artur Pittermann Longen. None of them had the financial or cultural capital necessary for arranging a successful art exhibition in Prague. As a result, Osma's first show in 1907 was, quite naturally, entirely arranged by its German members.[119]

In this first joint presentation, the rural background of the Czech members was in one sense downplayed: specifically, they deliberately communicated with their metropolitan German-speaking friends mainly in German and neglected Czech,[120] although at the same time the pictures in this first exhibition placed emphasis on the subject matter of the Czech landscape and its rural inhabitants.[121] Proof that the Czech members of Osma were already hoping to reach beyond the boundaries of their linguistic territory can be found in the exhibited paintings by Otakar Kubín, made during his tour of Italy, or those by Bohumil Kubišta from his stays in Pula and Florence. → FIG. 77–80

Nowak, Feigl, and Horb drew upon their cultural contacts in organizing the exhibition and ensuring that it received positive critical attention.[122] One review was written by Max Oppenheimer, a Viennese painter who had studied at the Prague Academy of Fine Arts in 1906 and had remained friends with his German-speaking colleagues there.[123] When in Prague, Oppenheimer associated with the same circle of authors as Kafka. In 1908, Max Brod wrote an article on his work for the magazine *Erdgeist*.[124] → FIG. 81–83

Brod, in fact, was the author of another positive response to the exhibition, in a review titled "Spring in Prague," published in the Berlin journal *Die Gegenwart*.[125] The Czech press, by contrast, harshly rejected the exhibition in critiques that were clearly tinged with nationalism and antisemitism.[126]

There is a clear likelihood that the first exhibition of Osma overlapped with the time when Max Brod was trying to promote Franz Kafka's drawings. In summer 1907, while preparing the publication of a volume of his own poetry, Brod attempted to convince the publisher Axel Juncker to print a drawing by Kafka on the book's title page.[127] This, however, never came to pass. In October 1907, Kafka wrote to his friend Hedwig Weiler: "*Erotes* will soon be published under the title of *The Path of a Lover* but without my title page, which has proved not reproduceable."[128]

Around this same time, Brod also spoke of Kafka's drawing talent among his friends in the art world. Feigl later recalled that "in the circle of the group of

[119] *Výstava 8 Kunstausstellung* (Prague: Osma, 1907). Friedrich Feigl and Willi Nowak also presented significantly more works at the exhibition than did their Czech-speaking colleagues. For more on this subject, see Nicholas Sawicki, *Na cestě k modernosti. Umělecké sdružení Osma a jeho okruh v letech 1900–1910* (Prague: Filozofická fakulta Univerzity Karlovy, 2014), 79–112.

[120] The discussions at Café Arco mentioned in the letters of Kubišta and the memoirs of Kubín were held in German. Letter from Kubišta to his uncle Oldřich, August 25, 1906, in *Bohumil Kubišta. Korespondence a úvahy*, ed. František Čeřovský and František Kubišta (Prague: SNKLU, 1960), 37; Otakar Kubín, "Vzpomínky" (manuscript), Archive of the National Gallery in Prague, Otakar Kubín Papers, AA 3716.

[121] An identification of the paintings displayed at the first exhibition is difficult, since the bilingual catalogue did not provide the names or even the techniques of the exhibited works. However, Otakar Kubín likely displayed a painting depicting a garden fence in his native Boskovice, while Filla showed *Villa in Bitýška* and Procházka presented *Rural Wedding*.

[122] Sawicki, *Na cestě k modernosti*, 77–112; Marie Rakušanová, *Kubišta – Filla. Zakladatelé moderního českého umění v poli kulturní produkce* (Brno: B&P, 2019), 44–52.

[123] Max Oppenheimer, "Ausstellung der Acht," *Prager Tagblatt*, May 1, 1907, 9.

[124] Max Brod, "Max Oppenheimer," *Erdgeist* 3, no. 18 (October 1908): 698–99.

[125] Max Brod, "Frühling in Prag," *Die Gegenwart* 36, no. 20 (1907): 316–17.

[126] Sawicki, *Na cestě k modernosti*, 99–105. In this context, Sawicki analyzes in further detail the critique of František Xaver Harlas in particular.

[127] Franz Kafka to Max Brod, mid-August 1907, in Kafka, *Letters to Friends, Family, and Editors*, 41. "And now I must express my gratitude, my poor boy, for the trouble you went to persuading your publisher of the excellence of my drawing."

[128] Franz Kafka to Hedwig Weiler, October 1907, in ibid., 54. See also Max Brod, *Der Weg des Verliebten: Gedichte von Max Brod* (Berlin: Axel Juncker, 1907).

modern painters known in Prague as 'The Eight,' Max Brod mentioned during a discussion: 'I can tell you the name of a very great artist—Franz Kafka.' And he showed us some drawings of his."[129] Although Brod would probably have been pleased if Kafka could have found a place among the artists of Osma, no such cooperation came about.[130]

A major shift occurred between the first and second Osma exhibitions regarding the group's Czech members. → FIG. 84–87 This shift was less about the evolution of the formal vocabulary of their works—which moved away from a free hand in the spirit of the German impressionist Max Liebermann and towards a Daumier-like deformation of outlines, a Munch-influenced flowing of color surfaces, and cautious paraphrases of Edgar Degas, Edouard Manet, and Paul Gauguin—but rather concerned their collective and determined accumulation of intellectual and social capital. Like Horb, Nowak, and Feigl with their contacts to German-speaking cultural circles, the group's Czech members began to forge their own relations with influential personalities in their linguistic community.[131] Their self-confidence also grew through time spent abroad, although at the outset they drew on their German friends' experience when organizing their travels, such as Filla, Procházka, and Feigl's 1906 journey across Europe.[132]

It is likely that no close personal contacts ever occurred between the Czech members of Osma and Franz Kafka. In fact, not even Brod was particularly close to them. After the 1966 publication of Brod's *The Prague Circle*,[133] which reprinted his review "Spring in Prague" and also included several paragraphs on the group's Czech and German founders, Brod was contacted by the nephew of Bohumil Kubišta, who had published a monograph on Kubišta and an edition of his correspondence. In his response, Brod wrote that he had no memory of Kubišta, and quite possibly had never even met him personally.[134] That Brod had no memories of Kubišta can be partly explained by the almost sixty years that had passed since they met in the circle of the Osma group, and it is also clear that Brod perceived the Czech-speaking members of the group less as independent individuals compared to his German-speaking friends.

All the same, one can speak of a shared intellectual affinity between Kafka, Brod, and the Czech-speaking members of Osma. During the period between the first and second group exhibitions, Bohumil Kubišta and Emil Filla read a significant amount of theoretical literature, primarily in German. They shared with Kafka an interest in Johann Wolfgang Goethe, and Kubišta paid particular attention to Goethe's theory of colors. They also read the philosopher Arthur Schopenhauer and the physicist and experimental psychologist Gustav Theodor Fechner.[135] Another essential work for Kubišta in 1908–1909 was the treatise *Foundations of an Aesthetic Theory of Color* by the previously discussed classmate of Kafka's, Emil Utitz.[136] Utitz's book had a significant impact on Kubišta's painting practice at the time, specifically his conception of the psychological impact of cold and warm colors and their mutual contrast in the eye of the viewer.[137] → FIG. 88

Like the young Czech artists of Osma, Kafka also owned and read the letters of Vincent van Gogh.[138] For this generation of painters, van Gogh was an important model in their search for an original approach to color and precise painterly expression. → FIG. 89, 90

The representatives of the early Czech avant-garde are also noteworthy for their fervent interest in the history of art. Emil Filla, Bohumil Kubišta,

129 J. P. Hodin, "Memories of Franz Kafka," *Horizon* 17 (January 1948): 32.

130 Ibid., 32. Also see the text by Nicholas Sawicki in the present volume.

131 Rakušanová, *Kubišta – Filla*, 56–102.

132 Marie Rakušanová, "Cesta Emila Filly, Antonína Procházky a Friedricha Feigla v roce 1906 po Evropě," *Umění* 52, no. 1 (2004): 72–83.

133 Brod, *Der Prager Kreis*, 65–66.

134 Max Brod to František Kubišta, November 10, 1966, Archive of the National Gallery in Prague, Bohumil Kubišta Papers, correspondence of František Kubišta.

135 See Kafka, *Briefe, 1900–1912*, 29. Traces of Fechner's ideas can be discerned primarily in the oeuvre of Kubišta. Mahulena Nešlehová, "Inspirations Drawn from Kubišta's Stay in Paris," in Marie Rakušanová et al., *Bohumil Kubišta: Degrees of Separation* (Prague: Karolinum, 2021), 186.

136 Emil Utitz, *Grundzüge der ästhetischen Farbenlehre* (Stuttgart: Ferdinand Enke, 1908). See also Emil Utitz, "Acht Jahre auf dem Altstädter Gymnasium," in *"Als Kafka mir entgegenkam": Erinnerungen an Franz Kafka*, ed. Hans-Gerd Koch, rev. ed. (Berlin: Verlag Klaus Wagenbach, 2005), 46–51. Based on personal recollections and correspondence from the time, it is evident that both Kafka and Brod often held a somewhat reserved position towards Utitz.

137 See also Mahulena Nešlehová, "The Concept of Colour in the Work of Bohumil Kubišta," in Rakušanová, *Kubišta: Degrees of Separation*, 71–74.

138 Vincent van Gogh, *Briefe* (Berlin: Bruno Cassirer, [1917]). Born, *Kafkas Bibliothek*, 138, 176. See also Bodo Plachta, "Franz Kafka Reads the Letters of Vincent van Gogh," *Variants. The Journal of the European Society for Textual Scholarship* 2–3 (2004): 173–94.

Antonín Procházka, and even the later member of Osma Vincenc Beneš all studied the historical past of their discipline, particularly the Old Masters, whose work they explored in their visits to Europe's museums and galleries. Their erudition was also evident in their theoretical texts and, later, in the journals they edited and published, such as *Volné směry* and *Umělecký měsíčník*. Franz Kafka similarly had an admiration for the Old Masters, as confirmed by several volumes in his library as well as by his own sketches, for instance, his copy of a portrait of a girl by Leonardo da Vinci, probably made according to a reproduction of the artwork in Adolf Rosenberg's monograph on the artist.[139] → **FIG. 91, 92**

139 Adolf Rosenberg, *Leonardo da Vinci* (Bielefeld: Velhagen und Klasing, 1898), 96. Hartmut Binder, *Kafka-Handbuch*, vol. 1 (Stuttgart: Alfred Kröner, 1979), 265.

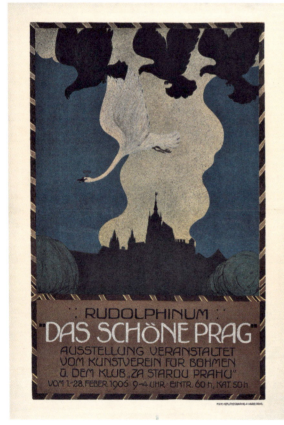

65

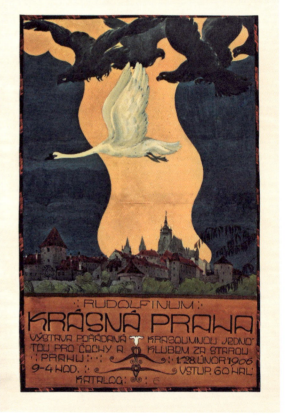

66

65 Jan Konůpek, poster for the exhibition *Das schöne Prag*, or *Krásná Praha*, Prague, 1906. Color lithograph, 99×69 cm. Moravian Gallery in Brno.

66 Jan Konůpek, maquette for the Czech version of the poster for the exhibition *Krásná Praha*, or *Das schöne Prag* Prague, 1906. Mixed media on paper, 87.5×57 cm. Moravian Gallery in Brno.

During his second stay in Paris in September 1911, Kafka repeatedly visited the Louvre in the company of Brod. From the notes in his diary, it is evident that he took particular notice of Tintoretto, Simone Martini, Andrea Mantegna, Titian, Velázquez, Jacob Jordaens, and Peter Paul Rubens. "In the Louvre from one bench to the next. Pain when one is skipped." He also noted the "Crowd in the Salon Carré, the excitement and the knots of people, as if the Mona Lisa had just been stolen," an event that had occurred less than three weeks previously.[140] It was an excited atmosphere in which visitors stared at the empty wall where the painting had once hung, and Kafka, at least for a moment, was among them. This unusual event also inspired the Pathé film company to produce its short comedy *Nick Winter and the Theft of the Mona Lisa*,[141] which Kafka and Brod viewed on one of the many cinema visits they undertook during their travels.[142] → FIG. 93

In Paris, Brod and Kafka took notice of how the categories of "high" and "low" art were mixed together in an atmosphere of far greater freedom than in Prague or any of the German-speaking cities of Europe. They attended cabaret and variété performances at La Cigale in Montmartre, the Théâtre de Vaudeville, and the Folies Bergère.[143] Kafka and Brod visited the latter venue on their very first visit to Paris in 1910, only several months after it had inspired a pastel sketch by Bohumil Kubišta.[144]

It must be noted that the exponents of the earliest Czech artistic avant-garde wanted to be seen as ascetics fully engaged in their art and in art theory and history.[145] Among the members of Osma who spent time in Paris before the First World War, we find only a few works that celebrate metropolitan nightlife or hedonistic recreation; these typically impressionist themes further developed by the fauvists seem to have held little interest for the young Czech painters. By contrast, according to the scholar Jacqueline Sudaka-Bénazéraf, the sheer quantity of references to Parisian places of amusement in Kafka's Parisian diaries, coupled with his descriptions of street scenes, cafés, brothels, and cabarets, evokes associations with the "gaze" found in the artworks of Monet, Degas, Toulouse-Lautrec, or Renoir.[146] Kafka's diaries from his Paris visit in 1911 contain the following striking passage:

> The characteristic condition of flatness: shirts, linens in general, napkins in the restaurant, sugar, large wheels of the mostly 2-wheeled carriages, horses harnessed one behind the other, flat steamers on the Seine, the balconies divide the houses crosswise and broaden these flat cross-sections of the houses, the flattened broad chimneys, the folded newspapers.[147]

The reader has the sense that what is being described is a modernist painting, not an impressionist picture, but rather a futurist or cubist one. Intriguingly, Kafka stresses the flattened quality of the items he observes, which he clearly regards as something characteristically Parisian. The question of the pictorial representation of spatial depth became crucial for modern painting at the moment when cubism emerged as a critical intervention into the illusory perspective of the Western tradition. Kafka's description piles flattened objects atop one another, just as analytical cubism, as it transitioned to its synthetic phase, arranged the signs of the objects on the two-dimensional paper or canvas in the form of flat planes. The German literary historian Detlev Schöttker has found that certain short stories by Kafka apply a "polyperspective"

[140] Kafka, *The Diaries*, 536–37. See also Hartmut Binder, *Kafka in Paris* (Munich: Langen, 1999).

[141] *Nick Winter et le vol de la Joconde*, France, 1911, directed by Paul Garbagni.

[142] Max Brod and Franz Kafka, *Eine Freundschaft: Reiseaufzeichnungen*, ed. Malcolm Pasley and Hannelore Rodlauer (Frankfurt am Main: S. Fischer, 1987), 293.

[143] Brod and Kafka, *Eine Freundschaft: Reiseaufzeichnungen*, 37–38.

[144] Bohumil Kubišta, *Chocolate Princesses from Folies Bergère*, 1910. Private collection. See also Kubín's painting inspired by his time in Paris, *Music Hall Bobino*, 1910. Retro Gallery. Rakušanová, *Kubišta: Degrees of Separation*, 602, cat. no. 218, 173.

[145] Later Czech art historians retroactively increased the significance of this tendency. See, for example, Miroslav Lamač, *Osma a Skupina výtvarných umělců* (Prague: Odeon, 1988), 495–504.

[146] Sudaka-Bénazéraf, *Le regard de Franz Kafka*, 184.

[147] Kafka, *The Diaries*, 522.

approach typical for cubist painting. Schöttker nevertheless associates this aspect of Kafka's writing not with his stays in Paris but, instead, with the artistic scene in Prague, where cubism was an inescapable presence from 1912 onward.[148]

Although Parisian models were essential to the phenomenon now termed Czech cubism, the transferal of artistic forms from the French capital to Prague caused them to change and, in certain cases, acquire entirely new functions. It is an open question whether Kafka, during his time in Paris, encountered the works of Picasso, Braque, Metzinger, Le Fauconnier, Gleizes or others. Max Brod, however, during his first stay in Paris in 1909, had at his disposal the services of the German-speaking Bohemian-Jewish painter Georg Kars, who guided him, among other destinations, to the city's leading art dealers and private galleries.[149] In *The Prague Circle,* Brod mentions that Kars had planned to participate in the first exhibition of Osma in Prague, but that he did not attend because he was holding his own exhibition in Paris at the time.[150]

Kars was trained at the Academy of Fine Arts in Munich and became friends with Max Horb when they were both living there. After a year's stay in Spain in 1907, where he met the later important cubist painter Juan Gris, Kars settled in Montmartre. → **FIG. 94, 95** As an intermediary and guide, he assisted the Prague artists Friedrich Feigl, Emil Filla, Emil Artur Pittermann Longen, and Bohumil Kubišta, and also developed a closer friendship with Otto Gutfreund while Gutfreund was studying in the sculptural studio of Antoine Bourdelle.[151] → **FIG. 96–98**

148 Schöttker, "Vielfältiges Sehen," 85–91, 95–96. Schöttker specifically mentions the "polyperspective" nature of Kafka's stories "Distracted Observation" and "The Passenger" from the early collection *Contemplation* (1913).

149 Brod and Kafka, *Eine Freundschaft: Reiseaufzeichnungen,* 27–36.

150 Brod, *Der Prager Kreis,* 64.

151 See Françoise Lucbert, "Kubišta's French Connections: Networks, Reception, Ideals," in Rakušanová, *Kubišta: Degrees of Separation,* 110–13. See also Anna Pravdová, *École de Paris a čeští umělci v meziválečné Paříži: Kars, Coubine, Eberl* (Řevnice: Arbor Vitae, 2023).

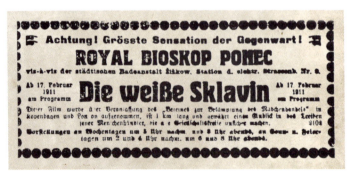

67

68

67 Advertisement for the film *Die weisse Sklavin* at the Royal Bioskop cinema in Prague, 1911. Private collection.

68 *Čas,* February 18, 1911. Advertisement for the film *Die weisse Sklavin* at the Royal Bioskop cinema. National Library of the Czech Republic.

THROUGH THE EYES OF FRANZ K.: BETWEEN IMAGE AND LANGUAGE

69 Scenes from the film *Die weisse Sklavin*, 1911, directed by August Blom.

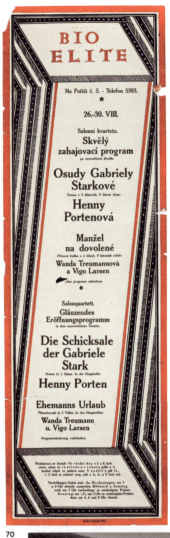

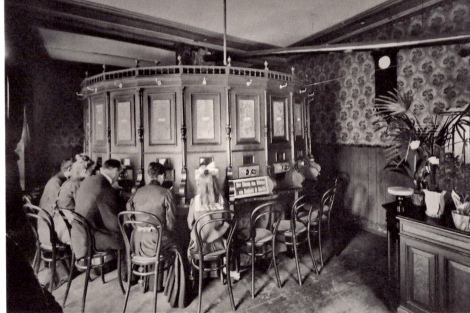

70 Poster for the Bio Elite cinema, Prague, 1924. Color lithograph, 90×30 cm. Museum of Decorative Arts in Prague.

71 Period photograph of the Basilica of Saint Anastasia, Verona. Stereoscopic photograph from a Kaiserpanorama. Private collection.

72 Photograph of a Kaiserpanorama cabinet. Private collection.

66

We have no direct evidence that Kars brought Brod or Kafka to see contemporary art during their time in Paris in 1910 and 1911. Nor, for that matter, is there any indication that Brod had much interest in cubism or other avant-garde tendencies. Both as critic and patron, Brod appears to have supported Czech artists only during the period when they exhibited with the German-speaking members of Osma.[152] After the second Osma exhibition in 1908, he was most intensively interested in the work of Willi Nowak, who in fact gave French lessons to Brod and Kafka in 1910 and 1911.[153] In spring 1910, Brod also received a request for a financial loan from Bohumil Kubišta, who was in great poverty during his own stay in Paris,[154] although nothing is known of any help that Brod may have offered. Nonetheless, a year and a half later, Kubišta sold his large canvas *Cement Works in Braník*, which during the Holocaust was absorbed into the collections of the Prague Jewish Museum after it had been confiscated from the property of an otherwise unknown collector, Ela Freund. There is a possibility that the sale of this work into the collection of a Prague Jewish family was mediated by Max Brod (although it is of course short-sighted to think that only a Jewish actor could have facilitated such a transaction).[155] → FIG. 99

Another question worth exploring is whether Brod and Kafka might have played a role in forming contacts between Czech artists and the Berlin publisher and gallery owner Herwarth Walden. Kafka had published a review of a book by Franz Blei, *The Powder-Box: A Ladies' Breviary*, in Walden's journal *Der neue Weg* as early as in 1909,[156] while Brod was a regular contributor to Walden's journal *Der Sturm*, founded in 1910. Two years later, Bohumil Kubišta had an exhibition at Walden's gallery of the same name.[157] Emil Filla and the Skupina výtvarných umělců (Group of Fine Artists), which operated between 1911 and 1914, began their intensive contacts with Walden in 1913 with an exhibition at his Berlin gallery not only their paintings but also of sculptures and architectural designs today subsumed under the term "cubism."[158] Filla's association with Der Sturm also introduced him to the painter Paul Citroën, who was a longstanding friend of Max Brod's.[159]

Thanks to the Group of Fine Artists or the efforts of its former members after its dissolution, the Prague public had the chance to see several exhibitions between 1912 and 1922 that showed the work of Pablo Picasso, who was a strong source of inspiration for Filla, Beneš, and the group's other members prior to the First World War. → FIG. 100–103 The group's members could extol the significance of Picasso's cubism at exhibitions and on the pages of their magazine *Umělecký měsíčník* thanks in part to the support provided by the art historian Vincenc Kramář, one of the first collectors of Parisian cubism.[160]

The only testimony of Kafka's contact with cubism is a dubious recollection from the generally unreliable Gustav Janouch about a supposed joint visit to the 1922 Picasso exhibition[161] organized by the Mánes Association with Kramář's assistance.[162] Nor do not know with certainty whether Kafka saw any of the cubist works on display at the prewar exhibitions of the Group of Fine Artists or the Mánes Association, which in 1914 organized an exhibition of European art curated by the French poet and critic Alexandre Mercereau that included numerous cubist works.[163] Also on display were works by several Czech artists, most notably Kubišta and Josef Čapek, who operated more freely with cubism than the members of the Group of Fine Artists. FIG. 104, 105 Another, looser interpretation of cubism can be found

152 At the first exhibition, Brod bought Feigl's view of "the Vltava weir," Nowak's "girls in the snow," and "a beautifully cheeky painting of a chanteuse singer" by Otakar Kubín. Max Brod, *Der Prager Kreis*, second edition (Frankfurt am Main: Suhrkamp, 1979), 65. See also Nicholas Sawicki, "The Critic as Patron and Mediator: Max Brod, Modern Art and Jewish Identity in Early-Twentieth-Century Prague," *Images: A Journal of Jewish Art and Visual Culture* 6 (2012): 50.

153 Max Brod and Franz Kafka, *Eine Freundschaft: Briefwechsel*, ed. Malcolm Pasley and Hannelore Rodlauer (Frankfurt am Main: S. Fischer, 1989), 464n64.

154 In a letter to Vincenc Beneš, Kubišta writes that he asked Brod for a loan. Bohumil Kubišta to Vincenc Beneš from Paris, spring 1910, in Kubišta, *Korespondence a úvahy*, 126.

155 Bohumil Kubišta, *Cement Factory in Braník*, 1911. Jewish Museum in Prague. It does not seem likely that this Ela Freund was a relative of the painter Ida Freund.

156 Franz Kafka, "Franz Blei – Die Puderquaste. Ein Damenbrevier," *Der neue Weg* 38, no. 2 (1909): 62.

157 Anke Daemgen, "Bohumil Kubišta and Germany," in Rakušanová, *Kubišta: Degrees of Separation*, 234–55.

158 Vojtěch Lahoda, "Emil Filla and Herwarth Walden," in Jiří Švestka and Tomáš Vlček et al., *Czech Cubism 1909–1925* (Prague: Modernista, 2006), 74–77.

159 Vojtěch Lahoda, *Emil Filla* (Prague: Academia, 2007), 215.

160 Olga Uhrová and Vojtěch Lahoda, eds., *Vincenc Kramář: From Old Masters to Picasso* (Prague: National Gallery in Prague, 2002).

161 Janouch, *Conversations with Kafka*, 85.

162 *LX. Výstava Spolku výtvarných umělců Mánes. Pablo Picasso* (Prague: Spolek výtvarných umělců Mánes, 1922).

163 *Moderní umění* (Prague: Spolek výtvarných umělců Mánes, 1914).

THROUGH THE EYES OF FRANZ K.: BETWEEN IMAGE AND LANGUAGE

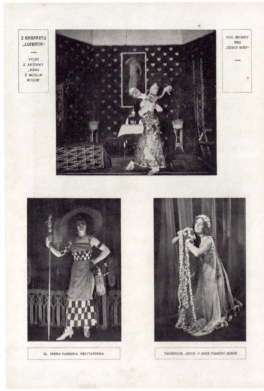

73

74

73 *Český svět*, September 22, 1911. Photographs of the Lucerna cabaret, Prague. At bottom right is the Viennese dancer Gusti Odys, about whom Kafka wrote in his diaries. National Library of the Czech Republic, Prague.

74 Otakar Štáfl, poster for the U Bílé labutě cabaret, Prague, 1915. Color lithograph, 156×72 cm. Museum of Decorative Arts in Prague.

75 V. H. Brunner, poster for the "American Bar Montmartre," Prague, 1914. Linocut, 62×90 cm. Museum of Decorative Arts in Prague.

76 Photograph of the Montmartre bar and cabaret, Prague, 1913–1914. National Museum in Prague.

77

78

77 Bohumil Kubišta, *Promenade in a Park in Florence*, 1907. Oil on canvas mounted on paperboard, 84×90 cm. Gallery of West Bohemia in Pilsen. Shown at the first exhibition of the Eight, Prague, 1907.

78 Otakar Kubín, *Brindisi*, 1906. Oil on canvas, 43×47.5 cm. National Gallery in Prague. Probably shown at the first exhibition of the Eight, Prague, 1907.

79 Friedrich Feigl, *Gruž*, 1908. Oil on canvas, 59.5×73.2 cm. Moravian Gallery in Brno.

80 Max Horb, *Square in Munich*, 1907. Oil on canvas, 58×73 cm. National Gallery in Prague. Shown at the first exhibition of the Eight, Prague, 1907.

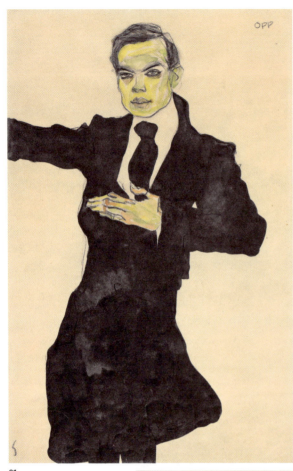

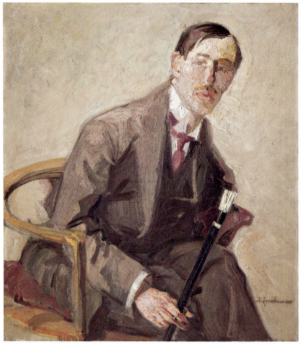

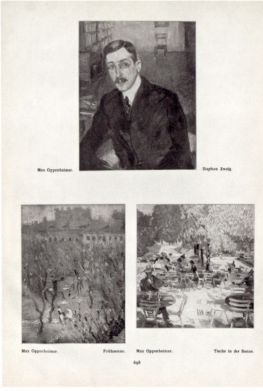

81 Egon Schiele, *Max Oppenheimer*, 1910. Black chalk, India ink, and watercolor on paper, 45.1×29.8 cm. Albertina, Vienna.

82 Max Oppenheimer, *Portrait of the Artist's Brother Friedrich Oppenheimer*, 1909. Oil on canvas, 95×85 cm. National Gallery in Prague.

83 *Erdgeist: Illustrierte Wochenschrift*, vol. 3, no. 18, 1908. Reproductions of Max Oppenheimer's paintings *Stephan Zweig*, *Spring Sunshine*, *Tables in the Sun*. Library of the Museum of Czech Literature, Prague.

THROUGH THE EYES OF FRANZ K.: BETWEEN IMAGE AND LANGUAGE

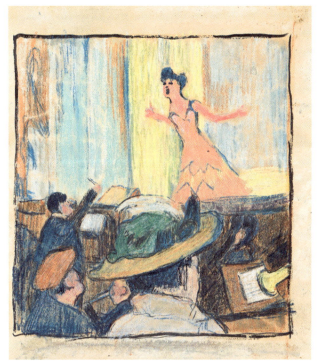

84 Otakar Kubín, *A Study of a Cabaret*, 1910. Pastel, ink, and brush on paper, 32.3×27.6 cm. National Gallery in Prague.

85 Antonín Procházka, *Circus*, 1907–1908. Oil on canvas, 47.5×65 cm. National Gallery in Prague. Shown at the second exhibition of the Eight, Prague, 1908.

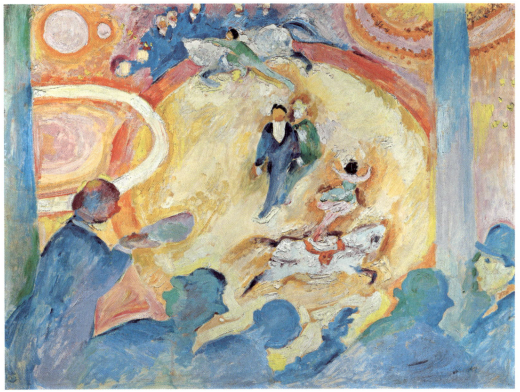

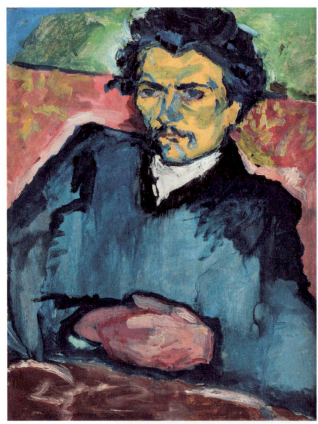

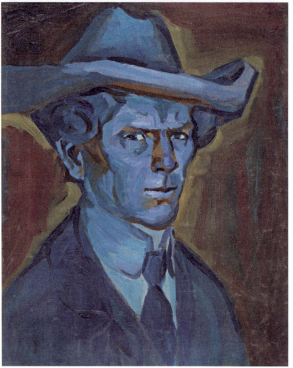

86 Emil Filla, *Portrait of the Writer Josef Uher*, 1908. Oil on paperboard, 68.8×54.4 cm. Moravian Gallery in Brno. Shown at the second exhibition of the Eight, Prague, 1908.

87 Willi Nowak, *Elbe Landscape*, 1907–1908. Oil on canvas, 45.5×55.5 cm. National Gallery in Prague. Shown at the second exhibition of the Eight, Prague, 1908.

88 Bohumil Kubišta, *Blue Self-Portrait*, 1909. Oil on canvas, 51.5×43 cm. Gallery of West Bohemia in Pilsen.

THROUGH THE EYES OF FRANZ K.: BETWEEN IMAGE AND LANGUAGE

89 Bohumil Kubišta, *Interior*, 1908. Oil on canvas, 46×59 cm. National Gallery in Prague. Shown at the second exhibition of the Eight, Prague, 1908.

90 Vincent van Gogh, *Briefe*, (Berlin: Bruno Cassirer, [1917]). Library of the Museum of Decorative Arts in Prague.

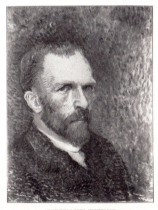

in the work of a former member of Osma, Emil Pittermann, whom Kafka knew primarily as a cabaret performer, appearing in both Prague and Berlin under the stage name of Artur Longen.[164] → FIG. 106

It is also worth mentioning that in April 1914 Kafka requested an extra copy of *Contemplation* from his publisher Kurt Wolff to give to the editor of *Umělecký měsíčník*, the Czech Jewish author and dramatist (and Kafka's distant relative) František Langer, in the hopes that a few short translations from the book might be published in this "important" publication.[165] This did not happen, because the journal soon ceased to exist. Langer had nevertheless mentioned Kafka in the journal previously, in relation to the series *Der jüngste Tag*, specifically noting that the series included Kafka's *The Stoker*.[166] These fragments of information can be taken as proof that Kafka knew *Umělecký měsíčník*, and that he not only read it but also paid attention to its illustrations, which included reproductions of artwork from a wide range of periods, with

[164] Kafka, *The Diaries*, 21.

[165] Franz Kafka to Kurt Wolff, April 22, 1914, in Kafka, *Letters to Friends, Family and Editors*, 124.

[166] František Langer, "Der Jüngste Tag," *Umělecký měsíčník* 2, no. 8 (1913): 223–24. See also Josef Čermák, "Die Kafka-Rezeption in Böhmen (1913–1949)," *Germanoslavica* 1, no. 1–2 (1994): 127.

91

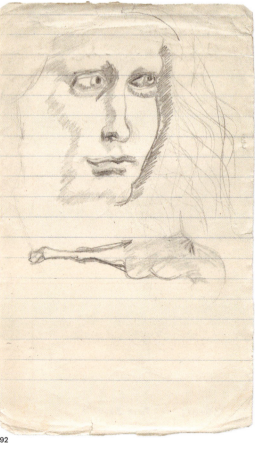

92

91 Adolf Rosenberg, *Leonardo da Vinci* (Bielefeld: Velhagen und Klasing, 1898). Private collection.

92 Franz Kafka, drawing after Leonardo da Vinci. Pencil on paper, 17×10.5 cm. Deutsches Literaturarchiv Marbach.

THROUGH THE EYES OF FRANZ K.: BETWEEN IMAGE AND LANGUAGE

93 Scenes from the film *Nick Winter et le vol de la Joconde*, 1911, directed by Paul Garbagni.

93

a specific emphasis on contemporary cubism and the work of Picasso. Kafka was strongly aware of the importance that French examples held for Czech art. In 1913, he wrote in a letter to Felice:

> The Czechs, you know, are very much inclined to emulate the French; and although this tendency usually lags behind and adopts the outmoded ways of the beloved country (for only experience that has already been digested is accessible to the alien), this fact is least injurious to the imitators of the French, for France is based on tradition; all progress there is very gradual, proceeding on its course while discarding virtually nothing, so that the imitator can almost keep pace without exerting himself.[167]

Kafka's perception of Paris as a site of plurality in culture and art is an intriguing one. The young Czech artists from the Group of Fine Artists would clearly have disagreed, since for them Paris was the symbol of a new art anchored by Picasso, which was what drew them to the city. Nor would they have sided with the perception that its progress was "gradual." For them, as for many of the later defenders of the canonical history of modernism, the Paris of those years was a stage for the rapid succession of one innovation after another.

The reason for the Czech cultural orientation toward France was, in fact, politically motivated and characterized by a tendency for selecting only isolated phenomena from Paris's aesthetic plurality and using them to create the appearance of a unified whole. This was true for the Parisian-inspired salon and history painting that decorates the Czech National Theatre, and this type of political thinking also played a role in the reception of Parisian cubism.

Kafka stood entirely outside of any such tendencies. The political framing of images was something he usually regarded neutrally, as merely one of many perspectives offered up daily for his gaze. Reflecting on the work of the Czech symbolist sculptor František Bílek, specifically his designs for monuments to Jan Hus, Jan Žižka, or Comenius, Kafka was primarily interested in how these artworks affected him personally, not in their political messages.[168] → FIG. 107, 108

In his "Schema for the characterization of small literatures," which he wrote in his diaries in 1911, Kafka listed as one of the key traits of minority cultures their connection to the political:

> Even if the individual matter is often thought through with calm, one still doesn't arrive at its boundaries, where it is connected with similar matters, one reaches soonest the boundary with politics, indeed one even strives to see this boundary before it's there and often to find this contradicting boundary everywhere.[169]

Czech nationalism hindered engagement with vital creative problems, since before one could get at their root, politics came first. One voice of opposition to this trend—which was particularly pronounced in Czech society immediately after the founding of an independent Czechoslovakia in 1918—was the left-wing group of writers and artists associated with the journal

[167] Franz Kafka to Felice Bauer, April 4, 1913, in Kafka, *Letters to Felice*, 234.

[168] Franz Kafka to Max Brod, June 30, 1922, in Kafka, *Letters to Friends, Family and Editors*, 422. See also the text by Marek Nekula in the present volume.

[169] Kafka, *The Diaries*, 166.

Červen. In July 1919, Fráňa Šrámek, Stanislav Kostka Neumann, Antonín Sova, and Karel Teige founded the Socialistická rada osvětových dělníků (Socialist Council of Intellectual Workers), and in their declaration, published in *Červen* in Czech and German, they appealed to their German colleagues to join them.[170] Kafka himself was in indirect contact with *Červen*. His lover Milena Jesenská, who translated his texts into Czech, published in other left-wing magazines like *Kmen* and *Tribuna*,[171] which *Červen* was closely associated with.[172] The journal placed great stress on illustrations, working with such artists as Josef Čapek, Jan Zrzavý, and Vlastislav Hofman, among others. → FIG. 109 Many of them had previously been part of the Group of Fine Artists, and in 1917 some of them joined the new group Tvrdošíjní (The Obstinate Ones), which collaborated with Bohemian-German and German-Jewish artists, among them Kafka's friend Friedrich Feigl.[173] Kafka encountered the work of another member of Tvrdošíjní, the graphic artist, architect, and theorist Vlastislav Hofman, not only in *Červen* but also at an exhibition in Prague of Hofman's series of prints inspired by the novels of Dostoevsky,[174] as the Prague German author Johannes Urzidil writes in his memoirs.[175] → FIG. 110 In addition to being published in *Červen*, the prints from this series were also reproduced in the Berlin periodical *Die Aktion*,[176] of which Kafka was a regular reader.[177]

Although Kafka ascribed small literatures (here, he mainly had Czech literature in mind) with an innate politicization, the artworks by Czech artists published in *Červen* had almost no political agenda. Indeed, the artists from the Tvrdošíjní group tended to avoid such a literal approach to art.

Some historians of literature and culture have ascribed to Kafka's work a veiled social or political critique. In Czech art history scholarship, his work has been interpreted by Tomáš Vlček as carrying "a bitter tone of protest against contemporary society" and as "a symbol of the alienated world of modern capitalist reality."[178] Kafka's writings, however, do not convey any clear message of social criticism. As Deleuze and Guattari noted, the "method of active dismantling [in Kafka's work] doesn't make use of criticism that is still part of representation."[179] Representation, whether textual or pictorial, was something that Kafka did not trust.

IMAGES AND REPRESENTATIONS OF THE MYTHIC LANGUAGE

In the tetralinguistic model of Henri Gobard, each particular language occupies a different place in space: vernacular language is *here*; vehicular language *everywhere*; referential language is *over there*, the mythic language is *beyond*. For Deleuze and Guattari, Kafka's mythic language of "spiritual reterritorialization" was Hebrew: "As a mythic language, Hebrew is connected with the start of Zionism and still possesses the quality of an active dream."[180] Kafka's complex relationship to Hebrew, both biblical and modern, is discussed in detail in the present volume by Marek Nekula, yet one interesting trajectory of inquiry might be to examine whether Kafka's interest in this language could have a parallel in the world of his visual experiences. Zischler's book *Kafka Goes to the Movies* brings up the film *Return to Zion*,[181] which Kafka saw in 1921 at Prague's Bio Lido cinema. → FIG. 111 Kafka devoted just one laconic sentence to the film in his diary: "Palestine film in the afternoon."[182] Zischler

[170] Nekula, *Franz Kafka and his Prague Contexts*, 174–75.

[171] *Kmen* published Kafka's "The Stoker" in Milena Jesenská's translation. Franz Kafka, "Topič," *Kmen* 4, no. 6, (1920): 61. See also the text by Marek Nekula in the present volume.

[172] From his correspondence, it is clear that Kafka read *Červen* as well. Franz Kafka to Milena Jesenská, October 22, 1920, in Franz Kafka, *Letters to Milena*, trans. Philip Boehm (New York: Schocken, 1990), 211–12. See also the text by Marek Nekula in the present volume.

[173] See, for example, the exhibition catalogue *Tvrdošíjní a hosté* (Prague: Krasoumná jednota, 1921).

[174] Vlastislav Hofman, *F. M. Dostojevskij* (Prague: Štencův grafický kabinet, 1917). That same year, František Borový published the prints as an album. See also Mahulena Nešlehová, *Vlastislav Hofman* (Prague: Společnost Vlastislava Hofmana – ÚDU AVČR, 2004), 163–64.

[175] Johannes Urzidil, *Da geht Kafka* (Munich: Deutscher Taschenbuch Verlag, 1966), 96.

[176] *Die Aktion* 8, no. 7–8 (February 1918): 98–99.

[177] Franz Kafka to Max Brod, November 14, 1917, in Kafka, *Letters to Friends, Family, and Editors*, 209; Max Brod to Franz Kafka, October 13, 1917, in Brod and Kafka, *Eine Freundschaft: Briefwechsel*, 181.

[178] Tomáš Vlček, *Praha 1900* (Prague: Panorama, 1986), 61, 298.

[179] Deleuze and Guattari, *Kafka*, 48.

[180] Ibid., 23, 25.

[181] *Shivat Zion*, 1920, directed by Ya'acov Ben-Dov.

[182] Kafka, *The Diaries*, 463 (entry for October 23, 1921).

nevertheless convincingly places Kafka's viewing of this Zionist documentary about the young *halutzim*—Jewish youth building up a new homeland in Palestine—into the context of his vacillating reflections on the possibility of his own emigration.[183] For Kafka, one argument in favor of this step may well have been the increasingly vehement outbreaks of antisemitism among the Czech population,[184] while the arguments against it lay in Kafka's poor health and his fear of travel.[185] In the end, Palestine remained only an image, "an unreachable terrain, a ground he is unable to tread, near enough to touch and far away—an imaginary space, a film."[186]

Without a doubt, Kafka's Zionism was far less visionary than that of his friends. Max Brod, for instance, had already tried to define a notion of Jewish identity before the First World War,[187] even extending his thinking to the arena of the fine arts. In 1917, Brod selected several reproductions of paintings by Friedrich Feigl and other artists for the anthology *Jewish Prague*, which he prepared in collaboration with Siegmund Kaznelson, editor of the Zionist weekly *Selbstwehr*.[188] In 1914, Feigl illustrated the publication *Das Ghettobuch*, a German translation of Yiddish authors such as Isaac-Leib Peretz, David Pinski, Sholem Asch, Sholem Aleichem, and others.[189] In 1921, Feigl created the woodcut *Höre Israel* for an album published on the occasion of the Twelfth Zionist Congress. → FIG. 112A, B, 113 In 1911, Kafka similarly began to take an interest in authors writing in Yiddish, among them the socially-minded poet and playwright Isaac-Leib Peretz,[190] whose dramas formed part of the repertoire of traveling Yiddish theater companies. → FIG. 114 It is telling that Kafka's interest in Yiddish was awakened by a visual impression rather than a linguistic one, specifically, the Lviv-based theater ensemble led by Yitzhak Löwy, which was famed for its striking physical language.[191] → FIG. 115

At the beginning of the twentieth century, the language of mythical meanings was claimed by theosophy, to which Kafka for a time turned his attention. In the spring of 1911, he attended two Prague lectures by Rudolf Steiner, and he even paid a visit to Steiner at his hotel to discuss his own possible future as a theosophist. Kafka's diary entry depicts the rhetorical impact of the lecture and his intimate conversation with Steiner, who was suffering from a severe cold, with a clear sense of detachment and irony.[192] The diary also confirms that Steiner's public appearances were attended by two of his most faithful Prague adherents, the artist Hilde Pollak and her husband Richard Pollak-Karlin. → FIG. 116 Theosophy and anthroposophy were also a source of inspiration for the previously discussed artist Ida Freund.[193]

Kafka is in addition known to have attended the 1922 exhibition at the Rudolfinum of the Bohemian-German art group Die Pilger, a title that invoked pilgrimage in the spiritual sense of seeking what is *beyond*.[194] → FIG. 117 The group came together around August Brömse, a Bohemian-German artist who taught courses in the graphic arts at the Prague Academy of Fine Arts.[195] Max Brod wrote a review of the exhibition, concentrating largely on the "mysticism" of Brömse's work.[196] → FIG. 118, 119

Kafka, who captured his own impressions of this exhibition in his diary, paid more attention to Brömse's pupils, specifically the painter Anton Bruder and the sculptor Jost Pietsch → FIG. 120, 121 Today, Die Pilger tends to be associated primarily with expressively exalted religious mysticism, as represented by Brömse and his most famous pupil, Maxim Kopf.[197] By contrast, Bruder and Pietsch, as well as the sculptor Mary Duras and the painter Julius

[183] Zischler, *Kafka Goes to the Movies*, 110–15. See also Iris Bruce, *Kafka and Cultural Zionism: Dates in Palestine* (Madison: University of Wisconsin Press, 2007).

[184] Franz Kafka to Milena Jesenská, November 1, 1920, in Kafka, *Letters to Milena*, 214 et al.

[185] Kafka, *Letters to Friends, Family, and Editors*, 339.

[186] Zischler, *Kafka goes to the Movies*, 115.

[187] Claus-Ekkehard Bärsch, *Max Brod im Kampf um das Judentum: Zum Leben und Werk eines deutsch-jüdischen Dichters aus Prag* (Vienna: Passagen, 1992); Mark H. Gelber, "Max Brod's Zionist Writings," *Leo Beck Institute Yearbook* 33 (1988): 437–48.

[188] *Das Jüdische Prag* (Prague: Selbstwehr, 1917). See also Sawicki, "The Critic as Patron and Mediator," 45–51.

[189] *Das Ghettobuch* (Munich: Georg Müller, 1914).

[190] Kafka, *The Diaries*, 45.

[191] Kafka's contacts with Löwy are discussed by Marek Nekula in his chapter in the present volume.

[192] Kafka, *The Diaries*, 17.

[193] Brod, *Streitbares Leben*, 261.

[194] The exhibition catalogue appeared in both a German and Czech version: *Sonderausstellung der Gruppe "Die Pilger"* (Prague: Kunstverein, 1922); *Souborná výstava skupiny "Poutníci"* (Prague: Krasoumná jednota, 1922). For providing copies of both publications, I thank Hana Klínková.

[195] Gabriela Kašková, *Die Schattenseiten: August Brömse und Kathrin Brömse* (Regensburg: Kunstforum Ostdeutsche Galerie, 2011).

[196] Max Brod, "Austellung 'Die Pilger,'" *Prager Abendblatt*, April 8, 1921, 6.

[197] Jana Orlíková et al., *August Brömse a skupina Poutníci* (Cheb: Galerie výtvarného umění, 2001).

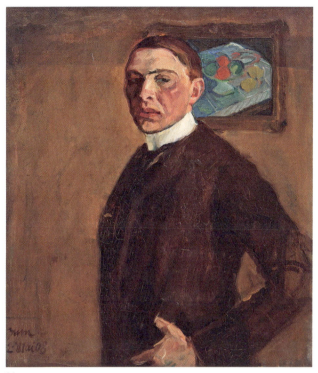

94

94 Georg Kars, *Self-Portrait*, 1908. Oil on canvas, 80×70.5cm. Velvary Municipal Museum.

95 Georg Kars, *Parisian Motif*, 1906. Oil on canvas, 52×65.5cm. National Gallery in Prague.

95

96 Georg Kars, *Otto Gutfreund*, 1913. Oil on canvas, 100.5×81cm. National Gallery in Prague.

198 See Anna Habánová and Ivo Habán, eds., *Mladí lvi v kleci* (Řevnice: Arbor Vitae, 2013), 40–59.

199 Kafka, *The Diaries*, 488.

200 Ibid., 487 (entry from April 7, 1922).

201 Kilcher, "Kafka's Drawing and Writing," 232. Max Brod, "Literarische und unliterarische Malerei," *Die Gegenwart* 37, no. 14 (1908): 221.

Pfeiffer, tended to show an interest in entirely realistic themes,[198] which Kafka evidently preferred. → FIG. 122 Kafka wrote as follows in his diaries:

> Nude girl (Bruder), German-Bohemian, faithfully captured by a lover in her grace that is inaccessible to anyone else, noble, convincing, seductive. Pietsch: Sitting Peasant Girl, one foot under her, resting with pleasure, bent at the ankle / Standing Girl, right arm clasps her body across her belly, left hand supports her head under her chin, a flat-nosed, simplemindedly profound, unique face.[199]

Kafka's thoroughness of observation is also reflected in a note in the diaries concerning Alfred Kubin's drawing *The Fairy Princess*: "Fairy Tale Princess (Kubin) naked on the divan, looks through the open window, landscape penetrating powerfully, in its manner open air as in the picture by Schwind."[200] → FIG. 123

Kafka first met Kubin, who had been invited to participate in the exhibition as a guest, in 1911. → FIG. 124 His friend Brod, by comparison, had already admired facsimiles of Kubin's fantastic and grotesque drawings in 1908, in a publication by Hans von Weber, and praised works by Kubin exhibited that same year at an exhibition in Prague organized by the Verein der bildenden Künstler in Böhmen.[201] Kafka and Brod's ties to Kubin are further confirmed

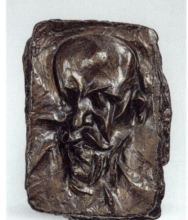

97A Period photograph of Otto Gutfreund's *Anxiety*.

97B Otto Gutfreund, *Anxiety*, 1911. Bronze, h. 148 cm. Gallery of West Bohemia in Pilsen.

98 Otto Gutfreund, *Portrait of the Artist's Father III*, 1912. Bronze relief, 40×28 cm. Gallery of West Bohemia in Pilsen.

by many entries in Kafka's diaries,[202] as well as by a portrait of Kubin sketched by Brod.[203] The few letters exchanged between Kafka and Kubin show that Kafka was reluctant to provide an unambiguous assessment of the artist's work: "Perhaps I will someday find words for saying again what your work has meant to me."[204] This connection has been a subject of inquiry for a long line of literary historians and theorists intrigued by the similarity in the imaginations of both authors, for instance comparing Kubin's fantastic 1909 novel *The Other Side* with Kafka's *The Castle* and other texts.[205] Purported further proof of an affinity between the two authors has also been identified in Kubin's illustrations to Kafka's "A Country Doctor," though these were created only after Kafka's death (1932).

Kafka's actual conversations with Kubin, most likely, had little to do with any matters reaching *beyond* the real or connecting with mythologies outside of it. Kafka's diary entries reveal that he had a far greater interest in Kubin's advice for a cure to his chronic constipation.[206]

KAFKA AND THE IMAGE: MISTRUST, DOUBT, DESIRE

Kafka's diary entry on his "Schema for the characterization of small literatures" inspired Deleuze and Guattari to reflect on the "minor" qualities of Kafka's own language use as a Jewish individual writing in German in the predominantly Czech city of Prague. Notably, however, in his own reflections Kafka paid generally little attention to the German of Prague's Jewish authors, instead taking his strongest inspiration from Yiddish and Czech literature.[207] It is nevertheless possible to apply Kafka's definition of "small" (or "minor") languages and literatures to the artistic output of the artists—for example, Friedrich Feigl, Max Horb, Willi Nowak, Ernst Ascher—to whom he felt the greatest affinity while in Prague. Most were Jewish and all spoke German. For Kafka, the "liveliness of such a literature is even greater than that of one rich in talent, for since there are no writers here before whose great gifts at least the majority of doubters would have to be silent, literary conflict on the greatest scale gains a true justification. Literature broken through by no talent therefore also displays no gaps through which the indifferent could slip. The claim of literature to attention thereby becomes more compelling."[208]

At the beginning of the twentieth century, Prague's German-speaking artists brought forth an exceptionally rich culture that approached painting and artistic creation generally with great seriousness. At the same time, among the German-speaking painters from Kafka's circle, we today do not find any universally recognized artist who might match or surpass any of the major artistic figures who define the canon of Central European modern art. This is of course partly due to the consequences of historical developments in the past century. The legacy and traditions of the Jewish population of Prague were eliminated by the Nazis along with the people themselves, and subsequently the city's German-speaking minority and its art and culture were deliberately forgotten after the violent expulsion of the Germans by the Czechoslovak state in 1945. Due to their forced emigration and troubled fates, the work of many German-speaking artists survives today only in fragments.

One artist of note who has been forgotten in this manner is Ernst Ascher, previously cited in the discussion of Kafka's diary entry regarding his intention

202 Franz Kafka, *The Diaries 1910–1923*, ed. Max Brod, trans. Joseph Kresh (1910–1913) and Martin Greenberg (1914–1923) (New York: Schocken Books, 1975), 57, 58, 60, 62, 80, 136, 307, 308.

203 Max Brod, *Alfred Kubin*, portrait in Brod's diary, September 1911, National Library of Israel.

204 Franz Kafka to Alfred Kubin, July 22, 1914, in Kafka, *Letters to Friends, Family, and Editors*, 110.

205 See, for example, Gérard-Georges Lemaire, *Kafka et Kubin* (Paris: La différence, 2002).

206 Kafka, *The Diaries*, 22 (entry from September 26, 1911).

207 Ibid., 161–62.

208 Ibid., 162.

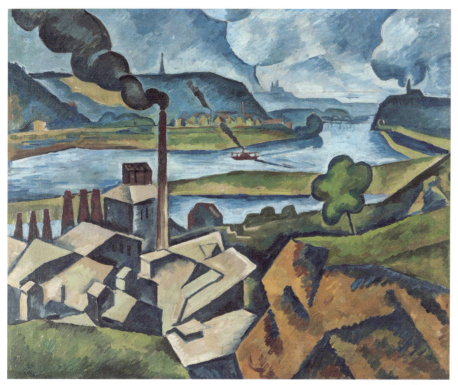

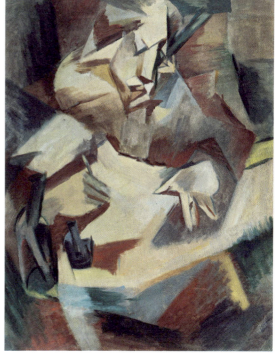

99 Bohumil Kubišta, *The Cement Works in Braník*, 1911. Oil on canvas, 67.5×83 cm. Jewish Museum in Prague.

100 Emil Filla, *The Thinker (Scribe)*, 1911. Oil on canvas, 72×58 cm. National Gallery in Prague.

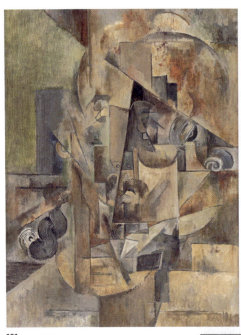

101

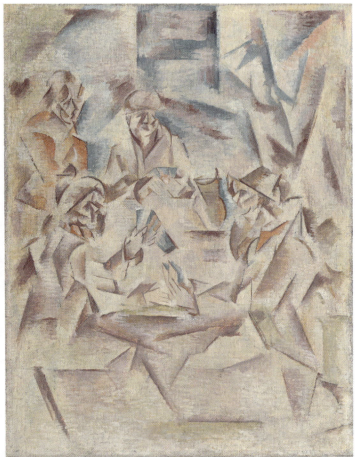

102

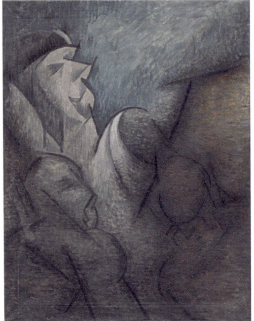

103

101 Emil Filla, *Head of an Old Man*, 1914. Oil on canvas, 66.5×50 cm. Gallery of West Bohemia in Pilsen.

102 Vincenc Beneš, *Card Players at a Table*, 1911. Oil on canvas, 110×89 cm. Gallery of Fine Arts in Ostrava.

103 Antonín Procházka, *Flight*, 1911. Oil on canvas, 80×64 cm. Aleš South Bohemian Gallery, Hluboká nad Vltavou.

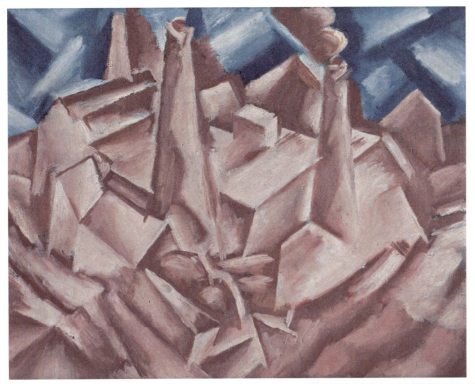

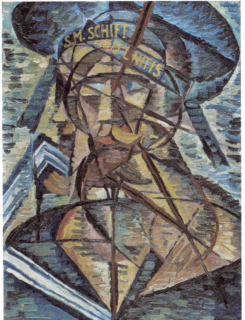

104 Josef Čapek, *Factory*, 1912. Oil on canvas, 48×61cm. Aleš South Bohemian Gallery, Hluboká nad Vltavou.

105 Bohumil Kubišta, *Sailor*, 1913. Oil on canvas, 49.5×37.5cm. Gallery of West Bohemia in Pilsen.

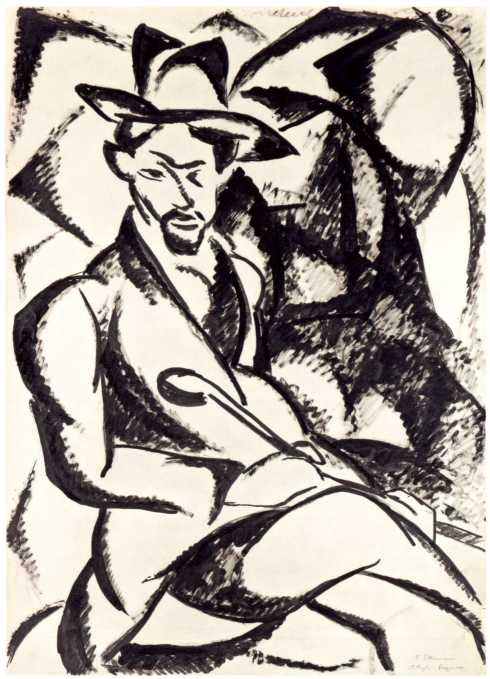

106

106 Emil Artur Pittermann Longen, *Portrait of Friedrich Feigl*, 1910. India ink on paper, 102×73 cm. Art Collections of the Museum of Czech Literature, Prague.

to pose nude for the painter as a model for St. Sebastian.[209] Ascher, who came from a large Prague Jewish family involved in the textile trade,[210] was associated with the circle of Prague authors writing in German that Max Brod later termed the "Prague Circle."[211] → FIG. 125, 126 Today, however, Ascher is almost completely overlooked, and unfortunately very few of his works survive. We nonetheless can gain a sense of his early trajectory thanks to an article by Brod, published in 1912 in the *Prager Tagblatt*.[212] At the time, Ascher was already living in Munich, and soon thereafter he settled permanently in Paris, where he established himself and became better known as a dealer in African ritual objects and artifacts than as a painter.[213]

In his article, Brod stresses the positive influence on Ascher's work of the artist Willi Nowak, whom Ascher knew most closely from the period when the two lived in Munich. Evidently, Brod had a particular liking for Nowak's work. As it happened, Nowak, a Bohemian-German artist, escaped the fate of Ascher and others; even after the communist coup of 1948, Nowak managed to prosper in Czechoslovakia, in part thanks to his loyalty to the new regime.[214] This adaptability similarly allowed Nowak to navigate his life as an artist. → FIG. 127 Although Nowak was clearly the most mature of the artists at the first group exhibition of Osma in 1907, he soon turned fully towards a pandering pseudo-rococo style that brought him great success among the bourgeois public in Prague, Vienna, Munich, and Berlin. Kafka purchased some of Nowak's artworks as well, although in his selection he probably relied on Brod's judgment.[215] Brod, in turn, purchased four works from the artist, and he had Nowak do portraits of him in oils and in a lithographic print. → FIG. 128 Kafka in his diaries noted the embarrassment he felt when visiting Nowak's studio. Surprised by his own untrained eye, Kafka observed artworks for which he could not render any judgment. He was also fascinated by Nowak's self-confidence, which he clearly found suspect: "One could not overlook the certainty with which the painter at every moment of the conversation trusted in the unforeseen of his inspiration and that only this trust made his artistic work with the best justification into an almost scientific one."[216]

Not counting Kafka's former classmate from his university studies in law—Max Horb, whose talent was unfortunately cut short from further development by his premature death in 1907[217]—Kafka's closest friend among the Osma artists was clearly the painter Friedrich Feigl. Feigl and Kafka had known each other from their studies at the Altstädter Gymnasium, and Kafka helped the artist's brother, Ernst Feigl, to achieve a reputation as a poet.[218] Feigl's name frequently appears in Kafka's correspondence with his fiancée Felice Bauer, who lived in Berlin, where Feigl and his wife Margarete had been living since 1911. In 1916, Kafka asked Felice to visit the painter and purchase from him a painting that Kafka's parents hoped to give as a wedding present to a relative. In his letters, Kafka attempts to find out what impression Feigl made on Felice, and informs her of his own views on the artist:

> Do you feel confident when it comes to pictures? I don't often. I did with 2 or 3 of Feigl's paintings. I believe he may have accomplished a great deal already. … What has a very powerful effect on me is his way of talking and thinking, half-crazy yet very methodical. Then there is his endless seeking and endless certainty which you, as I would too, call "instantaneous optimism."[219]

209 Ibid., 186.

210 Ernst Ascher, known as Enda, was a cousin of the textile designer Zika (Zikmund) Ascher, who founded the renowned London firm Ascher Studios. Marie Rakušanová, "Sonderbund 1912," in *1912. 100 let od otevření Obecního domu*, ed. Otto M. Urban (Prague: Arbor Vitae, 2012), 166.

211 Brod, *Der Prager Kreis*, see the photograph on page 77.

212 Max Brod, "Notiz über einen jungen Maler," *Herder-Blätter* 1, no. 3 (May 1912): 56.

213 Rakušanová, "Sonderbund 1912," 162–67.

214 Václav Formánek, *Vilém Nowak* (Prague: Odeon, 1978).

215 Franz Kafka to Max Brod, summer 1909, in Kafka, *Letters to Friends, Family, and Editors*, 58. In this letter, Kafka asks Brod for advice "about Nowak." We do not know what work Kafka purchased in 1909 or whether he purchased it at all, but he later acquired two of Nowak's lithographs from 1911. See Nicholas Sawicki's chapter in the present volume.

216 Kafka, *The Diaries*, 157 (entry from December 23, 1911).

217 The importance of Max Horb's work for Kafka's own drawings is addressed in the present volume by Nicholas Sawicki.

218 Franz Kafka to George H. Meyer of the Kurt Wolff publishing house, September 30, 1916, in Kafka, *Letters to Friends, Family, and Editors*, 196.

219 Franz Kafka to Felice Bauer, August 31, 1916, in Kafka, *Letters to Felice*, 494. See also Zuzana Duchková, "Feigl in Berlin, in der Lichterstadt," in *Friedrich Feigl, 1884–1965*, ed. Nicholas Sawicki (Řevnice and Cheb: Arbor Vitae and Galerie výtvarného umění v Chebu, 2016), 140–97, and, in the same volume, Nicholas Sawicki, "Biografie," 254–63.

Feigl makes an appearance in another, still more personal light in Kafka's letters to Felice in 1912. Kafka was at the time fascinated by Feigl's happy existence as a newlywed artist; by contrast, he himself felt more than a bit uncertain in his own role as Felice's suitor, since he saw marital devotion as being in sharp conflict with his creative work. As he writes to Felice,

> I only wanted (and that's why it was doubly important to take the poor painter's arm and drag him this way and that) to hear that he has been married for a year, is happy, works all day, lives in 2 rooms in a house in a garden at Wilmersdorf, and other such things which arouse envy and courage.[220]

In the same letter, Kafka encloses a reproduction of Feigl's self-portrait, which he mentions once more a few days later: "One more thing, I don't go courting; if I did, I shouldn't have to envy any painter (who, I must say, in his self-portrait looks like a criminal ape), but could let the whole world envy me."[221]

Many decades later, Feigl recalled a discussion that he had with Kafka on the topic of the bases of the various artistic disciplines: "We arrived at the conclusion that the essential element of painting is space, for music it is time, and in literary work causality, which corresponded to the basic types of the sensual perception of space, time, and cause."[222] In his letters to Felice, however, Kafka expressed considerable mistrust and skepticism toward Feigl's theorizing: "This painter, for example, has a great urge to hold forth about theories on art, no doubt subjectively true, but all the same as feeble and easy to snuff out as a candle."[223]

Feigl was long regarded as the creator of the only portrait of Franz Kafka to be completed during the author's life. The ink sketch, which he titled *Franz Kafka Reads "The Bucket Rider,"* was allegedly drawn in 1917.[224] → FIG. 129 Feigl is known to have been present during the reading mentioned in the work's title, yet in reality he drew the portrait twenty-two years later for the art historian J. P. Hodin, his neighbor in London.[225]

The fact that Kafka never had himself portrayed in a painting during his lifetime can be seen as evidence of his distrust of images. Likewise, Josef K. in *The Trial* also decides not to be painted by Titorelli. Instead he simply, "without thinking," chooses from Titorelli's production three absolutely identical depictions of a heath with frail trees and a setting sun, and, being "in no mood to discuss the mendicant artist's professional life," hastily promises to eventually purchase all the canvases in his studio.[226] What makes Titorelli untrustworthy is not only that he presents three identical pictures as different works, but also that he tries to create the impression that he is an expert in the interpretation of law and jurisprudence. Kafka allows the painter a long and seemingly knowledgeable speech about the trial of Josef K. Through his own training as a lawyer, Kafka brings the artist Titorelli into the mysterious judicial conspiracy against the unsuspecting bank official Josef K. In fact, hidden behind the painter's bed are doors leading to further spaces of the court offices, which extend through attics and attic studios throughout the city.[227]

One major expert on Kafka's work, Josef Čermák, has drawn attention to a woodcut portrait of Kafka that was created during his lifetime, even if the writer possibly never knew about it. Working from a 1917 photograph of Kafka, the printmaker Karel Votlučka made this portrait in 1921 for the literary journal *Nova et Vetera*, published by Josef Florian in Stará Říše.[228]

220 Franz Kafka to Felice Bauer, November 28, 1912, in Kafka, *Letters to Felice*, 75.

221 Franz Kafka to Felice Bauer, December 7, 1912, in ibid., 152.

222 Hodin, "Memories of Franz Kafka," 32.

223 Franz Kafka to Felice Bauer, November 28, 1912, in Kafka, *Letters to Felice*, 75.

224 See Wolfgang Rothe, *Kafka in der Kunst* (Stuttgart/Zurich: Belser, 1979), 21; Klaus Wagenbach, *Franz Kafka. Bilder aus seinem Leben* (Berlin: Verlag Klaus Wagenbach, 2008), 215; Hartmut Binder, *Kafkas Welt. Eine Lebenschronik in Bildern* (Hamburg: Rowohlt, 2008), 513; Sabine Fischer, "'Franz Kafka liest den Kübelreiter'. Ein Porträt des Autors als Autorenporträt?," *Jahrbuch der Deutschen Schillergesellschaft* 63 (2019).

225 Kilcher, "Kafka's Drawing and Writing," 244–45. Hodin was born in Prague and had a fascination with Kafka.

226 Kafka, *The Trial*, 149–50.

227 Ibid., 148–49.

228 Josef Čermák, "Franz Kafka und seine ersten Illustratoren (Karel Votlučka und Wilhelm Wessel)," *Brücken: Zeitschrift für Sprach-, Literatur- und Kulturwissenschaft* 15, no. 1–2 (2007): 81.

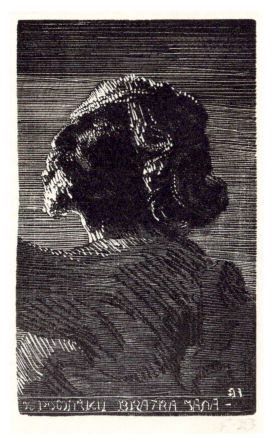

107

107 František Bílek, *From the Monument to Jan Žižka: A Cycle of 10 Portraits*, ca. 1915. Woodcut, 27.1×21.4 cm. Prague City Gallery.

108 *Umělecký měsíčník*, vol. 2, no. 11–12, 1912–1913. Illustration by Zdeněk Kratochvíl, "Funny Corner IX: A Conversation between Jaroslav Hašek and Jan Žižka." Private collection.

108

109 *Červen*, vol. 1, no. 3, 1918–1919. Reproduction of Jan Zrzavý's *Acrobats* on the cover. National Library of the Czech Republic, Prague.

Kafka nevertheless allowed himself to be photographed repeatedly and without any objections, and he also attentively observed the photographic portraits of his friends and acquaintances.[229] "That first photograph of yours is very dear to me," he wrote in 1912 to Felice Bauer, "for the little girl no longer exists, and so the photograph is all there is. But the other picture only portrays your dear presence, and my yearning carries my glance beyond the disquieting little picture."[230] Photography compelled Kafka to realize the impossibility of approaching the subject of desire that it portrayed, which was always eluding his gaze. Lacan's theory of the visual image regards the process of seeing as the expression of a desire for "the Other" ("objet a" – "autre"), which is always somewhere else, where the gaze can never reach it with immediacy. The visual image is the quintessence of the unfulfillable, traumatic desire for what is lacking.[231] Kafka's mistrust of images could have arisen from his subconscious sense of their deceitful character. He trusted neither the intuitive inspirations described by visual artists (Nowak), nor their sophisticated artistic theories (Feigl), nor the gestures expressed by modern expressive dance or the emotions mediated by the new medium of film. While he could find them captivating, they above all forced him to experience a sense that something was missing from his own life.

[229] See further: Duttlinger, *Kafka and Photography,* 140–87.

[230] Franz Kafka to Felice Bauer, November 29, 1912, in Kafka, *Letters to Felice*, 75.

[231] Lacan, "What is a Picture," 105–22.

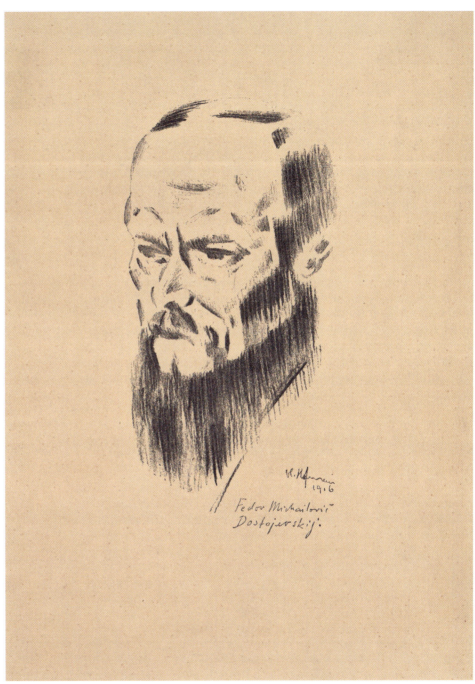

110

110 Vlastislav Hofman,
 Dostoevsky, 1916.
 Lithograph, 22.5×11.5 cm.
 Olomouc Museum of Art.

Some authors have placed not only Kafka's drawings but even his way of writing into the category of expressionism or other modernist tendencies. Yet any comparison with Paul Klee, Alfred Kubin (already noted by Feigl), or the members of Der Blaue Reiter and Die Brücke[232] fails to provide a key to Kafka's drawings, let alone his views on the relationship between text and image. Kafka's story "Murder" certainly did appear in 1918 in the almanac *Die neue Dichtung* alongside expressive drawings by Ludwig Meidner, yet Kafka evidently had no say on the choice of illustrations.[233] Similarly, Kafka only expressed his view of the frontispiece for *The Stoker* to the publisher Kurt Wolff once the book had already appeared, praising the choice of an old engraving New York harbor as a pleasant surprise, although he admitted that, had the decision been his, he would not have used the illustration.[234] → FIG. 130, 131

In 1924, when the Czech publisher Josef Florian was preparing the Czech publication of Kafka's novella *The Metamorphosis* (*Proměna* in Czech) through his publishing house in the small Moravian village of Stará Říše, he originally commissioned the illustrations for the book from the German artist Wilhelm Wessel.[235] The planned book did not appear in print until 1929, and with illustrations by Otto Coester.[236] Both of these German artists resorted to the motif of a beetle in their illustrations, though Wessel took greater liberties with its form than the more literal Coester. → FIG. 219 Coester's drawings meet the true function of an illustration, faithfully reproducing a selected portion of text from the book, yet Kafka himself had no desire for such descriptiveness, particularly in the case of *The Metamorphosis*.[237] In fact, as he wrote in an October 1915 letter to Georg Heinrich Meyer, an editor with the publisher Kurt Wolff, regarding the upcoming publication of the novella:

> You recently mentioned that Ottomar Starke is going to do a drawing for the title page of *Metamorphosis*. ... This prospect has given me a minor and perhaps unnecessary fright. It struck me that Starke, as an illustrator, might want to draw the insect itself. Not that, please not that! I do not want to restrict him, but only to make this plea out of my deeper knowledge of the story. The insect itself cannot be depicted. It cannot even be shown from a distance. Perhaps there is no such intention and my plea can be dismissed with a smile—so much the better. ... If I were to offer suggestions for an illustration, I would choose such scenes as the following: the parents and the head clerk in front of the locked door, or even better, the parents and the sister in the lighted room, with the door open upon the adjoining room that lies in darkness.[238]

Kafka's writings, likewise, not only refuse to present the reader with a coherent narrative but go so far as to cast doubt on the ability of language to transmit clearly interpretable meaning. This skepticism toward "representation" in Kafka's literary works was extended by Kafka to all visual phenomena and toward anything that claimed itself to be a "true illustration." → FIG. 132, 133

In his stories, novels, diaries, and correspondence, Kafka enjoyed describing images that refrained from any conveyance of "meaning." Even today, contemporary artists and philosophers are fascinated by Kafka's description of the strange being Odradek in "The Cares of a Family Man,"[239] nor can we forget his description of Gregor Samsa's insect body pressed against the

232 Sudaka-Bénazéraf, *Le regard de Franz Kafka*, 186. Nicholas Sawicki in his chapter in the present volume deliberately avoids any application of the term "expressionist" to Kafka's drawings.

233 Besides "Murder," the almanac also published "A Country Doctor." See *Die neue Dichtung. Ein Almanach* (Leipzig: Kurt Wolff, 1918), 17–25, 72–75.

234 Franz Kafka to Kurt Wolff, May 25, 1913, in Kafka, *Letters to Friends, Family, and Editors*, 126. Franz Kafka, *Der Heizer* (Leipzig: Kurt Wolff Verlag, 1913). The issue of Kafka's relationship to the illustrations of his texts is thoroughly addressed by Kilcher, "Kafka's Drawing and Writing," 268–74.

235 Marie Rakušanová and Jan Placák, *Vzplanutí* (Olomouc: Ztichlá klika, 2008), 184.

236 Franz Kafka, *Proměna*, trans. P. L.V. [Ludvík Vrána] and František Pastor (Stará Říše na Moravě: Marta Florianová, 1929).

237 Coester's illustrations were also used in the Czech publication of *The Metamorphosis* from 1963, translated and designed by the sculptor Zbyněk Sekal. Sekal also designed the binding, using the motif of an abstract insignia of lines (evoking a beetle) and the dust jacket using a photograph by Emila Medková. The non-representational quality of the binding and cover would likely have met Kafka's standards. Franz Kafka, *Proměna*, trans. Zbyněk Sekal (Prague: SNKLU, 1963).

238 Franz Kafka to Georg Heinrich Meyer, October 25, 1915, in Kafka, *Letters to Friends, Family, and Editors*, 146.

239 Franz Kafka, "The Cares of a Family Man," in Franz Kafka, *Stories*, ed. Nahum Glatzer (New York: Schocken, 1971), 427–28. Exhibitions such as *Le Siècle de Kafka* at the Centre Pompidou in Paris (1984), *Odradek* at the CCS Bard Galleries (1998) and Malmö Konsthall (2023), or the 2015–2023 Brussels project *Odradek Residence* examined Kafka's relationship to art in an asynchronic framework, with a focus on ahistorical connections and in particular the inspiration contemporary artists find in his work.

glass of a picture of a woman muffled in fur.[240] Kafka's visual imagination was formed by the great quantity of disparate images which he encountered in his daily life and neither judged nor categorized. He did not trust pictorial representation as such, and it did not matter to him whether it was the most vulgar kitsch or a leading work of European modernism. This everyday open experience, paradoxically coupled with his own prejudices against visuality, gave rise to incredible representations balancing between image and language, such as this example from a letter to his sister Ottla:

> Dear Ottla, A great pity that this time I will not be in Prague on the 28th. I had grand plans, not petty tissue-paper packages and the like, as usual, but something really grand, obviously already under the influence of Berlin taste, something like the present grand revue which is called "Europe Is Talking about It." It would have become a replica of the Schelesen bath which so delighted you. I would simply have cleared out my room, placed a large container there, and filled it with sour milk; that would have been the pool. Over the milk, I would have scattered slices of cucumber. According to the number of your years (which I would have had to ask someone to tell me; I cannot remember them; for me you grow no older), I would have set up the bathing huts, built of chocolate bars. … High up on the ceiling of the room, slantwise in one corner, I would have hung up a gigantic rayed sun composed of Olmütz Limburger cheese. It would have been ravishing; no one would have been able to endure the sight for long.[241]

[240] Franz Kafka, *The Metamorphosis and Other Stories*, trans. Willa and Edwin Muir (New York: Schocken, 1995), 105.

[241] Franz Kafka to Ottla David, October 1923, in Franz Kafka, *Letters to Ottla and the Family*, trans. Richard and Clara Winston (New York: Schocken, 1982), 132–33.

111 Scenes from the film *Shivat Zion*, 1920, directed by Ya'acov Ben-Dov.

THROUGH THE EYES OF FRANZ K.: BETWEEN IMAGE AND LANGUAGE

112A, B

112A, B *Das Ghettobuch: die schönsten Geschichten aus dem Ghetto,* edited by Artur Landsberger (Munich: Georg Müller, 1914). The illustration in Fig. 112B is by Friedrich Feigl. Jewish Museum in Prague.

113 Friedrich Feigl, *Höre Israel*, from the album *Künstlergabe zum XII. Zionisten-Kongress*, 1921. Woodcut, 17.3×13.6 cm. Jewish Museum in Prague.

113

THROUGH THE EYES OF FRANZ K.: BETWEEN IMAGE AND LANGUAGE

114

115

114 Emil Artur Pittermann Longen, poster for a performance of Isaac-Leib Peretz's *The Strike*, 1920. Color lithograph, 94×67cm. Museum of Decorative Arts in Prague.

115 Photograph of Yitzhak Löwy as "The Wild Man" in the eponymous play by Jacob Gordin, 1911–1912. Bildarchiv Klaus Wagenbach.

116　Hilde Pollak, *Expression 6*, ca. 1914–1920. Watercolor and pencil on paper, 82.5×116 cm. Jewish Museum in Prague.

THROUGH THE EYES OF FRANZ K.: BETWEEN IMAGE AND LANGUAGE

117

117 August Brömse, poster for exhibition by Die Pilger at the Rudolfinum, Prague, 1922. Lithograph, 63×47cm. Kunstforum Ostdeutsche Galerie Regensburg.

118 August Brömse, *The Lamentation*, 1914. Oil on canvas, 167×98cm. National Gallery in Prague. Shown at the 1922 Die Pilger exhibition at the Rudolfinum, Prague.

118

100

119 Maxim Kopf, *On the Lake (Evening)*, 1920. Oil on canvas, 65.5×77.5 cm. Liberec Regional Gallery. Probably shown at the 1922 Die Pilger exhibition at the Rudolfinum, Prague.

120 Jost Pietsch, *Drowning Man*, ca. 1920. Wood, h. 40. National Gallery in Prague. Probably shown at the 1922 Die Pilger exhibition at the Rudolfinum, Prague.

121 Anton Bruder, *Girl among Flowers*, 1922. Oil on canvas, 85×98.5 cm. National Gallery in Prague.

122

123

124

122 Julius Pfeiffer, *Portrait of M. D. (Mary Duras)*, 1921. Oil on canvas, 140.5×100.5 cm. National Gallery in Prague. Shown at the 1922 Die Pilger exhibition at the Rudolfinum, Prague.

123 Alfred Kubin, *The Fairy Princess*, ca. 1920. Lithograph, 27.2×19.5 cm. Albertina, Vienna.

124 Alfred Kubin, *On a Trapeze*, ca. 1930. Color ink, pen, and watercolor on paper, 36.9×28 cm. Albertina, Vienna.

125

126

125 Ernst Ascher, *Ruins (Demolition of the Jewish Quarter)*, 1910. Oil on canvas, 62.5 × 46.5 cm. Private collection.

126 Ernst Ascher, *Portrait of Egon Erwin Kisch*, 1910. Oil on canvas, 86 × 77 cm. Art Collections of the Museum of Czech Literature, Prague.

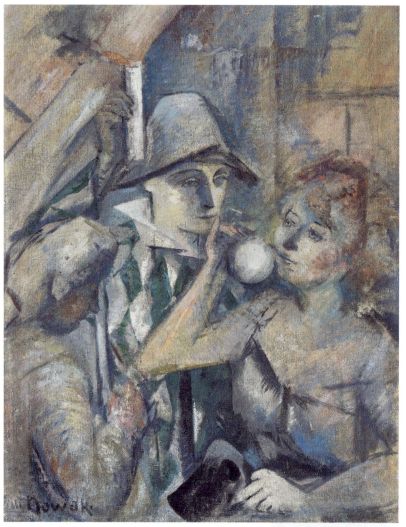

127

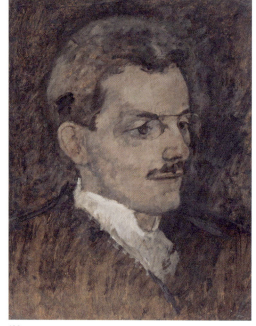

128

127 Willi Nowak, *Harlequin*, ca. 1920. Oil on canvas, 74×59 cm. National Gallery in Prague.

128 Willi Nowak, *Max Brod*, ca. 1911. Oil on paperboard, 40×31.5 cm. Jewish Museum in Prague.

THROUGH THE EYES OF FRANZ K.: BETWEEN IMAGE AND LANGUAGE

129

129 Friedrich Feigl, *Franz Kafka Reads "The Bucket Rider,"* 1946. India ink, brush, and pencil on paper, 25.2×20.2 cm. Deutsches Literaturarchiv Marbach.

130 *Die neue Dichtung* (Leipzig: Kurt Wolff, 1918), with Kafka's "The Murder" and illustration by Ludwig Meidner. National Library of the Czech Republic, Prague.

131 Franz Kafka, *Der Heizer: ein Fragment* (Leipzig: Kurt Wolff, 1913). Private collection.

THROUGH THE EYES OF FRANZ K.: BETWEEN IMAGE AND LANGUAGE

132 Wilhelm Wessel, unused illustration (1924) for the first Czech edition of Kafka's *Die Verwandlung*. Watercolor and pencil on paper, 15.7×10.2 cm. Ztichlá klika Gallery, Prague.

133 Franz Kafka, *Die Verwandlung* (Leipzig: Kurt Wolff, 1916). Cover illustration by Ottomar Starke. Private collection.

132

133

7) *der Vater*	Äußere Form der schriftlichen Arbeiten					
8)	Versäumte halbe Schultage	entschuldigt				
9)		nicht entschuldigt				
a) Des Schülers	Sittliches Betragen		1	1	1	
	Fleiß		1	1	1	
1) Franz	**Fortgang**					
2) Kafka						
3) 3. VII 1883	Religion		2	1	1	1
4) Prag	Lesen		1	1	1	1
5) mos. d.	Schreiben		2	2	2	2
6) Prag Wassek, Pzeh	Unterrichtssprache	Sprachlehre	1	1	1	1
		Rechtschreiben	1	1	1	1
b) Des Vaters oder der Mutter		Schriftlicher Gedankenausdruck	1	1	1	1
	Rechnen in Verbindung mit der geometrischen Formenlehre		1	1	1	1
7) Hermann Kafka	Naturgeschichte und Naturlehre		1	1	1	1
	Geographie und Geschichte		1	1	1	1
8) Kaufmann	Zeichnen		2	2	2	2
9) Zeltnerg. 3 n. I	Gesang		1	1	1	1
	Weibliche Handarbeiten		–	–	–	–
c) Des Vormundes oder Kostherrn	Turnen		2	2	2	2
	Böhmisch		1	1	1	1
7) der Vater						
8)	Äußere Form der schriftlichen Arbeiten		2	2	2	2
9)	Versäumte halbe Schultage	entschuldigt	2	–	7	4
		nicht entschuldigt	–	–	–	–

KAFKA GOES TO SCHOOL: DRAWING AS OBLIGATION AND FORMATIVE INFLUENCE

Alexander Klee

From September 16, 1889, until the fourth grade in 1893, Franz Kafka attended the Deutsche Knabenschule on Prague's Fleischmarkt (Masný trh).[1] As evidenced by his school records, despite his otherwise good performance, drawing was not one of Kafka's strengths in primary school.[2] → **FIG. 134–136** In September 1893, he moved on to secondary school in the Altstädter Gymnasium.[3] Here, drawing was no longer a mandatory subject but an elective, and despite his interest in drawing as a university student many years later, Kafka no longer took it.[4] Where did Kafka's eventual talent for and interest in drawing develop, and what were his reasons for avoiding drawing courses in secondary school? The reasons for why he did not take drawing as a gymnasium student can be traced back to the primary school curriculum itself, which was limited to the drawing of geometric forms.[5] This pedagogy, which emphasized discipline and was not very friendly to children, has often been portrayed negatively in biographies of Kafka.[6] It was an approach to drawing education that had a historical basis, and which promoted a strict form of instruction that ruled out creativity or the possibility of drawing from nature.

With the School and Church Act of May 25, 1868, all schools in the Austro-Hungarian monarchy, including primary schools, were made interdenominational institutions and the educational system was in essence placed under state management.[7] These developments marked the culmination of a continued disempowerment of the church as an important operator of schools alongside the state. Additionally, the national aspirations of the various lands within the monarchy had been guaranteed by the December Constitution of 1867, which stated that "in those lands inhabited by multiple ethnicities, public teaching institutions shall be organized in such a manner that every such ethnic group shall receive the necessary materials for instruction in its language without being forced to learn a second national language."[8] This provision, meant to avoid the imposition of a uniform language requirement on any particular ethnic group within the empire, reflects the fragile nature of

1 Klaus Wagenbach, *Franz Kafka, Biographie seiner Jugend* (Berlin: Verlag Klaus Wagenbach, 2006), 29. I am grateful to Hana Klínková for her help in researching Kafka's school records.

2 "Výroční zprávy obecné školy v Masné ulici. Výpis známek Franze Kafky z katalogu školní docházky a prospěchu žáků ve školním roce 1892–1893." Prague City Archives, inv. 82, sign. NŠ/B/I/13-82.

3 Wagenbach, *Franz Kafka*, 34.

4 Kafka's case was not unique. There were many students, including those who would in the future become artists, who chose not to take drawing courses at the gymnasium level, or who took the subject only minimally. On the other hand, there were others, like Max Brod, who took drawing courses continually; Brod studied at the German-language gymnasium on Stephansgasse (Štěpánská ulice). See Kafka's gymnasium records in the Prague City Archives, fonds 1058 (Německé státní gymnázium Staré město), and Brod's gymnasium records, fonds 932 (Německé státní gymnázium Nové město, Štěpánská 20).

5 Hartmut Binder, "Kindheit in Prag: Kafkas Volksschuljahre," in *Humanismen Som Salt & Styrka: Bilder & betraktelser, tillägnade Harry Järv*, ed. Louise Asklöf (Stockholm: Atlantis, 1987), 96 and subsequent. I am grateful to Zuzana Jürgens for calling my attention to this exceptionally well-founded observation.

6 Wagenbach, *Franz Kafka*, 36.

7 Peter Urbanitsch, "II. Schule zwischen Staat und Nation, A. Bildung und Bildungsinstitutionen zwischen Kulturförderung und Politik in Cisleithanien," in *Die Habsburgermonarchie 1848–1918*, Band X, *Das kulturelle Leben. Akteure – Tendenzen – Ausprägungen*. Teilband 1: *Staat Konfession und Identität*, ed. Andreas Gottsmann (Vienna: Verlag der ÖAW, 2021), 213.

8 Urbanitsch, "II. Schule zwischen Staat und Nation," 213. See also Hannelore Burger, "Das mehrsprachige Unterrichtswesen der Verfassungszeit (1867–1918) und die sprachnationalen Identitäten der Juden," in *Franz Kafka im sprachnationalen Kontext seiner Zeit*, ed.

KAFKA GOES TO SCHOOL: DRAWING AS OBLIGATION AND FORMATIVE INFLUENCE

134 Period photograph of the primary school on the Fleischmarkt in Prague attended by Franz Kafka.

Marek Nekula, Ingrid Fleischmann, and Albrecht Greule (Cologne: Böhlau, 2007), 151–66.

9 Wagenbach, *Franz Kafka*, 29.

10 Adolf Ficker, *Bericht über österreichisches Unterrichtswesen: Geschichte, Organisation und Statistik des österreichischen Unterrichtswesens* (Vienna: Alfred Hölder, 1873), 47.

11 Alois Naske, *Der Zeichenunterricht an Volks- und Bürgerschulen* (Brno: Karel Winkler, 1877), 5.

12 *Entwürfe von Lehrplänen und Instructionen zur Regelung des Zeichenunterrichts an Volks-, Bürger- und Mittelschulen und verwandten Lehranstalten* (Vienna: Verlag d. k.k. Österr. Museums, 1873), 1.

Austro-Hungarian society and its various linguistic and national groups at the time: it was passed in part to assuage Bohemia's German-speaking minority, which had responded negatively to an earlier law from 1864 that placed Czech on an equal footing with German in Bohemia's schools—a requirement German speakers referred to as the "compulsory language law." Despite the language freedoms guaranteed by the December Constitution, these linguistic conflicts continued to find expression in the form of skirmishes between German- and Czech-language students in Kafka's time.[9]

As a part of these reforms, in 1870 the Ministry of Education passed a School and Educational Directive for General Primary Schools,[10] and prescribed drawing as a regular subject of primary school instruction.[11] After 1873, school curricula contained the following objectives for drawing in the first four primary school grades:

> To develop pupils' ability to properly understand geometric forms; training of visual perception and capacity for visualization as applied to simple objects present in life.
>
> Lower level: 1st and 2nd grade
> At this level, instruction consists of preparatory exercises common to writing and drawing with the goal of achieving a certain degree of manual dexterity. These exercises are followed by the drawing of simple objects related to instruction in the sciences.
>
> Intermediate level: 3rd and 4th grade
> Exercises involving the drawing of various forms based on the straight line, angles, the triangle, and the square. Application of these forms as part of simple shapes. Beginning of drawing dictation.[12]

KAFKA GOES TO SCHOOL: DRAWING AS OBLIGATION AND FORMATIVE INFLUENCE

135 Franz Kafka (back row, second from left) in a secondary school photograph from 1898, with the school director Anton Frank and classroom teacher Emil Gschwind. Bildarchiv Klaus Wagenbach.

136 Franz Kafka's grades from the records of his primary school on the Fleischmarkt, Prague, for the 1892–1893 school year. Prague City Archives.

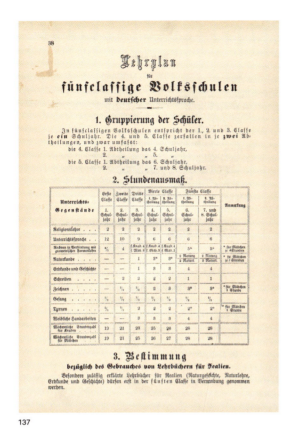

137

13	*Lehrpläne für allgemeine Volksschulen in Böhmen nach dem Erlasse des k.k. Landesschulrathes vom 18. Juli 1885* (Prague: Heinrich Mercy, 1885), 43.
14	*Entwürfe von Lehrplänen*, 4.
15	Alexander Klee, "Forming a Common Language: The Teaching of Drawing in the Habsburg Empire from 1850," in *Drawing Education: Worldwide! Continuities – Transfers – Mixtures*, ed. Nino Nanobashvili and Tobias Teutenberg (Heidelberg: Heidelberg University Publishing, 2019), 79–80.

137 *Lehrpläne für allgemeine Volksschulen in Böhmen nach dem Erlasse des k.k. Landesschulrathes vom 18. Juli 1885* (Prague: Heinrich Mercy, 1885). Private collection.

In 1885, a new set of school directives was published for primary schools in Bohemia. Except for replacing "drawing dictation" (a drawing method in which pupils connected dots to produce a geometric figure) with the sentence "With the cube as a starting point, by considering simple angular solids, knowledge is imparted of these solids and of various surfaces, angles, and lines," no other changes were made to this definition of the goals of instruction for the first four grades. This focus on geometric forms in drawing persisted throughout Kafka's primary school years.[13] → FIG. 137

One member of the commission that passed the original curriculum was Josef Grandauer, who himself provided authoritative directives for drawing instruction. → FIG. 138 Kafka would have practiced creating drawings of this type—they were to be executed as freehand drawings, meaning without the use of ruler and compass—while still at primary school.[14] Achieving this objective required a great deal of practice. The prescribed number of teaching hours was correspondingly high as well, more than double the number common in other European countries.[15] Consequently, drawing instruction in Austro-Hungarian primary schools was assigned a much greater importance than elsewhere. There were multiple reasons for this, rooted in the complicated political structure of the multiethnic state.[16] The ideas of educational reformers such as Friedrich Herbart and Heinrich Pestalozzi, which linked geometric forms to mathematics, may have played a role. This approach to drawing instruction, moreover, allowed little room for developing an individual style and favored a transnational shared culture in which mathematics and

drawing could not be appropriated as national characteristics or elements. This was by intention, and was repeatedly expressed by educators in the Habsburg monarchy, most concisely by Gustav Adolf Lindner:

> The language of perception and drawing, which serves it, is a cosmopolitan means of human understanding as much as music. While words and writing are conventional signs invented by humanity and only understood by those to whom their meaning has been explained, the notes of music and their interrelationships and the lines of drawing in their no less harmonious combinations are a language through which nature speaks to us directly, a language that can be understood in Philadelphia and Beijing just as well as in Berlin and Paris.[17]

In this way, conflicts of religion, nationality, and ethnicity could be kept out of formative education and excluded from instruction, or at least their impact on pupils' understanding of the world and their community was relativized.

For Kafka, the development of manual drawing skills in primary school may well have influenced his later work. For instance, it may explain Kafka's profound understanding of the interrelationship of forms in cubism, futurism, expressionism, and other artistic styles of which he was aware thanks to his friends in the group Osma, or Die Acht (the Eight).[18] Similarly, the crystalline forms so prominently present in Czech cubism may have had their origins here as well. → FIG. 139 Could not Kafka's later tendency for drawing pointy, geometric figures also be a product of his drawing education? The same goes for the linguistic nature of drawing, which was cited as a goal of drawing instruction, for example by Lindner, and which can be repeatedly found in Kafka's work—either in a humorous manner, as in a letter to Felice Bauer from February 1913, → FIG. 140 or in the abstract script that Kafka experimented with in October/November 1922.[19] → FIG. 141

In summation, it can be said that, even if Kafka disliked drawing classes, the instruction he received was one factor—and quite surely an important one—that helped him to realize his illustrative intentions. Keeping in mind Linder's definition of drawing as a medium of communication, it becomes clear that, as shaped by the school curriculum, in Kafka's drawings the relationship between literature and drawing—and between writing as a literary art and writing as visual expression—is of central importance.

[16] For a detailed discussion of this topic, see Klee, "Forming a Common Language."

[17] Gustav A. Lindner, "'Das ABC der Anschauung' als Grundlage eines rationellen Elementarunterrichtes im Zeichnen," in *Programm des k. k. Gymnasiums zu Cilli am Schluße des Schuljahres 1871* (Celje: E. Jeretin, 1871), 4.

[18] Andreas Kilcher, ed., *Franz Kafka: The Drawings* (New Haven: Yale University Press, 2022), 241–42.

[19] Franz Kafka, *Letters to Felice*, ed. Erich Heller and Jürgen Born, trans. James Stern and Elisabeth Duckworth (New York: Schocken, 1973), 189–90. See also Nicholas Sawicki's contribution to the present volume.

KAFKA GOES TO SCHOOL: DRAWING AS OBLIGATION AND FORMATIVE INFLUENCE

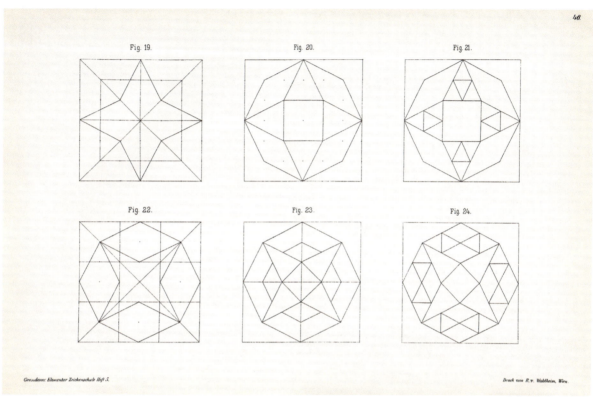

138

139

138 Basic shapes to be used for drawing exercises. From: Josef Grandauer, *Elementar-Zeichenschule. Vorlagen zum Vorzeichnen auf der Schultafel in den Volks- und Bürgerschulen* (Vienna: R. v. Waldheim, 1870). Private collection.

139 Pavel Janák, *Box with a Lid*, 1911. Glazed earthenware with black decoration, h. 12 cm. Museum of Decorative Arts in Prague.

115

140 Letter from Franz Kafka to Felice Bauer, February 11–12, 1913. Kafka's drawings accompany the passage "… how we walked in my dream …" Private collection.

KAFKA GOES TO SCHOOL: DRAWING AS OBLIGATION AND FORMATIVE INFLUENCE

141

141 Patterns and ornaments among the loose pages of Kafka's manuscripts, October/November 1922. Pencil on paper, 22.2×14.4 cm. The Bodleian Libraries, University of Oxford.

117

Meiselgasse 6.

Günther KALSER seit 1901 beh. bew. Bureau für

Militär-Angelegenheiten

nach wie vor
I., Rotenturmstrasse 31 a

Auskünfte und Eingaben in allen Militär- und Wehrangelegenheiten. — Heiratskautionen.
Bureaustunden 9–6 Uhr. Telephon Nr. 19.112.

Telephon 17.619 Telephon 17.619

Restaurant Riedhof
VIII., Wickenburggasse 15, Schlösselgasse 14

Feinstes Restaurant, Wiener und französische Küche, jeden Samstag und Sonntag **Bockbieranstich**, fünf große Speisesäle, Klubzimmer, neu renovierte Chambres séparées, Diners und Hochzeiten in und außer dem Hause. Jeden **Samstag Abendkonzert** im Marmorsaale bei freiem Entree.
Josef Pohl, Restaurateur, langjähriger Küchenchef des Grand Hotel de l'Europe in Salzburg.

Herrenhemden
von

BERECZ & LÖBL
k. und k. Hof-Wäschelieferanten

WIEN
I., Babenbergerstr. 1
I., Schottengasse 6
I., Kärntnerstraße 53

sind die elegantesten

ungarische Frage! Oder mehrere Broschüren des Grafen Sternberg! Wirkt wie Strychnin. Krämpfe mit letalem Ausgang.

B²; Franz Pichler; Dr. M. Brodf..d. Rückporto!

Adi Ah. Bedingungslos unbrauchbar!

„Eifriger Leser 94". Senden Sie das beim Paprika-Schlesinger ein.

Moderne. Sie haben einen neuen Typus gefunden: «Die Suchenden». Im Fundbureau würde man das, was Sie suchen, unter die Gegenstände einreihen, für die man keinen Finderlohn gibt, weil sie wertlos sind.

Himmelfahrt. Leider nicht neu.

Franz Gater, Prag. Wir sind doch kein «Reiseverlag», wie das Fachwort so schön lautet. Machen Sie einen «Fremdenführer durch Melnik» daraus. Sie brauchen nicht viel zu ändern.

V. Heisa. Wir sollen im Briefkasten antworten, aber «nicht boshaft sein». Dabei schicken Sie uns eine reizende Babygeschichte von Frühling, Murmeltier und Igel. Wir sind artig: wir schweigen.

Genickstarre. Läßt unbedingt geistige Defekte zurück. Zwei Spielarten: in Preußen zieht sie den Kopf nach rückwärts und oben, in Österreich nach vorn und unten.

Hanns Fischl; Leo R.; P. M.; E. B.; M. M....k; 1236, Gmunden; Aichinger, Linz; O. in L. Nichts.

Altes Luder. «Wassergeschichten» erwünscht. Aber bessere.

Särnblom, Berlin. Wir honorieren **jede** Einsendung, **wenn** wir sie akzeptieren. Im gegebenen Falle also nicht. Rückporto!

Nr. 27 ihr drittes Quartal!

ir besonderen Beachtung!

1. April 1906:

astdrucke

Bei h a l b jähriger Abonnements-Einzahlung liefern wir einen

□ Der Bezugspreis beträgt für □

Österreich-Ungarn

vierteljährlich K 3.80

FRANZ KAFKA'S DRAWINGS: FORM, FIGURE, CONTEXT

Nicholas Sawicki

For most of the century that has passed since Franz Kafka's death, relatively little has been known about his connection to the visual arts or his own artistic production. The question has lingered since the time that Max Brod, Kafka's close friend and literary executor, first published reproductions of Kafka's drawings in his biography of 1937.[1] → FIG. 142A, B Through the years, it has faded in and out of view, receiving occasional attention from critics, scholars, and followers of Kafka's literary work, although continually limited by a scarcity of available images and sources.[2] In his extensive publications on Kafka and the editions of Kafka's writings that he edited, Brod reproduced only a small number of drawings and did not offer much commentary on them.[3] Apart from this, one of the few other widely known period sources to address Kafka's interest in art was the 1951 book by the critic Gustav Janouch, *Conversations with Kafka*, → FIG. 143 which Janouch claimed to be based on discussions he and Kafka had together in the early 1920s but which in actuality consisted of mostly invented dialogues.[4]

Until recently, it was not known that beyond these limited sources, a considerable volume of other visual and documentary materials had survived to illuminate Kafka's interest in art. As the past few years have revealed, Brod in fact collected and preserved a far greater number of drawings by Kafka than he originally published. When he fled Prague for Palestine in March 1939, taking Kafka's literary manuscripts with him, he brought with him more than a hundred pages of Kafka's drawings. In 1952, he made a gift of these

[1] Max Brod, *Franz Kafka: Eine Biographie* (Prague: Heinrich Mercy Sohn, 1937). Brod published three pages of drawings by Kafka in his biography. In subsequent years, he published additional drawings in his numerous other writings on Kafka. See also Andreas Kilcher, ed., *Franz Kafka: The Drawings*, trans. Kurt Beals (New Haven: Yale University Press, 2022). Kilcher's book was first published in German by C. H. Beck in 2021.

[2] For examples of earlier scholarship on Kafka's drawings, see Claude Gandelman, "Kafka as an Expressionist Draftsman," *Neohelicon* 2, no. 3–4 (September 1971): 237–77; Jacqueline Sudaka-Bénazéraf, *Le regard de Franz Kafka: Dessins d'un écrivain* (Paris: Maissonneuve & Larose, 2001); Niels Bokhove and Marijke van Dorst, *Einmal ein großer Zeichner: Franz Kafka als bildender Künstler* (Prague: Vitalis, 2006); Friederike Fellner, *Kafkas Zeichnungen* (Paderborn: Wilhelm Fink, 2014).

[3] Brod's only substantive written commentary on the drawings appears in his book *Franz Kafkas Glauben und Lehre* (Munich: Verlag Kurt Desch, 1948), 189–92.

[4] Gustav Janouch, *Gespräche mit Kafka* (Frankfurt am Main: S. Fischer, 1951); Gustav Janouch, *Conversations with Kafka*, trans. Goronwy Rees (New York: Frederick A. Praeger, 1953). Janouch later republished his book in a considerably revised second edition. For a nuanced analysis of the fabricated nature of Janouch's book, see Hartmut Binder, "Gustav Janouchs 'Gespräche mit Kafka,'" in *Kafka-Handbuch*, vol. 2, ed. Hartmut Binder (Stuttgart: Kröner, 1979), 554–62, and Veronika Tuckerová, *Reading Kafka in Prague: The Reception of Franz Kafka between the East and West during the Cold War* (Ph.D., Columbia University, 2012).

 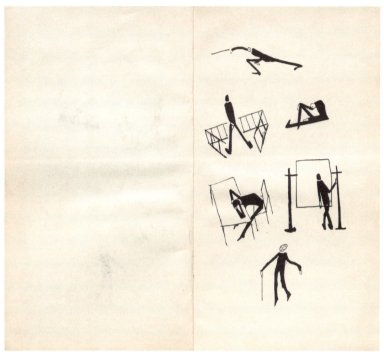

142A, B

142A, B Max Brod, *Franz Kafka: Eine Biographie* (Prague: Heinrich Mercy Sohn, 1937). National Library of the Czech Republic, Prague.

143 Gustav Janouch, *Gespräche mit Kafka* (Frankfurt am Main: S. Fischer, 1951). Private collection.

FRANZ KAFKA'S DRAWINGS: FORM, FIGURE, CONTEXT

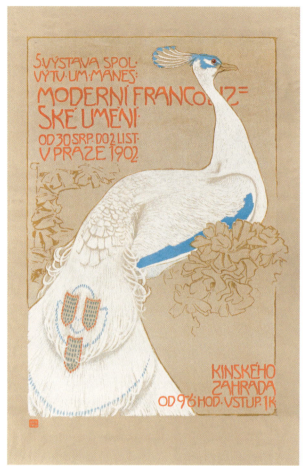

144

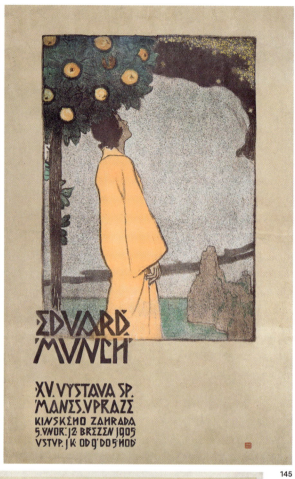

145

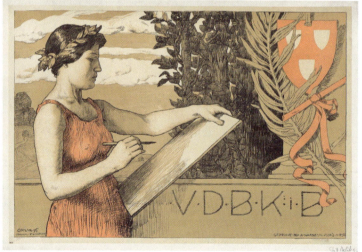

146

144 Jan Preisler, poster for the exhibition *Modern French Art*, Mánes Association of Fine Artists, Prague, 1902. Color lithograph, 110.5×72.4 cm. Museum of Decorative Arts in Prague.

145 Jan Preisler, poster for exhibition by Edvard Munch, Mánes Association of Fine Artists, Prague, 1905. Color lithograph, 112×77 cm. Museum of Decorative Arts in Prague.

146 Emil Orlik, poster for the Verein deutscher bildender Künstler in Böhmen, Prague, 1895. Color lithograph, 63.6×92.6 cm. Museum of Decorative Arts in Prague.

124

drawings to his secretary, Ilse Esther Hoffe, and they remained with her family, out of view and stored in a bank vault in Zurich, until a court decision in 2016 ruled that the drawings should be transferred to the National Library of Israel, which in 2021 photographed and digitized them, making them publicly available for the first time.[5]

Today, with access to these rediscovered visual materials, the comprehensive catalog of the drawings recently published by Andreas Kilcher, and historical sources and documents until now overlooked, it is possible to more closely understand Kafka's artistic work and interests. It is also possible to more thoroughly situate his art in relation to artistic developments in Prague in the early twentieth century—the city where Kafka spent nearly the entirety of his life, and where his literary and artistic work developed.

ARTISTIC MODERNISM IN PRAGUE

Kafka's interest in art was at its strongest during his time as a university student and in the few years that followed, and it began to diminish once he shifted his focus to literary writing and began to publish fiction in early 1908.[6] Brod in his biographical writings indicated that he acquired most of the drawings he owned by Kafka when the two of them were studying law together at Prague University, and that he "cut a number of them from the margins of [Kafka's] law school books."[7] Kafka began his university studies in fall 1901 and completed his degree in 1906. Brod joined him as a student in 1902.[8] The majority of Kafka's drawings appear to date from this period, although a small number may have been produced somewhat later.[9] These years were formative for Kafka and coincided with a time of remarkable transformation within the artistic scene in Prague.

In the first decade of the twentieth century, Prague established itself as a vibrant artistic capital and a center for modernism with a growing international reputation. In 1902, a new building was built for Prague's Academy of Fine Arts, and within several years enrollment in the school nearly doubled.[10] That same year, a new exhibition pavilion was constructed in the Kinsky Gardens by the Spolek výtvarných umělců Mánes (Mánes Association of Fine Artists), a Czech organization that, over the next decade, became the city's leading venue for modern art, exhibiting work by Czech artists as well as by prominent artists from abroad.[11] Its inaugural exhibition that spring featured the sculptural works and drawings of Auguste Rodin, his largest showing outside France. This was followed by an exhibition of impressionism → FIG. 144 that showed works by Edgar Degas, Claude Monet, Auguste Renoir, and other mostly French painters, their works sent by leading European galleries. Edvard Munch exhibited in early 1905, → FIG. 145 and his work landed in Prague like an explosive charge. "A hand which hurls paint on canvas as his does should rather wield a knife or throw a bomb," wrote the critic František Xaver Šalda, in what initially reads like admonition but was in fact high praise.[12] The works of Paul Gauguin, Vincent van Gogh, Paul Cézanne, and other post-impressionist painters were shown in 1907. Soon enough, there were works by Henri Matisse and cubist paintings by Georges Braque and Pablo Picasso. Braque showed in Prague for the first time 1910 with the Mánes Association, and beginning in 1912 he and Picasso showed with the Skupina výtvarných umělců (Group of Fine Artists), a conduit for cubism in Prague.[13]

5. On the provenance of the drawings, their original ownership by Max Brod, and the court case that ruled their transfer to the National Library of Israel, see Kilcher, ed., *Franz Kafka*, 7–28. On the court case specifically, see Benjamin Balint, *Kafka's Last Trial: The Case of a Literary Legacy* (New York: W. W. Norton, 2018).

6. Kafka's first published fiction, a series of short vignettes, appeared in the illustrated Munich journal *Hyperion* 1, no. 1 (1908): 91–94.

7. Brod, *Glauben und Lehre*, 191.

8. On Kafka's university education and early friendship with Brod, see Reiner Stach, *Kafka: The Early Years* (Princeton: Princeton University Press, 2013), 204–21.

9. Kilcher, ed., *Franz Kafka*, 239, dates the majority of Kafka's surviving drawings to his "time as a student from 1901 to 1906, as well as during the following year, when he was a legal trainee at the higher regional court, until the fall of 1907." It is possible that at least some of the drawings were produced at a somewhat later point.

10. On the Academy of Fine Arts, see Nicholas Sawicki, *Na cestě k modernosti: Umělecké sdružení Osma a jeho okruh v letech 1900–1910* (Prague: Filozofická fakulta Univerzity Karlovy, 2014), 21–33.

11. For English-language introductory reading on major exhibitions of modern art from abroad in Prague, see, for example, Marta Filipová, *Modernity, History, and Politics in Czech Art* (New York: Routledge, 2020), and Petr Wittlich, *Czech Modern Painters* (Prague: Karolinum, 2013).

12. František X. Šalda, "Násilník snu," *Volné směry* 9 (1904–1905): 101–7. Translated into English by J. P. Hodin under the title "The Violent Dreamer: Some Remarks on the Work of Edvard Munch," *The Journal of Aesthetics and Art Criticism* 28, no. 2 (Winter 1969): 149–53.

13. The scholarship on cubism in Prague is extensive. For a starting point, see Miroslav Lamač, ed., *Cubisme tchèque* (Paris: Centre Georges Pompidou, 1992), and Jiří Švestka, Tomáš Vlček, Pavel Liška, et al., *Czech Cubism 1909–1925* (Prague: Modernista, 2006).

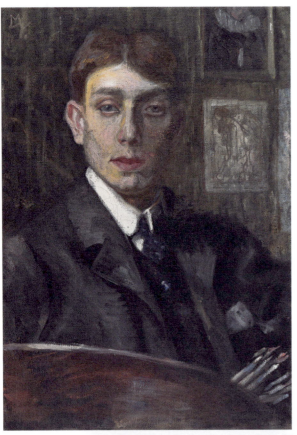

147

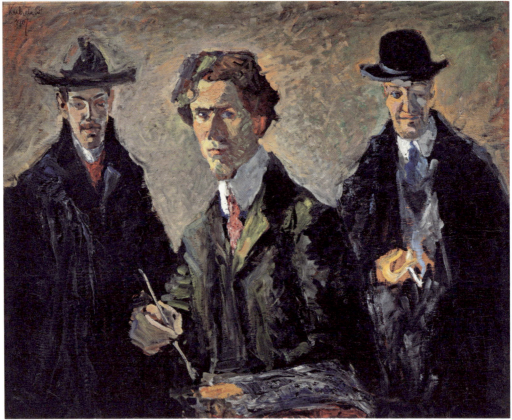

148

147 Max Horb, *Self-Portrait*, 1905. Oil on canvas, 70×50 cm. Retro Gallery, Prague.

148 Bohumil Kubišta, *Triple Portrait*, 1907. Oil on paperboard, 86.5×108.5 cm. National Gallery in Prague.

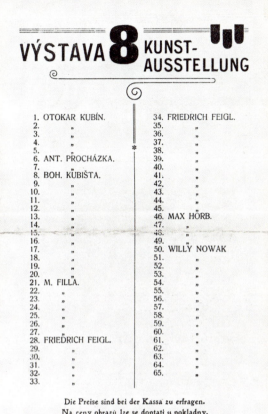

149

149 Cover of the catalogue for the first exhibition of the Eight, Prague, 1907. Private collection.

150 Willi Nowak, *Girl with Apples*, 1911. Color lithograph, 24.5 x 21.5 cm. Private collection.

151 Willi Nowak, *Walk*, 1911. Color lithograph, 23×32.7 cm. Moravian Gallery in Brno.

151

FRANZ KAFKA'S DRAWINGS: FORM, FIGURE, CONTEXT

152

152 Alfred Kubin, *The Horror*, 1902. Aquatint, 33.8×31.4 cm. National Gallery in Prague.

153

153 Richard Teschner, *Downpour*, 1902. Oil on board, 21×17 cm. Belvedere, Vienna.

FRANZ KAFKA'S DRAWINGS: FORM, FIGURE, CONTEXT

154 Max Horb, *The Tailor's Workshop*, 1907. Oil on burlap, 56×67 cm. Stockholm University Art Collections.

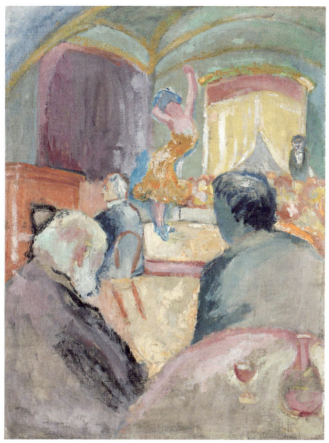

155

155 Emil Filla, *Cabaret*, ca. 1907. Oil on canvas, 78×59.5 cm. Olomouc Museum of Art.

156 Willi Nowak, *Garden*, 1905–1906. Oil on canvas, 52×66 cm. National Gallery in Prague. Shown at the first exhibition of the Eight, Prague, 1907.

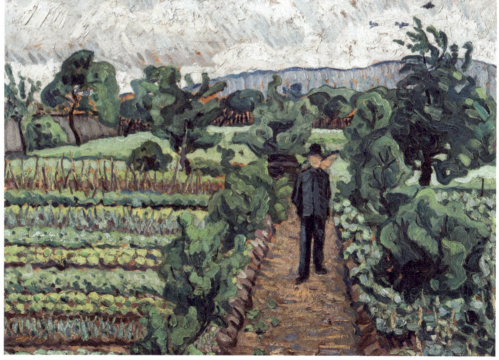

156

Prague's main organization for German-speaking artists, the Verein deutscher bildender Künstler in Böhmen (Association of German Artists in Bohemia), was also a site of intensive artistic activity. Established in 1895 → FIG. 146 by artists including Emil Orlik, Karl Krattner, and others, with Rainer Maria Rilke as a member, it gained increased visibility in 1907 with a large exhibition held that year in the Rudolfinum.[14] Both Czech- and German-speaking artists also exhibited with the Krasoumná jednota pro Čechy, or Kunstverein für Böhmen (Art Association for Bohemia). This was the oldest local association for artists, and its organizational structure and exhibitions were divided into separate Czech and German sections, following a long historical legacy that split cultural and political life in Prague into competing German and Czech national spheres, each encompassing Christian as well as Jewish populations.[15] Emil Orlik exhibited with the association in 1902, in a showing that notably included new work he had produced during recent travels to Japan.[16] Another important cultural hub for the German-speaking community in Prague was the university reading club, the Lese- und Redehalle der deutschen Studenten. Kafka and Brod were members, and both were active in its art and literature section.[17]

For Kafka, Brod, and their generational contemporaries in Prague at the start of the twentieth century, it was increasingly possible to imagine pursuing the life of an artist. This applied even to individuals of backgrounds and identities that had not been traditionally well represented in the local art world. Aspiring artists from the rural agricultural and middle classes increasingly made their way to Prague to study, and women artists, although excluded from the Academy of Fine Arts, had access to private academies and to Prague's School of Applied Arts and in 1906 formed the Klub deutscher Künstlerinnen in Prag (Club of German Women Artists in Prague).[18] For the first time in history, Jewish students began to enroll in larger numbers at the Academy of Fine Arts and to establish themselves on the local artistic scene, defying the stereotype of a "people of the book," which Martin Buber, the philosopher and theorist of cultural Zionism, whose later lectures in Prague Kafka attended, famously discarded as a dated notion.[19]

The artist Max Horb, → FIG. 147 who initially studied law with Kafka and Brod at Prague University and was a member of the Lese- und Redehalle, was part of this new contingent of Jewish artists. Horb spent his secondary-school years in Prague and, after a year at the university, quit to enroll in the Academy of Fine Arts. He ultimately left the academy as well, together with other classmates who found the environment there too restrictive. They established a group that called itself Osma in Czech, or Die Acht in German (the Eight), the name based on the number of artists in the group's first exhibition in spring 1907.[20] The composition of the Eight posed a radical challenge and offered an alternative to Prague's ethnically divided cultural landscape, as it incorporated artists

14 See Hugo Steiner, *Aus einer Kneipzeitung des Vereins deutscher bildender Künstler in Böhmen* (Prague: 1933). See also Sawicki, *Na cestě k modernosti*, 77–78, 87–88.

15 Vít Vlnas, ed., *Obrazárna v Čechách, 1796–1918* (Prague: Národní galerie, 1996); Tomáš Sekyrka, "Sehr geehrte Mitglieder! Členové Krasoumné jednoty pro Čechy v roce 1894," in *Orbis artium: K jubileu Lubomíra Slavíčka*, ed. Jiří Kroupa, Michaela Šeferisová Loudová, Lubomír Konečný (Brno: Masarykova univerzita, 2009), 103–13.

16 Kilcher proposes that Orlik's exhibition may have had an influence on Kafka as an artist, in *Franz Kafka*, 220–22, and a similar point is made by Stach, *Kafka: The Early Years*, 217–18. See also the contribution to the present volume by Marie Rakušanová.

17 Kilcher, ed., *Franz Kafka*, 218–19. Stach, *Kafka: The Early Years*, 213–21. For further reading on the Lese- und Redehalle, see Scott Spector, *Prague Territories: National Conflict and Cultural Innovation in Franz Kafka's Fin de Siècle* (Berkeley: University of California Press, 2002).

18 One of the first mentions of the Klub deutscher Künstlerinnen in the Prague press appears in the German-language daily *Bohemia*, December 14, 1906, 7. For further information, see also Marie Rakušanová's contribution to this volume.

19 See Martin Buber's "Address on Jewish Art" (1901), in *The First Buber: Youthful Zionist Writings of Martin Buber*, ed. Gilya Schmidt (Syracuse: Syracuse University Press, 1999), 52. For an account of how Buber's views on art were received in Prague, see Nicholas Sawicki, "The Critic as Patron and Mediator: Max Brod, Modern Art, and Jewish Identity in Early-Twentieth-Century Prague," *Images: A Journal of Jewish Art and Visual Culture* 6 (2012): 30–51. On Kafka's understanding of Buber and Zionism, see Iris Bruce, *Kafka and Cultural Zionism: Dates in Palestine* (Madison: University of Wisconsin Press, 2007), and *Kafka, Zionism, and Beyond*, ed. Mark H. Gelber (Tübingen: Max Niemeyer, 2004).

20 For a comprehensive history of the Eight, see Sawicki, *Na cestě k modernosti*, and the two-volume study by Miroslav Lamač, *Osma a Skupina výtvarných umělců, 1907–1917* (Prague: Odeon, 1988), and Miroslav Lamač and Jiří Padrta, ed., *Osma a Skupina výtvarných umělců, 1907–1917: Teorie, kritika, polemika* (Prague: Odeon, 1992).

from Czech- as well as German-speaking family backgrounds and included two Jewish members, Horb and Friedrich Feigl. The group's other artists were Emil Filla, Otakar Kubín, Bohumil Kubišta, Willi Nowak, Emil Pittermann, and Antonín Procházka, later joined by Vincenc Beneš and Linka Scheithauerová for a second exhibition in 1908.

Kubišta would give visual form to these artists' diverse backgrounds in a well-known portrait of himself with Feigl and Pittermann.[21] → FIG. 148 Max Brod, who was an outspoken early advocate of the Eight and collected their paintings, celebrated these same characteristics in his review of the group's first exhibition, which he titled "Spring in Prague" and published in the Berlin journal *Die Gegenwart*. There, Brod heralded the Eight as representatives of a larger shift taking place among the younger generation in Prague. Shared collective beliefs and experiences and a shared interest in modernism, Brod argued, were pushing the traditional premise "of a purely German or purely Czech nation" to a position of lesser importance.[22] Brod's conviction was not yet widely held by other art critics and writers, many of whom recoiled at the idea and attacked the Eight in the press, sometimes with antisemitic remarks.[23] Yet for Brod and Kafka, as well as many of their fellow contemporaries in the artistic and literary communities, close friendships and working relationships that crossed ethno-linguistic and religious lines were increasingly seen as a common and desirable part of cultural and intellectual life, and fundamental to modernism.

KAFKA AMONG THE ARTISTS

Kafka was connected to this artistic world on a personal level. In a November 1907 letter to Hedwig Weiler, he wrote that he was now "mixed up with a whole crowd" of new acquaintances: "Army officers, Berliners, Frenchmen, painters, cabaret singers," and it is difficult to imagine Kafka's reference to painters as being anything other than an implication of the Eight, to whom he was directly connected through Horb and Brod.[24] The group's first exhibition earlier that year → FIG. 149 took place in a rented shop close to the apartment where Kafka lived with his family. More specifically, during preparations for one of the group's two exhibitions, Brod, in an effort to support and promote Kafka's burgeoning drawing practice, approached the Eight to ask the artists to consider including and exhibiting Kafka's work, although he was not successful in persuading them.

This information comes from Friedrich Feigl, who shared the recollection in conversations with the Prague-born critic J. P. Hodin during their years of emigration in London, which Hodin recorded in surviving notes and typescripts, excerpts of which he published in 1948.[25] Feigl and Kafka had been students together at the Altstädter Gymnasium in Prague, although they studied in different grades and did not know one another well in their youth. After the exhibitions of the Eight, their relationship deepened.[26] In 1912, one year after Feigl left Prague and moved to Berlin, Kafka visited him there, and in 1916 Kafka asked Felice Bauer to help him purchase a painting from Feigl as a wedding present for his cousin: a "Paris picture," as he described it to Felice.[27] Feigl indicated to Hodin that Kafka may have bought a different work from him: "He bought a picture of mine, a Prague study. There was a touch of Munch about it, something uncanny."[28] Kafka was also friendly

21 On Kubišta's triple portrait, see Marie Rakušanová ed., *Degrees of Separation: Bohumil Kubišta and the European Avant-Garde* (Prague: Karolinum, 2021), 77, and Mahulena Nešlehová, *Bohumil Kubišta* (Prague: Odeon, 1993), 29–31.

22 Max Brod, "Frühling in Prag," *Die Gegenwart* 36, no. 20 (1907): For an analysis of Brod's review, see Sawicki, *Na cestě k modernosti*, 83–84, 106–8, and "The Critic as Patron and Mediator," 36–39.

23 On the attacks on the Eight in the press and on antisemitism in Czech-language art criticism, see Sawicki, *Na cestě k modernosti*, 109–12, and "The Critic as Patron and Mediator," 39–40. See also Eva Janáčová, ed., *Images of Malice: Visual Representations of Anti-Judaism and Antisemitism in the Bohemian Lands* (Prague: Karolinum, 2022).

24 Franz Kafka to Hedwig Weiler, November 22, 1907, in Franz Kafka, *Letters to Friends, Family, and Editors*, trans. Richard and Clara Winston (New York: Schocken, 1977), 38–39.

25 J. P. Hodin, "Memories of Franz Kafka," *Horizon* 17 (January 1948): 26–45. The notebook in which Hodin recorded his conversations with Feigl survives, as does an unpublished typescript that Hodin titled "Franz Kafka's Drawings: A Critical Study." Both are deposited in his personal papers in the Tate Archive, London, fonds 20062, sign. 7.53.1. See also Kilcher, ed., *Franz Kafka*, 19–24. On Hodin's close relationship with Feigl, see Rachel Dickson and Sarah MacDougall, "Feigl v Anglii: 'Moderní umění je jako Sputnik,'" in *Friedrich Feigl, 1884–1965*, ed. Nicholas Sawicki (Řevnice and Cheb: Arbor Vitae and Galerie výtvarného umění v Chebu, 2016), 198–253.

26 See Zuzana Duchková, "Feigl v Berlíně, ve městě světel," in Sawicki, ed., *Friedrich Feigl,* 140–97, and in the same volume, Nicholas Sawicki, "Biografie," 254–63.

27 Franz Kafka, letters to Felice Bauer, August 18, 19, and 31, 1916, in Franz Kafka, *Letters to Felice*, ed. Erich Heller and Jürgen Born, trans. James Stern and Elisabeth Duckworth (New York: Schocken, 1973), 489–94.

28 Hodin, "Memories of Franz Kafka," 33.

with Willi Nowak. Together with Brod, he visited Nowak's studio in Prague in late 1911 to view Nowak's progress on a lithograph portrait of Brod, based on an earlier portrait in oils. Kafka recorded a lengthy account of the visit in his diaries and left the studio with two purchases. "Bought two lithographs 'Apple Salesgirl' and 'Walk,'" he wrote in his diaries.[29] Nowak in his correspondence later recalled that Kafka and Brod also visited him one summer at his family's home in the town of Mníšek pod Brdy outside Prague.[30] The whereabouts of the artworks that Kafka collected are today unknown, but two prints by Nowak matching Kafka's descriptions survive in contemporary collections.[31] → FIG. 150, 151

When Brod came to the Eight to ask them to consider Kafka's work, Feigl described the encounter as follows: "Max Brod mentioned during a discussion: 'I can tell you the name of a very great artist—Franz Kafka.' And he showed us some drawings of his, which evoked the memory of early Paul Klee or Kubin. They were expressionistic."[32] Paul Klee was not known in Prague in the early twentieth century, but Kubin—the Bohemian-born printmaker and illustrator Alfred Kubin—was someone Kafka knew personally and whose art he knew well. Kafka's diaries record their interactions, and the two of them were introduced by Brod in 1911, by which time Kubin was living in Upper Austria.[33] Whether Feigl knew of this later connection or not, his comparison of Kafka's drawings with the work of Kubin was not particularly discerning.[34] Kubin was a pioneer of turn-of-the-century symbolist decadence. He depicted fantastical scenes with strong narrative elements and an emphasis on physical setting, and relied on traditional illusionistic techniques of representation. → FIG. 152 Kubin shared these attributes with other artists more local to Prague, such as Richard Teschner.[35] → FIG. 153 Kafka's drawings generally lack these qualities, and if Feigl viewed them as "expressionistic," it is important to qualify this by stating that the majority of them dated to before the period when expressionism started circulating as an idea and practice among artists.[36]

"We couldn't do it, he was too immature," was Feigl's explanation to Hodin as to why the Eight turned down Brod's proposal to include Kafka in their exhibitions.[37] It would probably have been more precise for Feigl to say that he and the other artists in the group simply perceived Kafka to be out of place. As artists, they identified first and foremost as painters and their main concern was to subject the traditional conventions of painting to radical reconsideration. They did so by exploring new ways of deploying color, brushwork, and line to depict form → FIG. 154–156 without reverting to the illusionism and naturalism that was still common among many artists in Prague at the time. There is no record that Kafka ever painted or that he even worked in color. All of his surviving works are drawings, and in this regard, from the perspective of medium alone, his art had little to recommend to the Eight. Another critical distinction between Kafka and the artists was that all of them had an advanced education in the arts, which Kafka never did.

Unlike his law school classmate Max Horb, who quit his legal studies to pursue the life of an artist, Kafka, as Feigl reminisced, "did not develop his gift for drawing further."[38] He destined himself for an adulthood in a respectable middle-class profession that his family, particularly his father, who owned a shop for clothing and accessories on Prague's Old Town Square, deemed appropriate for their only male child, two brothers having died in infancy, and his sisters, Ottla, Valli, and Elli, groomed for marriage. "There was

29 Franz Kafka, *The Diaries*, trans. Ross Benjamin (New York: Schocken Books, 2022), 158.

30 Willi Nowak to Miroslav Haas, n.d. [ca. 1965]. Archive of the National Gallery in Prague, Willi Nowak Papers, fonds 96, sign. AA 3039. Nowak's papers also contain a letter dated January 22, 1977, from the historian and biographer Hartmut Binder, inquiring about his relationship with Kafka.

31 Kilcher, ed., *Franz Kafka*, 246, was the first to match these surviving prints by Nowak to Kafka's descriptions, and both date to 1911.

32 Hodin, "Memories of Franz Kafka," 32.

33 Kafka, *The Diaries*, 20–24.

34 The connection between Kafka and Kubin has been explored by others scholars, including Philip Rhein and Gérard-Georges Lemaire. See the contribution to the present volume by Marie Rakušanová.

35 On symbolism and decadence in Prague, and for a discussion of Kubin and Teschner, see Otto M. Urban, *In Morbid Colors: Art and the Idea of Decadence in the Bohemian Lands, 1880–1914* (Řevnice: Arbor Vitae, 2006). See also Annegret Hoberg, ed., *Alfred Kubin: Drawings 1897–1909* (New York: Neue Galerie, 2008).

36 Gandelman, in "Kafka as an Expressionist Draftsman," also characterizes Kafka's drawings as "expressionist." For a discussion of how the idea and term first began to circulate, see Donald E. Gordon, "On the Origin of the Word 'Expressionism,'" *Journal of the Warburg and Courtauld Institutes* 29 (1966): 368–85. For specific discussion of expressionism in the artistic community in Prague, see Marie Rakušanová, Petr Wittlich, Vojtěch Lahoda, and Karel Srp, *Křičte ústa: Předpoklady expresionismu* (Prague: Academia, 2007), Alena Pomajzlová, ed., *Expresionismus a české umění, 1905–1927* (Prague: National Gallery in Prague, 1994), and Marie Rakušanová, "Prague—Brno: Expressionism in Context," in *The Routledge Companion to Expressionism in a Transnational Context*, ed. Isabel Wünsche (New York: Routledge, 2018), 33–55.

37 Hodin, "Franz Kafka's Drawings: A Critical Study," 46.

38 Hodin, "Memories of Franz Kafka," 32.

actually no such thing for me as liberty to choose my career," Kafka wrote in the famous letter he wrote to his father, the one he never sent. "This was something from which I expected no rescue; here I had long ago given up."[39] Although Kafka had taken drawing courses in primary school, after that, in secondary school at the Altstädter Gymnasium, where drawing was taught as an elective course, he did not choose to study the subject.[40] His main training appears to have been private drawing instruction, probably during his university years, and in a letter to Felice Bauer from February 1913, he indicated that his teacher was a woman. "I was once a great draftsman, you know, but then I started to take academic drawing lessons with a bad woman painter and ruined my talent. Think of that!"[41] Andreas Kilcher suggests that Kafka's instructor may have been Ida Freund, a founding member of the Klub deutscher Künstlerinnen, although it is difficult to state so with certainty, since there are no records.[42]

If Kafka dreamed about other paths along which his own life could develop, or if he ever aspired to live the life of a visual artist, he did not follow through on the normal steps that a young man his age would have needed to take to pursue such a vocation. Yet he maintained his friendships with artists, and for a considerable period of time, during his university years and in the few years that followed, he cultivated a drawing practice that held great meaning to him. Kafka's letter to Felice speaks of his pictures in the past tense, making evident that by this point in his life, in 1913, he was no longer actively drawing. But Kafka was clear in the letter about the enjoyment that his art had once brought him. Between the lines of the self-deprecating language that fills so much of Kafka's correspondence, the important role that drawing had for him stands out. "One of these days I'll send you a few of my old drawings, to give you something to laugh at," Kafka wrote to Felice. "These drawings gave me greater satisfaction in those days—it's years ago—than anything else."[43]

PORTRAITS, FIGURES, AND BODIES WITHOUT SPACE

There are today approximately one hundred and twenty pages of drawings by Kafka in the holdings of the National Library of Israel, originally owned by Brod, as well as a handful of drawings in other collections, including two that Brod sold in 1952 to the Albertina in Vienna.[44] Most of the drawings concentrate on figures, sometimes accompanied by the occasional dog or horse—the majority in pencil, some in black ink. Except for a bound octavo notebook of drawings with black covers that remains intact, its pages still in their original configuration, most of the drawings are rendered on loose pieces of paper removed from ruled notebooks and ledgers, or cut down or folded from larger sheets of unruled paper. The paper and notebooks on which Kafka worked are small and were portable enough that he could easily carry them around with him, drawing during his daily walks around the city of Prague and in the coffee houses he frequented.

The most conventional drawings are portraits that Kafka made of family and friends, as well as his own self-portraits. From these works, it is evident that the drawing instruction that Kafka received from his private instructor, even if he believed it "ruined [his] talent," provided him with a strong understanding of traditional techniques of rendering. One of the drawings → FIG. 157 depicts his mother in reading glasses and, in the lower part of the page,

[39] Franz Kafka, "Letter to His Father," in *Dearest Father: Stories and Other Writings*, trans. Ernst Kaiser and Eithne Wilkins (New York: Schocken, 1954), 181.

[40] For further reading, see Alexander Klee's contribution to the present volume.

[41] Franz Kafka, letter to Felice Bauer, February 11–12, 1913, in Kafka, *Letters to Felice*, 189.

[42] Kilcher, ed., *Franz Kafka*, 225, 358n73.

[43] Kafka, *Letters to Felice*, 189.

[44] Brod's correspondence regarding the sale of the two drawings is deposited in the archives of the Albertina, Vienna. My thanks to Elisabeth Dutz, the museum's Curator of Austrian and German Art from 1890 to 1945, for providing me with copies of this documentation.

157 Franz Kafka, self-portrait and portrait of Julie Kafka. Pencil on paper, 17.5×11.2 cm. National Library of Israel, Jerusalem.

45 Hodin and Feigl, in one of their meetings together in London, when they were looking at a black and white photograph of the drawing, believed it to be a portrait of Johannes Urzidil. Hodin, "Franz Kafka's Drawings: A Critical Study," 43. Urzidil was more than a decade Kafka's junior, and his first contact with Kafka was not until later, so this identification must be incorrect. See Johannes Urzidil, *Da geht Kafka* (Munich: Deutscher Taschenbuch Verlag, 1966), translated into English by Harold Basilius as *There Goes Kafka* (Detroit: Wayne State University Press, 1968).

a small self-portrait with his hair parted down the middle. In another drawing, → FIG. 158 Kafka's self-portrait is larger and takes up more of the image area. In both pictures, there is definition and structure to the head and face, which he renders with an abbreviated modeling, filling in rough, uneven shadows with his pencil; it is clear that Kafka is working towards a naturalistic likeness. In another portrait drawing, its right edge cut irregularly, → FIG. 159 he depicts a young man close to his own age who bears some resemblance to the painter Nowak.[45] The drawing is more carefully executed, with greater detail and softer transitions between light and shadow.

Rendering likenesses of friends and family was a common practice among artists, and in this respect, as well as in their overall manner, Kafka's portrait drawings are not significantly different from those by other artists working in Prague. They can be situated comfortably alongside Emil Orlik's earlier pencil portrait of Rainer Maria Rilke, → FIG. 160 quickly drawn on the letterhead of the Verein deutscher bildender Künstler in Böhmen, or Feigl's self-portraits from early in his career. → FIG. 161 The same can be said for some of Kafka's other relatively naturalistic drawings, such as his pencil drawing of a young

FRANZ KAFKA'S DRAWINGS: FORM, FIGURE, CONTEXT

158

159

158 Franz Kafka, self-portrait. Pencil on paper, 10.5×17.1cm. National Library of Israel, Jerusalem.

159 Franz Kafka, portrait of a young man. Pencil on paper, 10.9×8.6cm. National Library of Israel, Jerusalem.

woman in a hat, walking down the street in pointed shoes. → **FIG. 162** Concentrating on the woman's head and face, Kafka depicts the rest of her body in faint and cursory lines, a typical convention for an artist recording a quick pencil drawing in a public setting, having neither time nor the inclination to more fully develop the forms.

In other works, the techniques and manner of drawing that Kafka employs are more distinctive. The mode of representation is less naturalistic, and it is the body, not facial features, to which Kafka turns his eyes and attention. On a set of open pages excised from a small ruled notebook, Kafka depicts multiple figures, each rendered in a somewhat different manner, → **FIG. 163** and in every instance the body is the central subject. There is a man with a cane rendered in blocky forms, and a woman holding a pair of skis, her torso and

160

161

160 Emil Orlik, portrait of Rainer Marie Rilke on the letterhead of the Verein deutscher bildender Künstler in Böhmen, 1896 (detail). Pencil on printed letterhead paper, 28.6×22.9 cm. Kunstforum Ostdeutsche Galerie Regensburg.

161 Friedrich Feigl, *Self-Portrait*, ca. 1902. Pencil on paper, 22.4×14.9 cm. Art Collections of the Museum of Czech Literature, Prague.

FRANZ KAFKA'S DRAWINGS: FORM, FIGURE, CONTEXT

162

162 Franz Kafka, woman walking. Pencil drawing on verso side of a printed photographic reproduction issued by the publisher S. Fischer, 10.1×6.6cm. National Library of Israel, Jerusalem.

limbs bent into a curve. Below this is a server in a restaurant, his posture unnaturally rigid. On the right-hand page, Kafka renders the outlined, sweeping forms of three additional figures, and next to this a more conventional life drawing of the hind quarters of a horse, its foreshortened body resembling the animal's true form, the only naturalistic depiction on the page.

Turning the same sheet of paper over to the other side, → FIG. 164 we encounter a man wearing a hat with raised peaks and a coat with a triangular collar, standing in front of a gothic tower. It is typologically similar to the tower at the foot of Charles Bridge in Prague's Old Town, although the drawing does not seem concerned with accurate representation, and the figure's location in the pictorially defined space visible here is entirely unusual for Kafka's work. In most drawings, Kafka does not provide a setting or environment for his figures at all. He sets them onto the paper as if they occupied only the space on the page, not physical space, and he shows no interest in architectural or natural surroundings.

More typical is a series of figure drawings → FIG. 165 rendered on the back of Kafka's portrait of his mother and his own self-portrait. Here, Kafka depicts his subjects using only line and contour to delineate their forms, a technique characteristic of many of the drawings. Although the horizontal arrangement of figures suggests a stable ground beneath the figures, there is no sidewalk, street, or setting in the picture. Kafka devotes all his emphasis to their bodies and limbs, which he stretches in order to accentuate and exaggerate the different poses they assume—walking, running, standing, and waving arms. Kafka's focus is on the ordinary human activities that he observes on the street and in public settings, activities that he routinely describes in his diaries. This is where he directs his attention, and in his drawings he gives new life to these activities through pictorial transformations that exchange the emphasis most artists of his time placed on details and physical surroundings in favor of an increased concentration on comportment, movement, and gesture, which he expands beyond the proportions of life. In another drawing, → FIG. 166 this time working in ink, Kafka depicts another group of figures walking. Their elongated limbs and the fluid lines of Kafka's pen amplify their movement across the page. At the top of the picture is a man leaning on a railing, the only figure in contact with a physical space or object.

When Kafka's contemporaries rendered figures in their drawings, they generally placed as much emphasis on the physical environment as on the figure itself, and sometimes more. Bohumil Kubišta's frequent drawings of individuals in public gardens and parks are a good example, → FIG. 167 as are Friedrich Feigl's drawings of Prague's Old Town. In the work of these and most other artists that Kafka was familiar with, the figure's spatial position in its setting was of pictorial importance. For Feigl in particular, the specificity of place was also significant—in one of his drawings, he even inscribed the location, Maiselova Street, → FIG. 168 not far from Kafka's home.

PICTORIAL EXAGGERATION, CARICATURE, AND CRITIQUE

Kafka's propensity in his drawings for pulling away from the physical environment and the smaller details of the human figure is interesting, for it strips away the more traditional markers of place and identity—contested territories of public life in Prague at the time—common in more conventional

FRANZ KAFKA'S DRAWINGS: FORM, FIGURE, CONTEXT

163　Franz Kafka, horse and figures. Pencil on ruled notebook paper, 16.3×19.8. National Library of Israel, Jerusalem.

FRANZ KAFKA'S DRAWINGS: FORM, FIGURE, CONTEXT

164

164 Franz Kafka, figures and tower. Verso side of fig. 163. Pencil on ruled notebook paper, 16.3×19.8 cm. National Library of Israel, Jerusalem.

FRANZ KAFKA'S DRAWINGS: FORM, FIGURE, CONTEXT

165

165 Franz Kafka, figures in various poses. Verso side of fig. 157. Pencil on paper, 11.2×17.5 cm. National Library of Israel, Jerusalem.

166 Franz Kafka, figures and man leaning against a railing. Ink on paper, 27.8×14 cm. National Library of Israel, Jerusalem.

FRANZ KAFKA'S DRAWINGS: FORM, FIGURE, CONTEXT

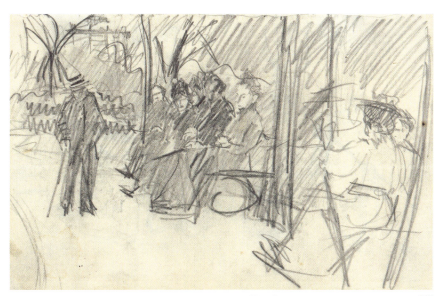

167 Bohumil Kubišta, *Benches in the Park*, 1907. Pencil on paper, 12.5×19.6 cm. Moravian Gallery in Brno.

168 Friedrich Feigl, *Maiselova Street in Prague*, 1909. Charcoal on paper, 25×17.9 cm. Moravian Gallery in Brno.

46 Kilcher, ed., *Franz Kafka*, 253.

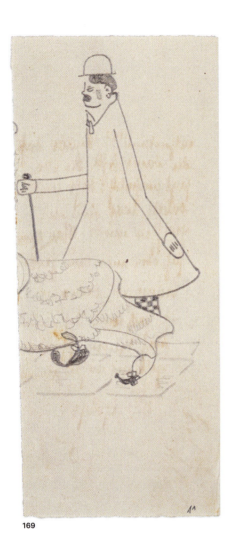

169 Franz Kafka, man walking a dog. Pencil on paper, 6.3×13 cm. National Library of Israel, Jerusalem.

drawing practices. In most of Kafka's work, as Andreas Kilcher writes, the figures are "free-floating, lacking any surroundings."[46] Kafka's sole focus is on the figure and the body to the exclusion of all else, and in most cases, even when he depicts multiple bodies on the same page and even when their forms intersect pictorially, the figures appear isolated from one another and do not often register one another's presence. Frequently, Kafka exaggerates forms. He extends physical features in unexpected, even comical directions, sometimes finding humor and contradiction in the individuals he observes and renders. He directs his gaze to a feature or discrepancy of the body that attracts his attention, and contorts and distends it beyond reality, in ways that are evidently intended for the effect of comedy.

On the street, Kafka observes a middle-aged man walking a dog, the dog's feet comically sheathed in rain boots, a new fashion. → **FIG. 169** The man wears checkered pants and strides forward with a walking stick. He has a head that

FRANZ KAFKA'S DRAWINGS: FORM, FIGURE, CONTEXT

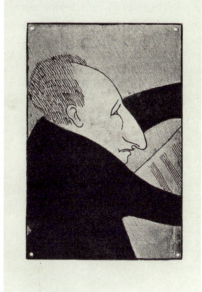

47 On the other side of the drawing is a note to Kafka, probably written by Ida Freund. It is discussed by Pavel Schmidt in his "Catalogue Raisonné" in Kilcher, ed., *Franz Kafka,* 311. See also the contribution to the present volume by Marie Rakušanová.

48 This was one of the drawings originally reproduced in Brod's 1937 biography of Kafka.

170 Franz Kafka, seated man with wineglass. Ink and pencil on paper, 16.2×10 cm. National Library of Israel, Jerusalem.

171 *Wir*, vol. 1, no. 1, 1906. Reproduction of a caricature by Max Horb. National Library of the Czech Republic, Prague.

is too small for his body, a broad moustache, a stub nose, and a half-round wedge for an eye, angled downward to give him a stern expression. The dog's hind legs look like fringed balloons, and the man's arms are hinged like those of a marionette.[47] An ink drawing of a curly-haired man hunched forward at a café table shows the man gaping at a glass of wine; he is a drunkard, his mouth wide open to the teeth, as if ready to bear down on the glass.[48] → FIG. 170 Kafka sets the initial outlines in pencil and then proceeds over this in ink. He stretches the man's mouth until it nearly reaches the back of his head, enlarges the nose until it extends far over the lips, and fills in the eyebrows and top of the head with curls of coarse, wiry hair. The man's arm hangs loose beside his body and, as in many other drawings, his hand resembles a stuffed mitten, lacking articulated fingers—it can hardly serve him for grasping the glass, which casts a strange reflection on the table, less a shadow than an outlined facsimile, as if the man is seeing double.

147

FRANZ KAFKA'S DRAWINGS: FORM, FIGURE, CONTEXT

In Kafka's letter to his father, he writes: "In order to assert myself a very little in relation to you, and partly from a kind of vengefulness, I soon began to observe little ridiculous things about you, collecting them and exaggerating them."[49] Such exaggerations appear prominently in Kafka's diaries.[50] It is this way with Kafka's drawings as well. What is evident in the previous two pictures, and what Kafka describes in his letter to his father, is the essential basis of caricature, a popular genre of drawing in Kafka's time: closely observing a person's bodily features and then exaggerating them for comical effect or derision.[51] Caricatures filled the pages of the magazines that Kafka read, and as he knew well, his friend Max Horb was not only a painter but also made a living producing caricatures and illustrations.[52] Horb published some of his earliest known works in the short-lived Prague journal *Wir*, → FIG. 171 edited by Richard Teschner and Paul Leppin, and he also prepared illustrations for a novella that Brod hoped to publish, one of which shows elements of humor: it depicts a row of figures of varied ages, genders, and appearances marching in a comical procession towards a seated cat, as if paying homage to the animal or lining up in servitude. → FIG. 172

[49] Kafka, "Letter to His Father," 156.

[50] See, for example, Kafka, *The Diaries*, 19–21.

[51] On the popularity of caricature in Prague, see Ondřej Chrobák and Tomáš Winter, ed., *V okovech smíchu: Karikatura a české umění 1900–1950* (Prague: Galerie hlavního města Prahy, 2006). For a case study of the significance that caricature held for other artists of Kafka's generation, in this instance in Vienna, see Claude Cernuschi, *Egon Schiele and the Art of Popular Illustration* (New York: Routledge, 2023).

[52] An envelope addressed to Horb and postmarked October 20, 1905, covered in drawings, is part of the collection of Kafka's drawings that Brod owned. Schmidt, "Catalogue Raisonné," 321, suggests that these drawings may have been "done by Horb himself." It is also possible that the drawings were by Kafka; in some of their works, the drawing styles of Horb and Kafka bear a resemblance to one another.

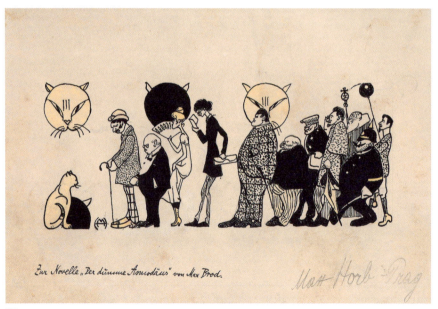

172

172 Max Horb, illustration for Max Brod's unpublished novella *Der dumme Asmodäus*, ca. 1905. India ink and pencil on paper, 12.5 × 19 cm. Private collection.

173 Franz Kafka, "Haughtiness of Wealth." With inscription by Kafka, "Übermuth des Reichthums." Pencil on brown paper, 18.4×21.1 cm. National Library of Israel, Jerusalem.

The theme of servitude and subservience is central to two drawings by Kafka that are closely connected to the traditions of caricature. Notably, they are among the few of his surviving drawings that demonstrate clear narrative intent, with the figures interacting with and responding to one another, not merely occupying the same pictorial field. These drawings also carry written inscriptions in Kafka's hand, as if he were assigning titles to caption them. This was a common practice in illustrations and caricatures in the press but rare for Kafka's drawings overall, the majority of which do not contain any writing. The first of the drawings → FIG. 173 is inscribed in the upper right with the phrase "Übermuth des Reichthums" ("haughtiness of wealth"). In the picture, an enormous fowl, a pheasant or other game bird, is held aloft on a platter by a bowed waiter whose head resembles the bird.[53] The waiter brings the meal to two women clothed and jeweled for a banquet, their bodies enveloped by their clothing. They are caricatures of affluence, seated at a long, otherwise empty table with no other guests. The second drawing, → FIG. 174 black ink over a pencil underdrawing, is inscribed with the phrase "Bittsteller und vornehmer Gönner" ("supplicant and distinguished patron").[54] The tall man at right must be the supplicant, for he removes his hat and holds it piously in his hands as he approaches, his body bent forward, toward a short, stout figure with an ornamented pointed hat: the patron, who puffs his chest outward until it becomes a shelf bearing aloft what appears to be a statuette, like a medal on a uniform that has sprung to life, thus commanding attention. The way that Kafka fills in the bodies with black ink is similar to the ink drawings in Kafka's bound octavo notebook with black covers, the source of Brod's first published images of Kafka's pictures, which Brod cut out of the notebook to reproduce. → FIG. 175, 176

The two titled drawings, "Übermuth des Reichthums" and "Bittsteller und vornehmer Gönner," are produced with playful intent, but they have an edge. Beyond their humor, they show Kafka to be paying close attention to the economic and social incongruities of class and labor. These are themes that painting—which, in Prague and elsewhere in the early twentieth century, continued to hold its traditional status as the privileged and thus the most heavily circumscribed medium of the visual arts—demonstrated only limited capacity to address. It was through caricature that these subjects were most often confronted, by artists such as František Gellner, whose illustrations filled left-leaning Czech satirical magazines such as *Šibeničky* → FIG. 177 and whose work Kafka would have known, or Thomas Theodor Heine and Bruno Paul, who dominated the pages of *Simplicissimus*, → FIG. 178 the most popular illustrated satirical magazine in the German language, based in Munich but widely read in Prague.

At least in one instance, Kafka rendered a drawing directly onto the pages of a magazine of this type, the Viennese satirical weekly *Die Muskete*. → FIG. 179 In the drawing, rendered in pencil, Kafka enters into dialogue with a printed illustration that is part of an advertisement for subscriptions to the journal. The illustration shows a group of well-dressed bourgeois men and women behind the bars of a cage, visited by a crouching jester who holds what appears to be a paddle in his right hand, and, with his left, extends two fingers towards the cage as if motioning two of the people forward for a beating—like a caricaturist summoning his prey. Into this scene, Kafka adds quick outlines of figures walking alongside the original characters, in addition to other figures outside the borders of the illustration, all of them with the elongated, curved limbs

[53] On the back side of the same page, Kafka wrote an additional phrase: "bedauernswerte Dienerschaft" ("pitiable servants"). Schmidt, "Catalogue Raisonné," 304–5.

[54] Schmidt, "Catalogue Raisonné," 311–12.

174

175

176

174 Franz Kafka, "Supplicant and Distinguished Patron." With inscription by Kafka, "Bittsteller und vornehmer Gönner." Ink on paper, with pencil inscription, 11.5×14.3 cm. National Library of Israel, Jerusalem.

175 Franz Kafka, man with a walking stick. Ink on paper, with pencil inscription, 6.3×4.6 cm. National Library of Israel, Jerusalem.

176 Franz Kafka, man at a table. Ink on paper, 12.5×8.5 cm. National Library of Israel, Jerusalem.

177
178

177 *Šibeničky*, vol. 1, no. 2, 1906. Cover illustration, "Association for Mutually Supporting Rulers," by František Gellner. The Digital Journal Archive, Czech Literary Bibliography, Institute of Czech Literature at the Czech Academy of Sciences.

178 *Simplicissimus*, vol. 6, no. 51, 1902. Cover illustration, "In the Austrian Parliament," by Bruno Paul. Library of the Museum of Decorative Arts in Prague.

characteristic of his drawings. It is spring, and the date is April 12, 1906. A few pages earlier in the same issue is an illustration of the Easter Hare and its eggs, in each one a caricature of a political head of state. The prior week's issue of the magazine, → **FIG. 180** published on the eve of the formation of Russia's first modern constitution, contained a caricatured scene of Tsar Nicholas II depicted as a skeletal crowned dwarf, confronted by revolutionaries carrying knives and a sledgehammer.

MODERNIST BODIES, SHAPED BY VIOLENCE

In other drawings, Kafka's manner of outlining forms and elongating and exaggerating the features of his figures brings his work into proximity with some of the more prominent modern artists from abroad who exhibited in Prague during the time he was most active in his drawing practice. The probability is high that in some of his works, Kafka, like others of his generation, was trying on and adapting modernist motifs and pictorial strategies that he observed in the work of other artists, not only in magazine caricatures and illustrations but also in the field of painting.

One of the two drawings by Kafka in the Albertina → **FIG. 181** was probably offered by Brod to the museum for exactly this reason, because it manifested connections between Kafka's art and that of artists broadly recognized in the canon of modernism that were overt and easily distinguished—connections

FRANZ KAFKA'S DRAWINGS: FORM, FIGURE, CONTEXT

179

180

179 Franz Kafka, pencil drawings on the back page of *Die Muskete*, no. 28, April 12, 1906. Private collection.

180 *Die Muskete*, April 5, 1906. Cover illustration, "The Last Point of Contention," by Karl Alexander Wilke. New York Public Library, Dorot Jewish Division.

FRANZ KAFKA'S DRAWINGS: FORM, FIGURE, CONTEXT

181

181 Franz Kafka, two
 seated figures. Pencil
 on ruled notebook
 paper, 16×8.7cm.
 Albertina, Vienna.

that allowed for Kafka to be fit into this already known artistic context. The drawing from the Albertina depicts two seated men, one delineated only by line, the other filled in almost entirely with pencil. The figure at left—legs crossed, pinched face, furrowed brow, and large eyes—closely resembles figures from the works of Edvard Munch. The man at right bears a passing resemblance to the postman Joseph Roulin in the paintings and drawings of Vincent van Gogh.[55]

The distorted oval head of the figure at left appears in other works as well. In one of Kafka's other drawings, → FIG. 182 the head is adjoined to a body that Kafka depicts with the undulating curves of the central figure in Munch's 1893 painting *The Scream*, Kafka's figure hovering at small scale above a clown or jester in a pointed hat, who takes up most of the page. Munch's picture was widely known: he created multiple versions of it, working in tempera as well as crayon, → FIG. 183 and two years later produced a lithograph → FIG. 184 that was widely reproduced in the art press in subsequent years.[56] A version of the painting was exhibited in Prague at Munch's exhibition of 1905, which included over one hundred and twenty works; Munch even attended the opening.[57] The strong contours and broad fields of color in Munch's paintings proved to be an important model for the artists of the Eight, in particular for Emil Filla, who adapted this manner to his own paintings. → FIG. 185

In Munch's works, bodies are pressed into poses and gestures that seek to express their emotional state. They bring their hands up to their faces or chest in anguish, or they turn their heads downward in sorrow in the aftermath of a tragedy or violence. In Kafka's work, the figures' distended bodily poses and facial features sometimes implicate violence as well; in some cases it is a hostility that Kafka depicts literally, as he does in another pencil drawing. → FIG. 186 At the top of the page, the body of a man, upside down, drops between two figures whose faces are turned forward and distorted, and the falling man strikes the head of the left figure with his foot. At the bottom of the page, a contorted figure lunges to the right and kicks his foot at the more conventionally rendered man standing near him, whose body Kafka fills in with shading. In another drawing, → FIG. 187 a man with longer, curled hair occupies nearly the entirety of the page, and one of his eyes appears bruised and shut close. Kafka accentuates this feature with slashes that run over the top of the eye and directly under it, continuing down until they touch the man's lips, which Kafka darkens into a wedge shape, as if indicating the possibility of further bodily damage. Additionally, the man's face and neck are depicted as hard-edged and angular.

It is possible that this drawing may be one of Kafka's later ones—perhaps one of the handful of pictures that date to after his university studies. Kafka's sharply angular, almost faceted treatment of the figure is unmistakably different from the curvilinear, elongated lines that he used to depict the figures in the majority of his other drawings. It also bears some resemblance to the early cubist works of Bohumil Kubišta, → FIG. 188, 189 the first artist in Prague to directly engage with cubism. Kubišta became aware of cubism when he was living in Paris in 1909, and Kafka, who traveled to Paris with Brod in 1910 and 1911, would have been informed of it as well, although probably from Prague, not Paris.[58] By 1910, not only Kubišta but also Braque was exhibiting cubist works in Prague, which were so widely covered in the local press, with such frequently sensational and punitive criticism, that there was no way for Kafka to lack awareness of them. Cubism in Prague was frequently associated with

[55] Bodo Plachta, "Franz Kafka Reads the Letters of Vincent van Gogh," *Variants. The Journal of the European Society for Textual Scholarship* 2–3 (2004): 173–94. Plachta asserts that Kafka's "first contact with the painter" was in 1917, but Kafka would have been familiar with Van Gogh's work at least a decade prior. As noted earlier, Van Gogh's works were first exhibited in Prague in 1907. They were widely discussed and reproduced in the Czech art press, as well as in art historical literature in Germany, most notably by Julius Meier-Graefe.

[56] See Jay Clarke, *Becoming Edvard Munch: Influence, Anxiety, and Myth* (Chicago: Art Institute of Chicago, 2009), 88–108.

[57] See Jiři Kotalík, *Edvard Munch a české umění* (Prague: National Gallery in Prague, 1982). Munch's *The Scream* is listed under its Czech title, *Výkřik* (cat. 34) in the exhibition catalog, *Katalog XV. výstavy Spolku výtvarných umělců Mánes v Praze, Edvard Munch* (Prague: 1905).

[58] See Nicholas Sawicki, "Between Montparnasse and Prague: Circulating Cubism in Left Bank Paris," in *Foreign Artists and Communities in Modern Paris, 1870–1914: Strangers in Paradise,* ed. Karen Carter and Susan Waller (Farnham: Ashgate, 2015), 67–80. For discussion of Kafka's travels with Brod to Paris, see Marie Rakušanová's contribution to the present volume, and more broadly, Max Brod and Franz Kafka, *Eine Freundschaft*, 2 vols., ed. Malcolm Pasley and Hannelore Rodlauer (Frankfurt am Main: S. Fischer, 1987–1989).

182

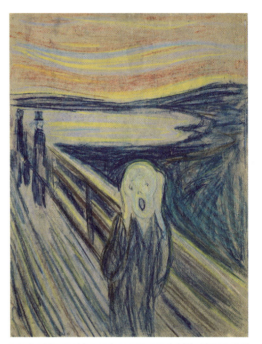

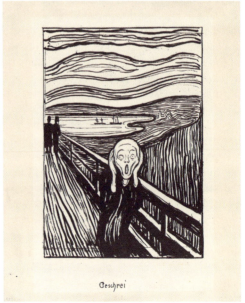

182 Franz Kafka, two figures. Pencil on ruled notebook paper, 16.7×9.6 cm. National Library of Israel, Jerusalem.

183 Edvard Munch, *The Scream*, 1893. Crayon on cardboard, 73.9×55.9 cm. Munchmuseet, Oslo.

184 Edvard Munch, *The Scream*, 1895. Lithograph, 35.5×25.4 cm. Munchmuseet, Oslo.

183
184

185 Emil Filla, *Red Ace*, 1908.
Oil on canvas, 65×75 cm.
National Gallery in
Prague.

FRANZ KAFKA'S DRAWINGS: FORM, FIGURE, CONTEXT

186

186 Franz Kafka, figures
striking each other.
Pencil on ruled
notebook paper,
16.7×9.6 cm.
National Library of
Israel, Jerusalem.

violence, a motif that Kubišta turned to in some of his cubist works, such as the painting *Murder*, → FIG. 190 and that was also manifest in caricatures of cubism.[59] In the journal *Umělecký měsíčník*, the main mouthpiece for cubism in Prague, the Czech caricaturist Zdeněk Kratochvíl, perhaps in reprisal against the critical assaults that cubism faced, depicted cubist artists inflicting physical violence on a lion—the historic emblem of the Kingdom of Bohemia and by the early twentieth century a symbol of Czech national identity—by hammering its body into angular cubist shapes.[60] → FIG. 191A, B

In nearly every one of the drawings where Kafka shifts from curved lines to more sharply angled, geometric forms, some element of physical violence or confrontation enters into the picture. An older man with a faceted head, angry face, and cylinder hat raises his arms into the air, pumping his fists forward with the motions of a boxer. → FIG. 192 In another drawing, a jockey rides his horse in a steeplechase, → FIG. 193 the horse clearing the fence.[61] The rider holds the handle of a horse whip in his hand and raises it over his head to strike the animal and propel it onwards. The instrument looks more like a sickle than a whip, and with his skeletal, angular face, the rider resembles a horseman from the Apocalypse. In Kafka's drawing, the common spectator sport of horse racing, popular in Prague and other major cities, is pictured as something considerably darker and more dynamic than would have been seen in conventional artistic representations of the subject at the time. This is the essential operation that Kafka undertakes in so many of his drawings, and it is also the basis for the work of many other modern artists of his time—taking a familiar, often ordinary aspect of observed reality and transforming it into something that, while still recognizable and legible, is inflected in new and unfamiliar directions, whether violent, comical, or simply different from what we expect to see.

[59] For discussion of Kubišta's painting, which also became the basis for an exhibition poster by the Polish artist Józef Wodyński for an exhibition in Lviv, Ukraine, that included Kubišta's work, see Rakušanová ed., *Degrees of Separation*, 342–45.

[60] Naomi Hume examines this theme in "Violent Humour: Caricatures of Cubism in Prague, 1912–1914," *Umění* 51, no. 2 (2003): 122–26. See also Chrobák and Winter, ed., *V okovech smíchu*.

[61] The drawing was originally reproduced in Brod's 1937 biography of Kafka. On the back of the same sheet of paper are three more images of horses, one with a jockey whose face is somewhat larger, less skeletal. Gandelman, "Kafka as an Expressionist Draftsman," 245, explicitly suggests that the principal drawing on the front "depicts a theme present in many Kafka stories—that of cruelty toward animals and animal silent suffering."

FRANZ KAFKA'S DRAWINGS: FORM, FIGURE, CONTEXT

187

187 Franz Kafka, man with angular face. Pencil on ruled notebook paper, 16.9×10.7 cm. National Library of Israel, Jerusalem.

FRANZ KAFKA'S DRAWINGS: FORM, FIGURE, CONTEXT

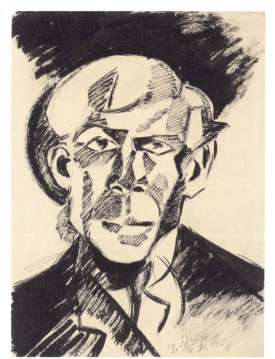

188

188 Bohumil Kubišta, *Self-Portrait*, 1910. India ink and pencil on paper, 31.5×24.5 cm. National Gallery in Prague.

189 Bohumil Kubišta, *Smoker (Self-Portrait)*, 1910. Oil on canvas, 88×94 cm. National Gallery in Prague.

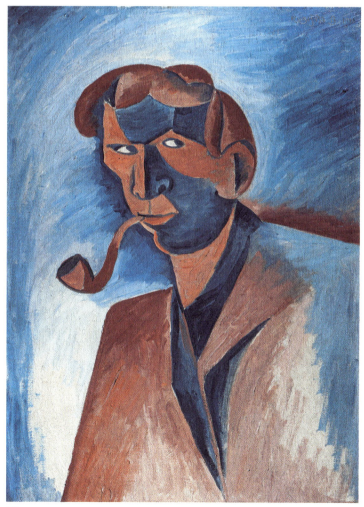

189

161

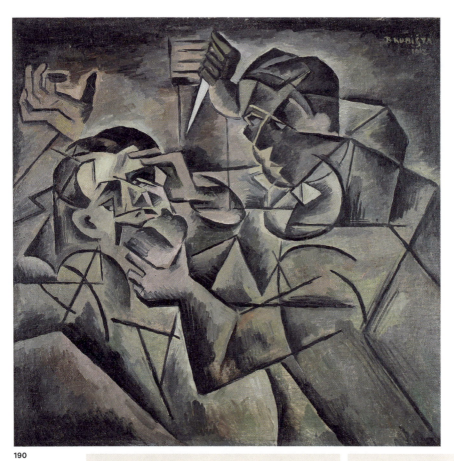

190

190 Bohumil Kubišta, *Murder*, 1912. Oil on canvas, 88×94 cm. Regional Gallery of Fine Arts in Zlín.

191A, B *Umělecký měsíčník*, vol. 2, no. 8, 1912–1913. Illustrations by Zdeněk Kratochvíl, "Funny Corner V: A Lesson in Cubism." Private collection.

191A, B

FRANZ KAFKA'S DRAWINGS: FORM, FIGURE, CONTEXT

192

193

192 Franz Kafka, man in cylinder hat and two figures. With inscriptions by Kafka at top, "subjektiv. Falschheit? / Convertierung / Rodtbircher?" and below, "Strafprozess." Pencil on letter paper, 22.7×14.6 cm. National Library of Israel, Jerusalem.

193 Franz Kafka, horse and rider. Ink and pencil on ruled notebook paper, 16.4×20.2 cm. National Library of Israel, Jerusalem.

Das Pferd wurde vorgeführt. Der
Mann zögerte. Die Frau schlug die
Augen auf [als] Zeichen der Zustimmung.
Von der Landstraße her kam ein
Trupp Reiter. Man begrüßte einander.

FRANZ KAFKA: THE LANGUAGES AND IMAGES OF (PRAGUE'S) PUBLIC SPACE

Marek Nekula

Franz Kafka, born in Prague on July 3, 1883, was buried in the New Jewish Cemetery in the Prague suburb of Olšany on June 11, 1924, eight days after his premature death in Kierling near Vienna. With the passage of time, he has become an emblematic symbol of the city where he was born, studied, lived, and is buried. → FIG. 194 Further elevating Kafka as an emblem of Prague was the famous Liblice conference on his work in 1963. It was there that Eduard Goldstücker voiced the belief that previous—surrealist and existentialist—interpretations of Kafka were "hanging in the air," and that it was necessary to bring them back to earth and to interpret Kafka "from the Prague perspective."[1] This same idea was also underscored by the cover of the German version of the conference proceedings, although it does not show much of a connection to Goldstücker's Marxist interpretation of Kafka at the Liblice conference, or to Kafka himself. → FIG. 195

Marxist theory focused primarily on the social "base" from which Kafka's literary work was said to emerge as part of the cultural "superstructure." When Goldstücker and similarly-minded contemporaries talked of interpreting Kafka "from the Prague perspective," they meant that Jewish authors, coming as they did from Prague's German-speaking petite bourgeoisie, perceived and addressed in their literary works the seismic shocks of modernity and the crisis of bourgeois liberalism sooner and more intensely than others.[2] According to Goldstücker, through his protagonist Karl Rossmann the utopian socialist Kafka called attention to and evoked sympathy for the working class as embodied by the figure of the Stoker, the title character of the first chapter of Kafka's unfinished novel *Amerika* (1927), authored between 1912 and 1914, with the chapter published separately in 1913.[3] This interpretation of Kafka's work also found support in assumptions about Kafka's sympathies for the anarchist movement, a conjecture that relied on the testimony of Michal Mareš and Gustav Janouch, which later turned out to be of doubtful veracity.[4]

In its association of Kafka with Prague, Marxist literary criticism in its own way followed the earlier ideas of Pavel Eisner, → FIG. 196 subsequently developed further by the German scholar Klaus Wagenbach.[5] Eisner identified the specificity of Prague German literature as stemming from its position within an imaginary "triple ghetto": linguistic (national), social, and tribal (religious or

[1] Eduard Goldstücker, "Jak je to s Franzem Kafkou?," *Literární noviny* 12, no. 7 (1963): 4.

[2] Eduard Goldstücker, "Über Franz Kafka aus der Prager Perspektive 1963," in *Franz Kafka aus Prager Sicht 1963*, ed. Eduard Goldstücker, František Kautman, Paul Reimann (Prague: ČSAV, 1965), 32.

[3] Goldstücker, "Über Franz Kafka aus der Prager Perspektive 1963," 37 and 43. See also Eduard Goldstücker, "Kafkas 'Der Heizer.' Versuch einer Interpretation," *Germanistica Pragensia* 2 (1964): 49–64; and Eduard Goldstücker, "Doslov," in Franz Kafka, *Zámek*, trans. Vladimír Kafka (Prague: Mladá fronta, 1964), 306–13.

[4] For more details, see Josef Čermák, *Franz Kafka: výmysly a mystifikace* (Prague: Gutenberg, 2005), which also appears in French translation under the title *Franz Kafka: Fables et mystifications* (Villeneuve: Presses Universitaires du Septentrion, 2010).

[5] Klaus Wagenbach, *Franz Kafka: Biographie seiner Jugend* (Bern: Francke, 1958).

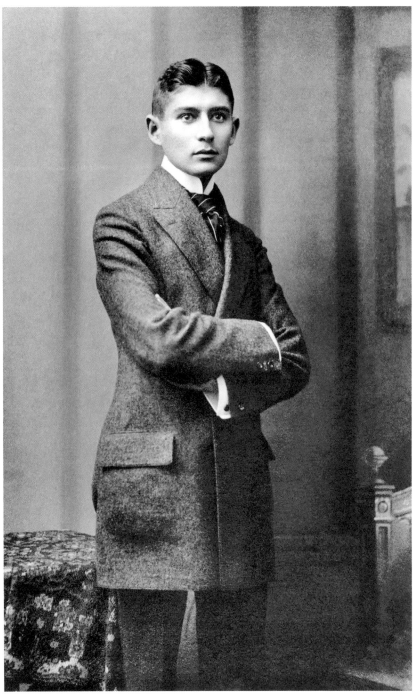

194 Photograph of Franz Kafka from the time of his graduation from Prague University, 1906. Prague City Archives.

195 *Franz Kafka aus Prager Sicht*, edited by Eduard Goldstücker (Prague: Academia, 1966). Private collection.

6 Pavel Eisner, "Německá literatura na půdě Československé republiky: Od r. 1848 do našich dnů," in *Československá vlastivěda*, vol. 7, *Písemnictví* (Prague: Sfinx – B. Janda, 1933), 365; Pavel Eisner, "Židé a Praha v literatuře," *Židovský kalendář* 19 (1938–1939): 120.

7 P. E. [Pavel Eisner], "Wie wurde Franz Kafka?," *Prager Presse*, March 19, 1938 (afternoon edition), 8.

racial). This ghetto, in Eisner's view, shaped the "ghetto of the artistic soul," or, alternatively termed, the "cerebral ghetto."[6] Eisner expressed this idea of a triple ghetto repeatedly. In his March 1938 review of Max Brod's biography of Kafka, which had been published in Prague in 1937 by the publishing house of Heinrich Mercy Sohn, he formulated it as follows:

> [The Prague Jew] was separated from the German nation by geographic distance, for Prague itself was never home to a German "nation," and … from the Czech nation by language and national orientation. … But it [this isolation in the ghetto] was fully determined by the *social* ghetto in the most immediate sense of the word. The Prague Jew was, to his misfortune, a member of the supposed higher classes. … In a diaspora more natural than the Prague one, a Jew could compensate for this social "elevation" that accompanied, nay, persecuted him like a shadow by means of a superior "common denominator" of language, ethnic affiliation, nationality, nation. In Prague, considering the people who immediately surrounded him, he could not do so. … The result: a terrible alienation between the Jew and his biological surroundings. … Anywhere else, the Jew was surrounded by a "nation" and a lived reality, in other words a solution … and a redemption; in Prague, all that surrounded him was a fiction, if he was foolish, or the metaphysical horror of a vacuum, if he was capable of understanding it. All this, of course, is no "explanation" for the incredible phenomenon of Franz Kafka. Yet perhaps it clarifies him a little by localizing him.[7]

What the close reading of Kafka's literary texts tends to reveal, however, is that a simplistic external "localization" of his writings is not possible. Eisner addresses this discrepancy with the argument that Kafka's works are connected "atmospherically" with Prague, which he understood as defined by the isolation of the ghetto.[8] Other scholars view the (internal) "localization" of Kafka's works as residing within the social base (Goldstücker); in the situation of a "minor literature" (Gilles Deleuze and Félix Guattari); in the intermediary position of Prague's Jewish community between two linguistic and national worlds (Scott Spector); or in Kafka's own intercultural context (Steffen Höhne and Manfred Weinberg).[9]

Yet what really is Kafka's Prague? A product of illustrated publications or essayistic discourse in the fields of literature and literary history?[10] A metaphor for the staid life of the middle classes, as formulated by Josef Čermák with reference to two of Kafka's letters to Felice Bauer, one from March 3, 1915 and the other probably from March 1916?[11] Or a public realm shaped equally by literary texts and personal writings, including those by Kafka himself, relating directly or indirectly to Prague; by real-world practice, as represented by maps of Kafka's Prague; → FIG. 197A, B and by the various inscriptions, memorial plaques, or monuments in Prague's urban fabric? On the occasion of an exhibition dedicated to Kafka's reception of the fine arts and contemporary visuality, I intend on the following pages to focus on Prague's urban space, architecture, and monuments, and on the meanings and functions that Kafka saw in them, explicitly rejected, or significantly ignored in his literary texts and personal writings, including his diaries and letters.

[8] Pavel Eisner, "Franz Kafka a Praha," *Kritický měsíčník* 9, no. 3/4 (1948): 66.

[9] Goldstücker, Kautman, Reimann, eds., *Franz Kafka aus Prager Sicht 1963*; Gilles Deleuze and Félix Guattari, *Kafka: Toward a Minor Literature*, trans. Dana Polan (Minneapolis: University of Minnesota Press, 1986); Scott Spector, *Prague Territories: National Conflict and Cultural Innovation in Franz Kafka's Fin de Siècle* (Berkeley: University of California Press, 2000); Steffen Höhne and Manfred Weinberg, eds., *Franz Kafka im interkulturellen Kontext* (Cologne: Böhlau, 2019).

[10] In her study, Veronika Tuckerová draws attention to the importance of Emanuel Frynta both as a guide to Prague for early Kafka scholars and as the author of a literary guide to Prague, published in 1960 by the Artia publishing house under the titles *Kafka lebte in Prag* (trans. Lotte Elsner) and *Kafka and Prague* (trans. Jean Layton), with photographs by Jan Lukas. In it, Frynta created a conservatively nostalgic construction of Kafka's physical Prague, which was later followed by publications by Josef Čermák, Hartmut Binder, and Jiří Gruša. See Veronika Tuckerová, "Prag als Zeitkapsel oder als moderne Stadt? Emanuel Frynta und Marthe Robert wandeln auf Kafkas Spuren," *Brücken: Zeitschrift für Sprach-, Literatur- und Kulturwissenschaft* 30, no. 1 (2023).

[11] Josef Čermák, "Kafka a Praha," in *Češi a Němci: Dějiny – kultura – politika*, ed. Walter Koschmal, Marek Nekula, Joachim Rogall (Prague: Paseka, 2001), 169.

196 Josef Ehm, period photographic portrait of Pavel Eisner. Photograph, 29×24 cm. Moravian Gallery in Brno.

FRANZ KAFKA: THE LANGUAGES AND IMAGES OF (PRAGUE'S) PUBLIC SPACE

197A, B

198

197A, B *Franz Kafka a Praha: Vzpomínky, úvahy, dokumenty*, with contributions by Hugo Siebenschein, Edwin Muir, Emil Utitz, Petr Demetz, and others (Prague: Žikeš, 1947). Private collection.

198 Period postcard of the Riva del Garda harbor with baroque sculpture of John of Nepomuk, with handwritten date "1906." Stengel & Co., Dresden. Private collection.

PUBLIC SPACE IN KAFKA'S LITERARY WORKS

In Kafka's written oeuvre, Prague's urban space is defined in significant detail really only in "Description of a Struggle," his earliest surviving literary work. The first version of the story was written between 1904 and 1907, with a second following between 1909 and 1910.[12] Parts of it were first published in June 1909 in the journal *Hyperion*. In the story, the narrator and a new acquaintance leave a nocturnal establishment to walk up the Laurenziberg (Petřín Hill) in Prague. A mimetic, concretizing reading would place the establishment they are leaving in Perlgasse (Perlová ulice), where such "nocturnal" businesses were then common. Shortly thereafter, the two men reach the Ferdinandstraße (Národní třída). The narrator and his acquaintance, who in the story can be seen as his alter ego, continue along the street to the Moldau (Vltava) and move along Franzensquai (Františkovo nábřeží), from which they observe the trees on the Schützeninsel (Střelecký ostrov) and the reflections in the river of the lamps on the bridge there. They then continue along the river and, passing through the archway at the end of Franzensquai, reach the Karlsbrücke (Charles Bridge). At Kreuzherrenplatz (Křižovnické náměstí), between the eastern bridge tower and the church at the mouth of Karlsgasse (Karlova ulice), the narrator sees the statue of Charles IV rising above him. In the moonlight, the statue seems to start moving, threatening to "umstürzen" (collapse), which it finally does, instead of the drunken narrator. They cross the bridge with its famous row of statues—the text identifies the statue of St. Ludmila, which Kafka writes with Czech orthography as "Ludmila" instead of the German "Ludmilla." The final destination remains the Laurenziberg. Such is the topographic reconstruction that both versions of the text suggest.[13] What, however, are the semantics of this space?

In one of his essays, the author and art historian Josef Kroutvor emphasizes the cold and emptiness of the nighttime city in "Description of a Struggle" and argues that it sets Kafka's tale apart from more traditional, picturesque depictions of Prague.[14] Literary scholar Petr A. Bílek, in turn, points out that the specific toponyms (e.g., Karlsbrücke, Charles Bridge) always contain a suffix designating a more generic definition of place (e.g., -brücke, bridge): hill (-berg), boulevard (-straße), embankment (-quai), island (-insel), tower (-turm), bridge (-brücke), street (-gasse), square (-platz), and church (-kirche). In place of a picture of an actual urban space, what comes to the forefront, Bílek writes, are "standard urban spatial features … producing the image of a city in an autonomous fictional world."[15]

In *The Trial*, written in 1914–1915 and published in 1925, the image of the city is shaped only in these most general terms—river, island, bridge, cathedral, quarry—without connection to any concrete named site. All the same, a considerable body of secondary literature has searched *The Trial* for the actual physical counterparts of these sites, be it St. Vitus Cathedral or the former Strahov quarry.[16] If we wish, we could interpret the book's "silver image of some saint [which] once glimmered into sight immediately before him" as the tombstone of St. John of Nepomuk, although the absence of the proper name and Kafka's use of the indefinite article ("some saint") complicates such a reading.[17] According to Eisner, "there are never any local mentions of Prague," although he also states that "all the same, the mysterious city shines through each page of this work, which could only have been born here, only in this locality have taken seed and grown upward like a tree of pain and otherworldly

12 Marcel Krings, *Franz Kafka: 'Beschreibung eines Kampfes' und 'Betrachtung'* (Heidelberg: Winter, 2018), 8.

13 Franz Kafka, *Beschreibung eines Kampfes und andere Schriften aus dem Nachlaß*, ed. Hans-Gerd Koch (Frankfurt am Main: Fischer Taschenbuch Verlag, 1994), 47–97 (Fassung A), and 98–134 (Fassung B). For a translation, see Franz Kafka, *The Complete Short Stories*, ed. Nahum N. Glatzer (London: Vintage, 2005), 9–51.

14 Josef Kroutvor, "Kafkas Stadt? Prag im Zyklus der toten Städte," in *Kafka und Prag*, ed. Kurt Krolop and Hans Dieter Zimmermann (Berlin: De Gruyter, 1992), 84.

15 Petr A. Bílek, "Reading Prague: Narrative Domains of the Image of the City in Fiction," *Style* 40, no. 3 (Czech Fictional Worlds) (2006): 250.

16 Čermák, "Kafka a Praha," 163.

17 Franz Kafka, *The Trial*, trans. Willa and Edwin Muir (London: Penguin Books, 1977), 243.

199 Franz Kafka, general on horseback. Pencil on paper, 34.2×21.3 cm. National Library of Israel, Jerusalem.

thirst."[18] Kroutvor and others similarly note that the representation of the city in *The Trial* is suffused with the atmosphere of Prague. In the city where Kafka sets his story, Kroutvor sees Prague's "inner labyrinth," in which the mythology of the "dead city" comes to life.[19]

Returning to the fragmentary "Description of a Struggle," its second version also has references to "the Ringplatz by the Town Hall, the Virgin's pillar, the church," as well as a reference to Wenceslas Square. As such, the text clearly makes direct reference to Prague, although it is a literary reference as well, and here the city of stonework comes to life: "the spire of the Town Hall is moving in little circles," while "the Virgin Mary's cloak is coiling around her pillar and the wind is tugging at it," threatening to pull the statue down to the ground.[20]

Considering the presence of such explicit references to specific Prague locations, it might be worthwhile to ask which places and monuments are, by contrast, omitted from the text, and what common features they may share. On Ferdinandstraße (Národní třída), for example, the narrator in "Description of a Struggle" could have mentioned the monument to the Czech linguist and nationalist Josef Jungmann (pedestal 1873, statue 1878) or the National Theatre (1881, reopened in 1883 after a fire), although he does not. Similarly not registered are the monument to Emperor Francis I (1850) hidden in the darkness along the embankment, the St. Nicholas church past Charles Bridge, and on Lesser Town Square below it the pro-Austrian monument to Marshall Radetzky (erected 1858, removed 1919). When the narrator and his alter ego cast their eyes across the river, there is also no mention of the viewing tower atop the Laurenziberg, constructed for the 1891 Jubilee Exposition as a modern self-representation of the Czech nation. Nor is there mention of the dark shadow of the "Emperor's castle," as Kafka describes it in the spirit of the "German" imagination of Prague in a letter from September 19, 1917, written in Czech to Růžena Hejná (Wettenglová).[21]

Examining this list more carefully, it is evident that Kafka's urban space in "Description of a Struggle" is empty of both people and specific spatial semantics, and that the topographic points he omits from openly naming are the monuments and buildings that in Prague's public space represented concrete nodes in the polarized Czech-German conflicts and discourses of the time. In this manner, "Description of a Struggle" can be regarded as a sophisticated literary response to the Czech-German national conflict. The national "struggle" of the public sphere is of course present in a more generalized form in the story itself: while the figure of the Virgin Mary seems in danger of collapsing under the wind but continues to stand, that of Charles IV has already fallen. Statues and monuments in Prague in reality did collapse. When an independent Czechoslovakia was founded in 1918, the physical space of Prague saw the spontaneous demolition of the Marian Column (the "Virgin's pillar" of Kafka's story) on Old Town Square, whereas the monument to Marshal Radetzky and the figure of Francis I were covered and quietly removed by the authorities, so as not to become the targets of similar attacks. With respect to the history of the 1940s and 1950s, Kurt Krolop and other literary scholars have repeatedly treated Kafka as a prophet of totalitarianism.[22] However, to see and reflect on the latent but potent national conflicts in Prague required no special prophetic gifts—only an ability to capture them with a distinct literary language and give them a universal dimension.

18 Eisner, "Německá literatura," 365.

19 Kroutvor, "Kafkas Stadt?" 84.

20 Franz Kafka, *The Complete Short Stories*, 35–36 and 40.

21 Franz Kafka, *Briefe 1914–1917*, ed. Hans-Gerd Koch (Frankfurt am Main: S. Fischer, 2005), 341. See also Marek Nekula, *Franz Kafka and His Prague Contexts: Studies in Language and Literature* (Prague: Karolinum, 2016), 211.

22 Kurt Krolop, "Kafka als Prophet?," in *Das Phänomen Franz Kafka. Vorträge des Symposions der Österreichischen Franz Kafka-Gesellschaft*, ed. Wolfgang Kraus and Norbert Winkler (Prague: Vitalis, 1997).

Kafka accomplishes this in his fragment, known as "The Hunter Gracchus," written between December 1916 and April 1917 and set in a town that he identifies as "Riva," located in the south and situated on a lake. Here, Kafka places a monument representing conflicts both past and present directly into the public space:

> Two boys were sitting on the wall of the wharf playing a game with dice. A man was reading a newspaper on the steps of a monument in the shadow of the sword-waving hero. A girl at the fountain was filling a tub with water. A fruit seller was sprawled beside his wares, looking out at the lake. ... An old man in a top hat with a mourning ribbon came down one of the narrow, steep little alleyways descending to the harbor. He looked around attentively, everything troubled him, the sight of garbage in a corner made him grimace, fruit peelings were scattered on the steps of the monument; as he went past, he pushed them aside with his cane.[23]

Several interpretations of this text, composed of fragments and assembled into a story by Max Brod, place it in Riva del Garda, the small, then Austrian, today Italian lake port which Kafka visited in 1909 and 1913. However, the actual monument in Riva del Garda was and is not a warrior with a sword, as presented in Kafka's text, but the baroque figure of St. John of Nepomuk. → **FIG. 198** If we read the text mimetically, the cross carried by this saint (in other representations, Nepomuk carries a palm frond, a symbol of martyrdom and spiritual victory, whose shape resembles a sword), is translated by Kafka (or by the newspaper on which its shadow falls) into the secular language of national struggle as a sword. In this way, Kafka links the tense atmosphere in Riva with Prague. Here, St. John of Nepomuk is of doubtful holiness, with his cross in the service of secular power. In Czech historical interpretations, Nepomuk, as a patron saint of Bohemia who was extensively misused by the propaganda of the Counter-Reformation, symbolized the violent re-Catholicization of Protestant Bohemia after its defeat at the Battle of White Mountain (1620) and the beheading of twenty-seven Bohemian leaders on Old Town Square one year later. Since these events led to the Bohemian state's loss of sovereignty, they formed the genesis of a nationalist narrative of Germanization and national oppression, which was also echoed in Czech-language journalism in Kafka's time.

In view of the fact that "The Hunter Gracchus" is a work of fiction, its localization in the real physical world is not essential to the story. Even so, its gloomy atmosphere cannot help but bring to mind the war raging at the time Kafka was writing it, or the great commanders and ranks of infantrymen who lost their lives for the ideals manifest in the monument, on the steps of which, in Kafka's story, the old man with the black mourning band, likely the relative of one of the fallen, angrily pushes aside fruit peels. For the old man in the story, the ideals celebrated by the monument are far from dead, and the shadow that the monument casts on the newspaper seems itself to come alive, like the statues in "Description of a Struggle"; Kafka's own words are "sword-waving". → **FIG. 199** Yet in the story, the shadow-drama on the thin, fluttering newspaper is stirred to action only by a movement of the hand or a breath of wind. In both the static scenery and the barely perceptible movement in this story, Peter-André Alt recognizes the aesthetics and practice of

[23] Franz Kafka, *Selected Stories*, trans. Stanley Corngold (New York: Norton, 2007), 109–10. See Franz Kafka, "Der Jäger Gracchus," in *Beim Bau der chinesischen Mauer und andere Schriften aus dem Nachlaß*, ed. Hans-Gerd Koch (Frankfurt am Main: Fischer Taschenbuch Verlag, 1994), 40.

the stereoscope. This popular viewing device for photographs, which came into use in the second half of the nineteenth century, produced a three-dimensional, spatial image of photographic panoramas that could, furthermore, be set into apparent motion by the viewer if they blinked one of their eyes. Alt also draws attention to the 1913 study *Perception and Concept*, which was known to Kafka. In this text, Max Brod and Felix Weltsch discuss "dissolved memory images" using the example of their own reminiscences from Riva.[24] In any event, the shadow of the statue falls on the newsprint and there encounters the ink of words on the page, presumably replete with the ideals celebrated by the monument and sanctified by the blood of the recently fallen.

These strategies of de-concretization, of rendering a generalized representation of what is otherwise a specific public site, are also found in Kafka's novel *The Castle*, written in 1922 and published posthumously in 1926. During revisions to the manuscript, Kafka changed the point of view in the first three chapters, originally written in the first person, to the third person, thus weakening the link between the narrator and the author or authorial subject. This was not Kafka's sole alteration. He also changed the phrase "glancing ... at the gravestones sunk in the ground" to "glancing ... at the crosses sunk in the ground".[25] Hence, the "old graveyard ... surrounded by a high wall" in the story—which in the first version recalls the Old Jewish Cemetery in the center of Prague—is severed from the original association. Here too, we find a shift away from the specific space of Prague to a more generalized space, which Kafka further modulates in *The Castle* through a deliberate confusion of public

24 Peter-André Alt, *Kafka und der Film: Über kinematographisches Erzählen* (Munich: C. H. Beck, 2009), 149ff.

25 Franz Kafka, *The Castle*, trans. Anthea Bell (Oxford: Oxford University Press, 2009), 29. The change can be identified in Franz Kafka, *Das Schloß, Apparatband*, ed. Malcolm Pasley, third edition (Frankfurt am Main: S. Fischer, 1983), 164.

200

200 Photographic reproduction of a 1904 drawing of the Svatopluk Čech Bridge by Jan Koula. H. Eckert, Prague, 1909. Prague City Archives.

and private space. Notably, while in the other previously mentioned literary works by Kafka, the symbolism invoked is one of nationality, the dimension that is obscured in this example is the Jewish dimension of the public space in Prague, and in Central Europe more generally.

Indeed, an analogous de-concretization is manifest in the backdrop of the city as it appears at the end of the story "The Judgment," which Kafka wrote on the night of September 22–23, 1912, and published in 1913. The window from which Georg Bendemann looks at the hill beyond the river in the fictional world of the story is matched by Klaus Wagenbach, in contradiction to Kafka's words,[26] to a real window on the uppermost floor of the apartment block "Zum Schiff" (K lodi).[27] This building, which has since been torn down, stood in Kafka's time at no. 36 Niklasstraße (Mikulášská třída), the address to which the Kafka family moved in June 1907. The bridge from which Georg Bendemann ultimately jumps after an argument with his father is identified by Wagenbach in his guidebook to Kafka's Prague as the Svatopluk Čech Bridge, which opened in 1908. → FIG. 200 In a letter to Hedwig Weiler from late October 1907, Kafka described the street where he lived, which leads up to the bridge, as "Suicide Lane."[28] In the story, however, Kafka does not depict the bridge's striking statues of the Goddess of Victory. The "traffic going over the bridge,"[29] in which the individual is destroyed both physically and metaphorically, shows that Kafka in his writings invokes a universal modern, urban space rather than Prague specifically, as Andrew J. Webber has noted with respect to Kafka's unspecific mentions of "the law courts and the cathedral" in *The Trial*, "the railway station and the hospital" in *The Metamorphosis*, and "the grand hotel and the high-rise block" in *Amerika*.[30]

Conflict, national or otherwise, is revealed in Kafka's work with reference to the modern city and its depopulated, dehumanized public spaces as an arena for this struggle, which Kafka accentuates in the way that he shifts from a specific to a generalized public space and how he changes a specific

26 Franz Kafka, *The Diaries*, trans. Ross Benjamin (New York: Schocken, 2022), 232.

27 Klaus Wagenbach, *Kafkas Prag: Ein Reisebuch* (Berlin: Verlag Klaus Wagenbach, 1993), 42–44 and 96.

28 Franz Kafka, *Letters to Friends, Family, and Editors*, trans. Richard and Clara Winston (New York: Schocken, 1977), 59.

29 Kafka, *Selected Stories*, 12.

30 Andrew J. Webber, "The City," in *Franz Kafka in Context*, ed. Carolin Duttlinger (Cambridge: Cambridge University Press, 2018), 233.

201 Period photograph of Josef Zítek and Josef Schulz's National Theatre, Prague, 1868–1883.

public place into an unspecific one. Sailing into New York in the first chapter of *Amerika*, Karl Rossmann catches a glimpse of the distant figure of a statue "in a sudden burst of sunlight." The statue appears here not with the torch characteristic of the Statue of Liberty, but is described as a "statue of the Goddess of Liberty" carrying a sword.[31] This motif of the figure with a sword also appears in *The Trial* in the form of Titorelli's "Justice and the goddess of Victory in one."[32] In Kafka's short story "The City Coat of Arms," written 1920, the coat of arms of the city, whose citizens work together to build the Tower of Babel "that will reach to heaven,"[33] is itself a distant recollection of the coat of arms of the city of Prague. In Kafka's story, the coat of arms is a "gigantic fist," a reference to the "prophesied day when the city [Babel] would be destroyed by five successive blows."[34] The coat of arms in the story differs from the emblem of Prague in that it lacks the sword that the city's Old Town received from Emperor Ferdinand III for heroically holding out against the Swedes in 1648. What both settings share in common is the violence of struggles and disputes, indeed the bloody conflict of their inhabitants.[35] As before, what is general becomes concrete, and what is concrete in turn becomes generalized.

PUBLIC SPACE IN KAFKA'S PERSONAL WRITINGS

In Kafka's diaries and correspondence, public space assumes a different character than in his literary fiction. Kafka's personal writings make explicit reference to actual buildings and monuments; he is aware of their significance and semantics, although these are obscured by the automatism of everyday life. Prague is for Kafka a space that he knows intimately and to which he to some extent also lays ownership. In a Czech postscript to an otherwise German-language letter, sent from Berlin to his sister Ottla in Prague in December 1923 and also addressed to his brother-in-law Josef David, Kafka writes:

> Pepa [Josef], please don't be annoyed at so much work; after all, Hakoah has lost to Slavia again. Give my regards to your parents and sisters. And Ottla, please explain to the parents that now I can write only once or twice a week; the stamps are already as expensive as at home. But I am enclosing Czech stamps for you two, so that I will also be supporting you a little.[36]

The phrase "at home" applies to Czechoslovakia and more specifically to Prague, the focal point of nearly the entirety of Kafka's life despite his move to the Berlin suburb of Steglitz in September 1923, shortly after meeting Dora Diamant (Dymant).

Kafka's friend Friedrich Thieberger believed that Kafka in fact saw his own world in Prague as small and cramped:

> Once, when we were looking out of the window [of the modern apartment of Kafka's parents in the Oppelt House] towards Old Town Square, he pointed at the buildings and said: "That was my Gymnasium, there in the building opposite is my university, and a bit further to the left is my office. My entire life," he said, his finger making several small circles in the air, "is enclosed in that small circle.[37]

31 Kafka, *Selected Stories*, 13. However, Stanley Corngold blurred this difference by translating "Statue der Freiheitsgöttin" (statue of the Goddess of Liberty) as "Statue of Liberty."

32 Kafka, *The Trial*, 162.

33 Kafka, *The Complete Short Stories*, 433.

34 Ibid., 434.

35 Ibid., 433.

36 Franz Kafka, *Letters to Ottla and the Family*, trans. Richard and Clara Winston (New York: Schocken, 1982), 140. Hakoah and Slavia were two Prague soccer clubs. Hakoah Prague was the local Jewish sports organization, and Slavia was Josef David's favorite club..

37 Hans-Gerd Koch, ed., *"Als Kafka mir entgegenkam": Erinnerungen an Franz Kafka*, revised edition (Berlin: Verlag Klaus Wagenbach, 2005), 133.

According to Dora Diamant, who is cited by Thieberger, this constricted world is invoked in Kafka's now-lost story "about the life of a snake in captivity" that "endlessly meandered along the rim of the tank in which it was enclosed but never found its way over the edge."[38]

Nevertheless, if we look thoroughly through Kafka's diaries and letters, we begin to notice that the public space in which he moved was not as cramped or confined as it would seem from the secondary literature. We can trace his steps across a wide range of venues, from lecture halls to cinemas and theaters.[39] Kafka frequented the New German Theatre and also visited the Czech National Theatre with its patriotic frescos by František Ženíšek and Mikoláš Aleš. He was at the latter, for instance, on October 16, 1911, when he attended a performance of Vojnović's *Dubrovnik Trilogy*; on December 17, 1911, for the premiere of Jaroslav Vrchlický's *Hippodamie;* and on January 21, 1922, for a staging of Beethoven's *Fidelio*.[40] → FIG. 201 Explorations of Prague's open public space were also a part of Kafka's routine, and he took regular strolls on Kampa Island, around Hradschin Castle (Hradčany), the parks of the Laurenziberg, and Letná. His walks took him to Nusle and up the hill to Vyšehrad, to Žižkov, where Kafka's family owned an asbestos factory, and to Troja and more distant outskirts of the city. Similarly, his travels for business, leisure, or curative rest routinely exposed him to other public spaces in Bohemia, Habsburg Austria, later in independent Czechoslovakia, and in other countries as well.

There is no doubt that Prague at times did appear to Kafka an inescapable prison, as he suggested in a famous passage from his letter to his former classmate Oskar Pollak, dated December 20, 1902: "Prague doesn't let go. Either of us. This old crone has claws. One has to yield, or else. We would have to set fire to it on two sides, at the Vyšehrad and at the Hradschin; then it would be possible for us to get away."[41]

There was in fact a quite personal history to this passage. Kafka, along with his classmate Paul Kisch, who was the elder brother of Egon Erwin Kisch, had planned to study German literature at the university in Munich, where another schoolmate, Emil Utitz, was already enrolled; he even arranged to receive a passport for the trip. Yet Kafka remained in Prague, and ultimately he never went to study in Munich.

But let us take a closer look at the Prague topography as described in Kafka's letter to Pollak. If we see Hradschin or the "Emperor's castle" as a symbol of Habsburg or German power and Vyšehrad with its Czech national cemetery as the core of the Czecho-Slavic imagination of Prague and Bohemia, then Kafka's comment has a more general social dimension which imagines the city as stretched between a German and a Czech stronghold. Kafka could not have been unaware of the nationalistic "struggle" in the city, or more precisely the "Babylonization" of Prague and Bohemia through the nationalized designation of public institutions as well as urban public space. One indication of this were the formerly bilingual but since 1894 Czech-only markings and signage of public areas in Prague. Kafka refers to the myth of Babel (which, as has already been noted, later played a role in his 1920 story "The City Coat of Arms") in the travel diary he kept on his trip to Paris with Max Brod in 1910–1911, where he tersely summarizes Brod's view of the "struggle" over public place-markings in Switzerland as a confusion of languages: "Max: Confusion of languages as solution to national difficulties. The chauvinist loses his bearings."[42]

[38] Ibid., 134.

[39] On the cinema as public space, see Ines Koeltzsch, *Geteilte Kulturen: Eine Geschichte der tschechisch-jüdisch-deutschen Beziehungen in Prag (1918–1938)* (Munich: Oldenbourg Wissenschaftsverlag, 2012). On the content relevant to Kafka, see Hans Zischler, *Kafka Goes to the Movies*, trans. Susan Gillespie (Chicago: University of Chicago Press, 2003).

[40] Kafka, *The Diaries*, 47, 153, and 471.

[41] Kafka, *Letters to Friends, Family, and Editors*, 25.

[42] Kafka, *The Diaries*, 507. Kafka's German wording "Verwirrung der Sprachen" is close to Genesis 11:9.

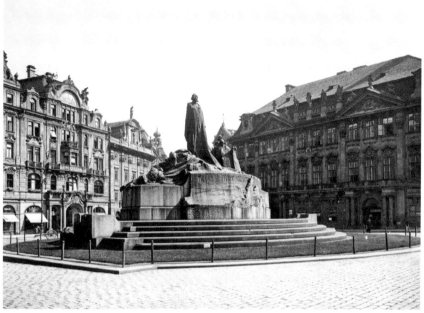

202A Ladislav Šaloun, monument to Jan Hus, Old Town Square, Prague, 1915. Photograph by Tomáš Vojta, ca. 1920. Prague City Archives.

202B Soldiers pledging an oath on November 8, 1918, the anniversary of the Battle of White Mountain. The Marian Column has already been pulled down. Prague City Archives.

As intimated above, however, public space is determined semantically not only by the language or languages spoken and visualized in it, but also by its buildings and monuments. And while public space in Kafka's literary imaginings is emptied both of people and significance, at the same historical moment Czech national activists were filling that space with ever more monuments that embodied national ideals, in turn forming the backdrop to nationalist speeches and assemblies and territorializing the Czech language and nation within the public space of Prague.

The year 1912 saw the erection of a massive secessionist monument to František Palacký on the Vltava embankment. Its creator, the Czech sculptor Stanislav Sucharda, used the inscriptions and the allegorical figures surrounding the seated figure of the historian and statesman to stage a mythical narrative of the death and victorious resurrection of the Czech nation. Moreover, with the sculpture's position directly facing Palacký Bridge, Sucharda drew a spatial and thematic connection with the bridge's four sculptural compositions by Josef Václav Myslbek. Dating from the 1890s, these earlier scenes from Czech, or more generally Slavic, myth also invoked the motif of national rebirth and renewal (after 1945, the statues were moved to Vyšehrad). In 1915, three years after the Palacký monument was erected, a monument to commemorate the medieval theologian Jan Hus, burned at the stake in Konstanz, was unveiled on Old Town Square. Designed in a similarly secessionist style by Ladislav Šaloun, its inscriptions and allegorical figures matched the nationalist interpretation of the Czech Reformation, making the monument an important site for national self-assertion and later, after the declaration of Czechoslovak independence, for swearing oaths of loyalty to the nation. → FIG. 202 A, B

Also suffusing Prague's public space with national references were such events as state funerals, assemblies, demonstrations, and athletic festivals, and Kafka mentions these in his personal writings. For example, in his diary entry from June 5, 1922, he writes about the funeral → FIG. 203 of the previously mentioned sculptor Myslbek.[43] This exceptionally prolific artist did much to shape the cityscape of Prague which Kafka reflects in his texts. According to a report in the June 6 edition of the *Národní listy* newspaper, Myslbek's funeral procession was organized by the Spolek výtvarných umělců Mánes (Mánes Association of Fine Artists). During the funeral ceremony in the council chamber of the Old Town Hall, speeches from politicians, architects, and artists emphasized the prevalence of Myslbek's work in the city:

> [It] stands either in the open air, before the eyes of all, throughout the city of Prague, on bridges, on squares, in gardens, in cemeteries, on building facades; or in interiors where the public may enter, in important locations of culture, in the foyer of the National Theatre, in the Cathedral of St. Vitus, in the pantheon of the National Museum, in galleries of art.[44]

In short, Myslbek's oeuvre had become an inseparable part of the public space of Prague. Particularly praised were his compositions of the legendary heroes Záboj and Slavoj, symbols of "national strength, resistance, and victory," and the prophet Princess Libuše, depicted alongside Přemysl the ploughman and installed on the Palacký Bridge as the embodiment of "faith in a glorious future." → FIG. 204 Nor did the funeral orators ignore Myslbek's even more prominent equestrian statue of St. Wenceslas, unveiled in front

43 Ibid., 448 (entry from June 5, 1922).

44 *Národní listy*, June 6, 1922, 2.

FRANZ KAFKA: THE LANGUAGES AND IMAGES OF (PRAGUE'S) PUBLIC SPACE

203 Franz Kafka, horse and wagon, November/December 1916. Pencil on paper, 16.5×9.9cm. The Bodleian Libraries, University of Oxford.

204

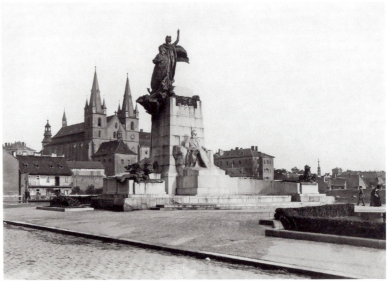

205

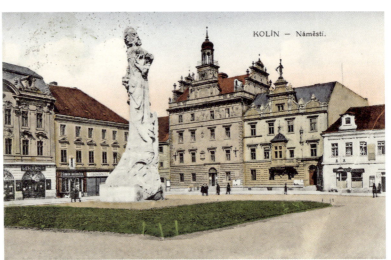

206

204 Josef Ehm, photograph of Josef Václav Myslbek's sculpture *Záboj and Slavoj* for the Palacký Bridge, Prague, 1891. Private collection.

205 Stanislav Sucharda, monument to František Palacký, Prague, 1912. Photograph by František Fink, ca. 1915. Prague City Archives.

206 Period postcard showing Hus Square in Kolín with František Bílek's monument to Jan Hus, 1914, with the inscription "A tree struck by lightning that burned for ages." Kolín Regional Museum.

of the National Museum in 1912—the same year as Sucharda's monument to František Palacký—as a symbol of "faith in the invincible and protecting power of the nation's spirit." Another statement made in the eulogizing of Myslbek was that "even for later ages, the entirety of his work will be an open book" in which future generations can read the history of the Czech nation. Myslbek's casket was conveyed down the Ferdinandstraße (Národní třída) directly past the National Theatre and the Palacký monument, and ceremoniously brought up to the national cemetery in Vyšehrad, where it was finally laid to rest to the music of the Czech national anthem.

The nationally significant places, buildings, and monuments along this route were well known to Kafka. Indeed, not long afterward, Kafka mentioned the Šaloun and Sucharda monuments → FIG. 205 in a letter to Max Brod:

> It is a wanton and senseless impoverishment of Prague and Bohemia that mediocre stuff like Šaloun's Hus or wretched stuff like Sucharda's Palacký are erected with all honors, while on the other hand sketches of Bílek's for a Žižka or Komenský monument, sketches of incomparable quality, remain unexecuted. If it were possible to rectify this disgrace, that would be doing a great deal, and a government organ would be the right place to begin.[45]

As this passage shows, Kafka did not reject Czech art in Prague's public spaces outright. Instead, he expresses his predilection for the oeuvre of František Bílek, who nevertheless depicted the heroes of the Czech Reformation, whose legacy in Kafka's time played a central role in efforts at defining Czech history and national identity. Like many other German-language authors in Prague, Kafka had a good knowledge of the Czech Reformation, having evidently read the historian Jaroslav Goll's 1916 book *Chelčický and the Unity of Brethren in the Fifteenth Century*.[46] Kafka's rejection of Sucharda and Šaloun's sculptural work thus had more to do with their style, which failed to meet Kafka's expectations, i.e., that art should primarily follow aesthetic, rather than national, goals.

While Kafka rejected these instances of overly nationalist art, he appreciated Bílek's intimate work and even followed it closely in the press (*Tribuna*), at exhibition spaces (the House of Artists), and in urban public spaces, both in Prague and nearby Kolín. → FIG. 206 We can infer as much from his letter to Brod on August 7, 1922:

> In saying this I keep thinking of the *Huss* [Hus monument] at Kolín (not so much the statue in the Modern Gallery and the monument [*Sorrow* from 1909, marking the grave of Václav Beneš Třebízský] in Vyšehrad Cemetery and still less the mass of relatively inaccessible small pieces in wood and graphic which used to be shown and are growing dim in my memory). At Kolín you come out of the side street and see before you the big square with the small houses bordering it, and in the center the *Huss*. At all times, in snow and in summer, it has a breathtaking, incomprehensible, and thus seemingly arbitrary unity, which is nevertheless imposed anew at every moment by that powerful hand and even takes in the spectator himself. The Weimar Goethe House achieves something of the sort,

[45] Franz Kafka to Max Brod, July 30, 1922, in Kafka, *Letters to Friends, Family, and Editors*, 433. The original German speaks of a "disgrace and wanton and senseless impoverishment" (Schande und mutwillig-sinnlose Verarmung). See Max Brod and Franz Kafka, *Eine Freundschaft: Briefwechsel*, ed. Malcolm Pasley and Hannelore Rodlauer (Frankfurt am Main: S. Fischer, 1989), 395.

[46] Franz Kafka to Ottla Kafka, February 1, 1919, in Kafka, *Letters to Ottla*, 61. See also Jürgen Born, *Kafkas Bibliothek: Ein beschreibendes Verzeichnis* (Frankfurt am Main: S. Fischer, 1990), 9.

[47] The building is depicted in a sketch by Kafka in his earlier travel diaries. See Franz Kafka and Max Brod, *Eine Freundschaft: Reiseaufzeichnungen*, ed. Malcolm Pasley and Hannelore Rodlauer (Frankfurt am Main: S. Fischer, 1987), 243.

perhaps largely through the blessing of time.[47] But it would be rather difficult to campaign for the creator of that, and the door of his house is always closed.

It would be very interesting to find out how the *Huss* monument came to be erected [in 1914]. As far as I can recall from the stories of my deceased cousin, all the municipal authorities were opposed to the monument beforehand, and even more afterward, and probably to this day.[48]

Kafka also mentions how the sculptor Bílek, to the surprise of Prague's residents, is every day "seen by hundreds and thousands as he takes his evening strolls among the ten trees of his dusty villa garden,"[49] and Brod, in a letter from August 8, 1922, discusses the possibility of the two of them paying a visit to Bílek's atelier.[50]

Unlike Brod, who states in the same letter that "he senses the fine arts quite feebly," Kafka had a sufficiently strong grasp of the arts, and references to art and artists are a repeated feature in Kafka's correspondence and diaries, for instance, in his notations from April 7, 1922, where he mentions Alfred Kubin or Moritz von Schwind.[51] This deep understanding of art also holds true for Kafka's perceptions of public space, as reflected by his above-cited letters to Pollak and Brod in which he rejected the preference accorded in Prague's public space to the national over the aesthetic.

Surprisingly, however, Kafka makes no mention of Šaloun's sculpture of Rabbi Loew ben Bezalel for the corner niche of the New Town Hall, completed in 1911–1913, which Šaloun wrote about in the later almanac *Jewish Prague* (1917), a publication that also included a contribution from Kafka himself. Kafka may not have been "a member of the Society for the Preservation of Ancient Monuments" like Josef K. in *The Trial*, but like the protagonist of his book, Kafka had "some knowledge of art [history]," so he would not have been found lacking by those who might have asked him to show them "some of the town's art treasures and monuments."[52] Whether the aforementioned

48 Kafka, *Letters to Friends, Family, and Editors*, 435.
49 Ibid., 437.
50 Brod and Kafka, *Eine Freundschaft: Briefwechsel*, 404.
51 Kafka, *The Diaries*, 487.

207 Franz Kafka, detail of Kafka's drawing of Julie Kafka, from his self-portrait and portrait of his mother (fig. 157). Pencil on paper, 17.5×11.2 cm. National Library of Israel, Jerusalem.

207

omission of Šaloun's sculpture of Rabbi Loew is accidental, or whether Kafka's judgment of Šaloun's Hus also applied to the sculptor's Orientalized rendering of the famous Jewish rabbi and scholar, remains uncertain.

KAFKA'S WORLDS: LINGUISTIC AND OTHERWISE

The "description of a struggle" from Kafka's personal writings discussed above reveals the rising force of Czech nationalist ideology in Prague's public space. Nevertheless, the public space that made up Kafka's world, linguistic or otherwise, was dominated by German. Above all, this was true for Kafka's education in public institutions, starting with the German primary school he attended on the Fleischmarkt (Masný trh) from 1889 and continuing with the Altstädter Gymnasium on Old Town Square where he studied from 1893 onward. According to his fellow pupil Hugo Bergmann, it was already in secondary school that Kafka displayed a desire to become a writer.[53] Even if Kafka, in later correspondence with Ottla, at one point terms himself a "half-German,"[54] German was and remained Kafka's "mother tongue."[55] It was the language he used for his diaries, letters, and literary works. Despite Kafka's psychological fixation on his father, it would appear that his mother was the crucial force in leading him to reading in German and to the traditions of the book. → FIG. 207

The German language also shaped Kafka's world during his studies of law at Prague's German University (starting in 1901). According to the transcript of courses issued upon his graduation, it was here that Kafka also attended classes in art history, philosophy, and literature.[56] In the spring semester of 1902, he took classes on early German literature and Hartmann von Aue (under professor Ferdinand Detter), and even attended a seminar on Gerstenberg's letters regarding the particularities of German literature (under professor August Sauer). In his free time, Kafka was active in the Lese- und Redehalle der deutschen Studenten in Prag (Reading and Lecture Group of German Students in Prague), where he first met Max Brod. Later he also attended meetings of the Brentano Circle.

Kafka's friendship with Brod is documented in their mutual correspondence (1904–1924), their jointly written travel diaries (1911–1913), Brod's great efforts toward the publication of Kafka's writings, his portrait of Kafka in *The Kingdom of Love* (1928), and his biography of Kafka from 1937. Their correspondence, written in German, is a valuable source of information about Kafka's connections to German literature and culture. A mere listing of names is of little use; practically every name is only the tip of a metaphorical iceberg, each worth uncovering in full. In the correspondence, we find references to close friends such as Oskar Baum and Felix Weltsch, alongside other friends and acquaintances who were also active in literary writing: Rudolf Fuchs, whom Kafka knew from the Café Arco; Willy Haas, who published both Kafka and Brod in his journal *Herder-Blätter*; Egon Erwin Kisch, whose older brother Paul had been in Kafka's class in secondary school; the translator Otto Pick; and the poet and author Franz Werfel. Even Ernst Weiß, who dissuaded Kafka from marrying Felice, appears in the letters. Taken as a whole, the correspondence offers a glimpse into the world of German literature, which was also enriched by German translations of classical, French, and Russian authors. This world is brought into further focus in Kafka's diaries, where he takes stock of public lectures or theater performances in German that he attended.

52 Kafka, *The Trial*, 218–20.

53 Koch, *Als Kafka mir entgegenkam*, 25.

54 Franz Kafka to Ottla Kafka, February 20, 1919, in Kafka, *Letters to Ottla and Family*, 64.

55 Franz Kafka to Milena Jesenská, May 18, 1920, in Franz Kafka, *Letters to Milena*, trans. Phillip Boehm (New York: Schocken, 1990), 14.

56 Reprinted in Nekula, *Franz Kafka and His Prague Contexts*, 153ff.

208 *Die Aktion*, vol. 6, no. 18/19, 1916, special issue titled "Böhmen." Library of the Museum of Czech Literature, Prague.

German also shaped Kafka's professional working life in public institutions. Upon completing his studies, Kafka briefly interned, among other places, at the Regional and Criminal Court and at a law office on Old Town Square. In 1907, he started employment at the Prague branch of the Assicurazioni Generali insurance company, and one year later he began working at the Workers' Accident Insurance Institute, where from his initial role as a trainee he gradually moved up to case officer, chief secretary of operations, and eventually senior secretary of the entire Institute. In these capacities, Kafka traveled for work to northern Bohemia, mostly to the then majority German region of Reichenberg (Liberec). He also wrote and co-wrote countless official documents in German: letters, annual reports, studies, and articles which have been published in full by Klaus Hermsdorf (1984) and by Hermsdorf and Benno Wagner (2004).

Kafka remained at the Institute after 1918, when this public institution responded to the change in state language by making Czech its official language. Unlike those officials who only knew German and therefore had to leave the Institute, Kafka—loyal to his employer and bilingual—was elevated in the institutional hierarchy. Despite his health problems with the onset of tuberculosis in 1917, which led to several curative stays in Schelesen (Želízy), Tatranské Matliary, and Meran, Kafka remained at the Institute for about a year and a half between the founding of independent Czechoslovakia and his retirement due to medical reasons on July 1, 1922. His correspondence with the new post-1918 directors, Jindřich Valenta and Bedřich Odstrčil, was maintained in Czech.

Kafka's ability to function in a Czech milieu despite his entirely German-language education can be attributed to several factors. First was his childhood in a bilingual setting. His parents Hermann Kafka and Julie Kafka, née Löwy, both spoke Czech as well as German, and they hired Czech-speaking staff in both their business and household, with whom they spoke and wrote in Czech.[57] With the birth of Kafka's sisters, the choice of their governesses was directly shaped by the need to support a broad linguistic knowledge for the children: one was German (Elvire Sterk), another was Czech (Anna Pouzarová), and yet another was French (Louise Bailly). Kafka's parents nevertheless had a preference for German in their own reading,[58] writing, and speaking. In one German-language letter from April 5, 1919, Julie Kafka asked her daughter Ottla to remind her fiancé that long conversations in Czech were too exhausting for her and her husband:

> Both your father and I have a great liking for him: if only he could speak a bit in German, yet he never says a single word in it, and though we both speak Czech quite well, it is for us an effort if we are forced to speak Czech for an entire evening. Maybe you could remind him of it.[59]

Another reason for Kafka's good knowledge of Czech is that he had taken it as an elective subject at public school, studying it for nearly ten years in total: in the third and fourth grade of primary school and during his entire time at Gymnasium (except for one semester, when he replaced it with a course in stenography). These courses also introduced Kafka to Czech literature of the nineteenth century, thanks mainly to his teacher Václav Rosický, with whom he remained in contact even after graduation.[60]

[57] See Kafka's message to Marie Wernerová in the letter to his sister Elli (Hermann), written between January 16 and 19, 1924. Reprinted in Nekula, *Franz Kafka and His Prague Contexts*, 56.

[58] As documented with respect to their frequent reading of the newspapers *Bohemia* and *Prager Tagblatt*.

[59] See Hartmut Binder, "Kafkas Briefscherze," *Jahrbuch der deutschen Schillergesellschaft* 13 (1969): 537.

[60] Kafka, *Letters to Friends, Family, and Editors*, 144.

Other ways in which Kafka encountered Czech literature included the translations from Czech to German undertaken by many of his friends and associates, which increased in frequency during the First World War. Otto Pick, for example, gave Kafka a copy of his *Recent Czech Poetry*, compiled in 1916 for a special issue of Franz Pfemfert's Berlin journal *Die Aktion*. → **FIG. 208** According to Hartmut Binder, Kafka assisted in compiling the volume by aiding Rudolf Fuchs with his translations.[61] The most significant figure among these intermediaries between the German and Czech languages, however, was Max Brod. In his correspondence with Kafka, it is clear that Brod was a leading source of information for Kafka on Czech literature and culture. In a letter from October 6, 1917, for instance, Kafka remarked upon Brod's translation of the libretto for Janáček's opera *Jenůfa*. Brod's efforts to promote Jaroslav Hašek, meanwhile, do not appear to have left any traces in their mutual correspondence.

Another important element in Kafka's contact with Czech literature involved the translation of his own writings into Czech. Of those who translated his work during his lifetime, a primary figure was Milena Polláková, who published under her maiden name Jesenská. After a few introductory letters in German, Kafka's correspondence with the woman who would become his lover continued in an alternating fashion, with Kafka writing in German and Jesenská in Czech. He also used Czech in his comments on Jesenská's translations of "The Stoker" and "The Merchant," which appeared in print in 1920 in the Czech literary journal *Kmen*.[62] → **FIG. 209** Because of Jesenská's translations and her own contributions to journals such as *Kmen*, *Cesta*, and *Tribuna*, for a time Kafka regularly read the Czech left-wing press, among other things mentioning that he read an article by Vladislav Vančura in *Kmen*.[63] The relationship between Kafka and Jesenská was hardly one-sided, and Kafka was on occasion able to send Jesenská references to new Czech literature as well. In November 1920, for example, he sent her a copy of Karel Čapek's *The Bandit* (1920).[64] Kafka also read the Czech press independently from Jesenská.[65]

Similarly, Kafka's Jewish world had its own specific linguistic anchoring, even if it was at the time consigned to the very margins of public space. Kafka was steeped in Jewish traditions in his family, at his synagogue, and by the separate Jewish religious instruction he received at school. In Kafka's "Letter to My Father," written in Želízy around November 10, 1919, he in fact showed anger at his father's inability to convey sufficient knowledge in that regard, lamenting the "insignificant scrap of Judaism" that his father had passed on to him:[66]

> You really had brought some traces of Judaism with you from the ghetto-like village community; it was not much and it dwindled still more in the city and during your military service, but still, the impressions and memories of your youth did just about suffice for some sort of Jewish life … but it was still too little to be handed on to the child, it all dribbled away while you were passing it on.[67]

The passage makes indirect reference to the southern Bohemian village of Osek, → **FIG. 210** where Hermann Kafka was born and grew up on the one "Jewish street," separated from the rest of the village, and where Franz Kafka's grandfather Jacob Kafka, the synagogue's *Shammes* and ritual butcher

[61] Hartmut Binder, ed., *Prager Profile. Vergessene Autoren im Schatten Kafkas* (Berlin: Mann, 1991), 21ff. On Kafka's library, see Herbert Blank, *V Kafkově knihovně / In Kafkas Bibliothek* (Prague: Nakladatelství Franze Kafky, 2004).

[62] Kafka, *Letters to Milena*, 27.

[63] Ibid., 202.

[64] Ibid., 219.

[65] On Kafka reading Czech, see Marek Nekula, "Franz Kafkas tschechische Lektüre im Kontext," *Bohemia* 43, no. 2 (2002), 346–80, as well as Anne Jamison, *Kafka's Other Prague: Writings from the Czechoslovak Republic* (Evanston: Northwestern University Press, 2018).

[66] Franz Kafka, *Letter to His Father*, trans. Ernst Kaiser and Eithne Wilkins (New York: Schocken, 1953), 77.

[67] Ibid., 79–81.

KMEN

LITERÁRNÍ TÝDENNÍK

ROČNÍK IV. V Praze, dne 22. dubna 1920. ČÍSLO 6.

Franz Kafka: Topič

Fragment

Se svolením autorovým přeložila Milena Jesenská

Když 16letý Karel Rosman, který byl svými chudými rodiči poslán do Ameriky, poněvadž ho svedla služka a měla s ním dítě, vjel již v zpomaleném parníku do newyorského přístavu, spatřil sochu Svobody, kterou již dávno pozoroval, jakoby ve světle náhle prudším. Její paže s mečem trčela jaksi nově vstříc a kolem její postavy vanul volný vzduch.

»Tak vysoko,« řekl si, a v tom, vůbec nemysle na odchod, byl stále rostoucím množstvím nosičů pomalu posunut až k zábradlí.

Jakýsi mladý muž, s nímž se byl při jízdě povrchně seznámil, řekl, předcházeje ho: »Nu, což pak nemáte přežádné chuti, abyste vystoupil?« »Jsem přece již hotov,« řekl Karel usmívaje se, a zdvihl z dobré nálady a poněvadž byl silný chlapec, kufr na ramena. Když však pohlédl za svým známým, který se již vzdaloval s ostatními a mával při tom hůlkou, s úlekem zpozoroval, že zapomněl dole v lodi svůj deštník. Rychle poprosil známého, aby mu laskavě u jeho zavazadla okamžik posečkal, čímž muž nebyl příliš obšťastněn, přehlédl ještě situaci, aby se při návratu vyznal, a pospíchal pryč.

S lítostí nalezl dole zavřenu chodbu, která by jeho cestu byla velice zkrátila, což patrně souviselo s vyloďováním cestujících, a bylo mu namáhavě si hledati cestu nespočetnými malými místnostmi, po krátkých schodech, které stále za sebou následovaly, korridory, neustále se zahýbajícími, prázdným pokojem s opuštěným psacím stolem, až skutečně, poněvadž touto cestou šel teprve jednou nebo dvakrát a vždy ve větší společnosti, úplně zabloudil. Ve své bezradnosti, poněvadž nepotkával lidí a slyšel jen nad sebou šoupání tisíce lidských nohou a pozoroval z dálky jakoby dech, poslední pracování již zastavovaných strojů, počal bez přemýšlení tlouci na první malá dvířka, na která při svém bloudění narazil.

»Vždyť je otevřeno,« ozvalo se uvnitř a Karel otevřel dvéře s poctivým oddechnutím. »Proč tlučete tak zběsile do dveří?« řekl ohromný člověk a skoro se po Karlovi ani neohlédl. Jakýmsi malým, svrchním oknem padalo ponuré, nahoře na lodi již dávno opotřebované světlo v žalostnou kabinu a v ní stáli těsně vedle sebe postel, skříň, židle a muž, jakoby složeni ve skladišti. »Zabloudil jsem,« řekl Karel, »ani jsem toho tak za jízdy nepozoroval, ale to je strašně veliká loď.« »To je pravda,« řekl muž s jistou pýchou, nepřestav se při tom nimrati se zámkem malého kufru, který oběma rukama vždy znovu přitlačil a čekal při tom na sklapnutí závory. »Ale pojďte přece dovnitř,« pokračoval muž, »nebudete přece státi venku.« »Nevyrušuji?« ptal se Karel. »Ale jak pak byste rušil?« »Jste Němec?« pokusil se Karel zabezpečiti, poněvadž mnoho slyšel o nebezpečí, které hrozí v Americe nově příchozím, obzvláště od Irů. »I jsem, jsem,« řekl muž. Karel ještě váhal. Tu muž náhle uchopil kliku a přisunul dveřmi, které rychle zavřel, Karla k sobě dovnitř. »Nemohu vystát, dívá-li se sem

61

209 *Kmen*, vol. 4, no. 6, 1920. Franz Kafka's "The Stoker," translated by Milena Jesenská. National Library of the Czech Republic, Prague.

FRANZ KAFKA: THE LANGUAGES AND IMAGES OF (PRAGUE'S) PUBLIC SPACE

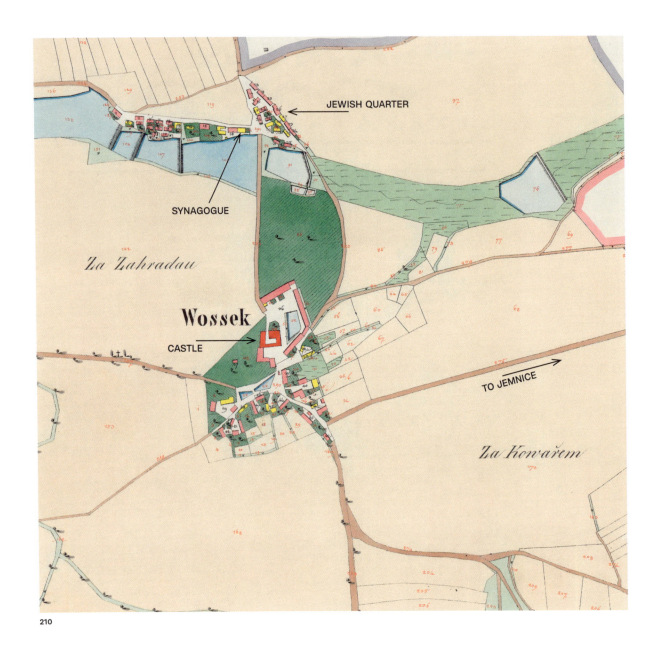

210 Map of Osek. Czech Office for Surveying, Mapping and Cadastre (ČÚZK).

(*Schächter*), is buried in the Jewish cemetery hidden in the forest, beneath a gravestone inscribed in Hebrew and German. Kafka's lukewarm relationship to Judaism was nevertheless not even fired up by visits to the synagogue, which he referred to only in terms of the long boring hours he spent there trying not to fall asleep.[68]

The real spark, it would seem, came with a performance by a Lviv theater company making a guest appearance at Prague's Café Savoy on Ziegengasse (Kozí ulice), to which Kafka was first invited by Brod on October 5, 1911. Over the next few weeks, Kafka returned to see the troupe multiple times, attending performances of the dramas *Night of the Seder* by Joseph Latteiner, *Sulamit* by Abraham Goldfaden, and *Kol nidre* by Abraham Scharkansky, among others. Kafka remained in close contact in subsequent months with the actor Yitzhak Löwy, whose language, Kafka wrote, "veers between Yiddish and German, inclining a bit toward the German."[69] Kafka's diary entries from this period are almost solely devoted to Löwy and around this time begin to feature individual words in Hebrew (*beshulim* – at peace; *rachmones* – mercy) and Yiddish (*bocher,* for a Talmudic school or its pupil). In some cases, although more rarely, he even uses entire sentences: "Wos mir seinen, seinen mir, Ober jueden seinen mir" ("What we are, we are, but Jews is what we are").[70] Sometimes, however, it is clear that Kafka does not fully understand the phrases he hears on the stage, meaning (eastern) Yiddish in general. For instance, he translates the phrase "toire is die beste schoire," either ironically or simply inaccurately, as "the Torah is the best commodity,"[71] although in fact it means "education is the best investment." For the word *belfer,* Kafka in his diaries provides an explanation in brackets: "assistant teacher."[72] It was evidently a new word for him.

Nor did Kafka have a command of western Yiddish, the language that his grandparents may have known and which, when raising their children, they abandoned in favor of the majority language(s) in the hopes of integrating into majority society—although their own German retained a Jewish ethnolect with Yiddish traces. When he was reading Brod's translation of Janáček's *Jenůfa,* Kafka found that certain unusual expressions reminded him of "the sort of German we have learned from the lips of our un-German mothers."[73] And in a critical discussion of the German language of Karl Kraus, Kafka noted that Jews are accused of "mauscheln" ("mumbling") even when their German is faultless and not influenced by Yiddish or any Jewish ethnolect of German.[74]

In November 1911, Kafka read Heinrich Graetz's 1888 publication *Popular History of the Jews*.[75] The following month, drawing upon Yitzhak Löwy's recitations and his descriptions of contemporary Jewish literature published in St. Petersburg, Lviv, and New York, as well as on his own knowledge, Kafka outlined a "Schema for the characterization of small literatures," by which he meant both Czech and Yiddish literature.[76] At a recital organized by Kafka for his friend in the ceremonial chamber of the Jewish Town Hall on February 18, 1912, Kafka gave the opening lecture on "jargon," in this case a reference to Yiddish. To prepare the lecture, Kafka relied on the *Histoire de la littérature judéo-allemande* (1911) by Meyer Isser Pinès, which he partially excerpted in his diaries.[77]

As a reader of poetry, Kafka found Yiddish fascinating, primarily in its aesthetic subtlety: "the links between Yiddish and German are too delicate and significant not to be torn to shreds the instant Yiddish is transformed back into German."[78] For Kafka, however, Yiddish did not merely hold aesthetic

[68] Ibid., 79.

[69] Franz Kafka to Max Brod, September 30 or October 1, 1917, in Kafka, *Letters to Friends, Family, and Editors*, 187.

[70] Kafka, *The Diaries*, 188.

[71] Ibid., 141.

[72] Ibid., 161.

[73] Franz Kafka to Max Brod, probably October 7 or 8, 1917, in Kafka, *Letters to Friends, Family, and Editors*, 193.

[74] Franz Kafka to Max Brod, June 1921, in ibid., 360.

[75] Peter-André Alt, *Franz Kafka: Der ewige Sohn*, 234. English: Peter-André Alt, *Franz Kafka, the Eternal Son: A Biography*, trans. Kristine A. Thorsen (Evanston: Northwestern University Press, 2018).

[76] Kafka, *The Diaries*, 161–62, 165–66, 168 (entries from December 25–27, 1911).

[77] Ibid., 188–91.

[78] Franz Kafka, "An Introductory Talk on the Yiddish Language," trans. Mark Anderson, in *Reading Kafka. Prague, Politics and the Fin-de-Siecle*, ed. Mark Anderson (New York: Schocken, 1989), 265–66.

211　*Das Jüdische Prag: Eine Sammelschrift* (Prague: Selbstwehr, 1917). Library of the Jewish Museum in Prague.

79　Ibid., 266.

80　Kafka, *The Diaries*, 197.

81　Kafka, *Letter to His Father*, 100. Kafka's word was "Ungeziefer." See Franz Kafka, "Brief an den Vater," in Franz Kafka, *Zur Frage der Gesetze und andere Schriften aus dem Nachlaß*, ed. Hans-Gerd Koch (Frankfurt am Main: Fischer Taschenbuch Verlag, 1994), 18.

value. The life-force of this Jewish language brought to his mind associations of "unity," "strength," and "self-confidence":

> But once Yiddish has taken hold of you and moved you—and Yiddish is everything, the words, the Chasidic melody, and the essential character of this East European Jewish actor himself—you will have forgotten your former reserve. Then you will come to feel the true unity of Yiddish, and so strongly that it will frighten you, yet it will no longer be fear of Yiddish but of yourselves. You would not be capable of bearing this fear on its own, but Yiddish instantly gives you, besides, a self-confidence that can stand up to this fear and is even stronger than it is.[79]

In a diary entry dated February 25, 1912, Kafka notes that his parents were not present at this lecture.[80] His father even went so far as to call Löwy "vermin,"[81] a designation clearly revealing Hermann Kafka's loathing and fear of the Yiddish world that his son was discussing in his lecture. Nor did the audience at the lecture, themselves from socially assimilated Jewish families, show particular interest in the subject under discussion. In contrast, Kafka discussed the question of Zionism with Brod and Weltsch. Although Kafka probably did not attend Martin Buber's "Three Speeches on Judaism," presented to the Bar Kochba association in Prague between 1909 and 1910, there is evidence that he was present at Buber's lecture "The Myth of the Jews" in January 1913. While Kafka

initially turned down Buber's offer to contribute to his journal *Der Jude*, he later sent him several manuscripts, from which Buber selected the stories "Jackals and Arabs" (1916) and "A Report to an Academy" (1917) for publication; these were stories that could be read with a Zionist interpretation. Kafka had a further connection to Buber through *Jewish Prague*, published in 1917 → **FIG. 211** by the publishing house Selbstwehr (Self-Defense). This volume was edited by Max Brod and Siegmund Kaznelson and included contributions by Max Brod, Franz Werfel, Rudolf Fuchs, and others. Kafka's contribution to the almanac was the short story "A Dream," later published in the collection *A Country Doctor* (1920).

Although Kafka remained in contact with Löwy, after Löwy's departure from Prague his fascination with the Yiddish actor quickly waned. Nonetheless, as late as 1917 Kafka edited Löwy's text "On the Jewish Theater." This outline of Löwy's life employs Yiddish expressions such as *trefe* (non-kosher), *chaser* (pig), *cheder* (Jewish primary school), *goyim*, *klaus* (a small prayer-room and classroom for Talmudic learning), or *kasche* (mash, in a phrase that connotes the thickening of atmosphere).[82] These words show that certain lexical Yiddishisms also became a part of Kafka's linguistic repertoire, even if their use was, understandably, mostly linked to his need to refer to specific concepts in the world of Orthodox Judaism.

During the First World War, the Yiddish language began to make itself felt in the public space of Prague with the arrival of Jewish refugees from Polish Galicia who were fleeing the fighting in the region. In his diary, Kafka mentions Polish Jews hurrying in their prayer shawls for Kol Nidre, the initial prayer before the evening service at Yom Kippur, and describes a loud argument between two women over *schmatten* ("rags") at a charity shop for Galician refugees.[83] He also mentions a visit to a class arranged by the Jewish Town Hall that Brod was teaching at the Prague Notschule (emergency school) for refugee children.[84] Nor should we overlook Kafka's attendance at Brod's lecture "Religion and Nation," or his trip to Marienbad (Mariánské Lázně) with Brod and Jiří Mordechai Langer to meet the "wonder rabbi" of Belz.[85] Kafka also paid great attention to Langer's talks on Hasidism, and he discussed what he called "controversial questions" with Dr. Jeiteles after a lecture on *mishnah* (orally transmitted law as the basis of the Talmud) at the Old Town Synagogue.[86] Generally, however, Kafka was confused ("my confusion," he wrote) by the "natural Jewish life" of the Eastern Jews, because it did not come naturally to him.[87] A concretizing reading of his story "An Old Manuscript," written 1916–1917 and published in the collection *A Country Doctor* (1920), might suggest certain distorted echoes of contemporary situations and discourses about Eastern Jews in Prague, such as the story's description of nomads flooding into a city and its squares, or how their language resembled the cries of jackdaws. However, once again it must be said that Kafka renders such descriptions in highly unspecific, generalized ways, and the story's setting in "the Middle Kingdom" impedes immediate concretization.

After 1917, perhaps inspired by Gershom Scholem, Kafka began studying Hebrew with increasing intensity.[88] When his illness broke out in August of that year, it had no effect on this new subject of interest; quite the opposite, in fact. Kafka imagined speaking Hebrew and building a life in Palestine, and his belief that this could be a realistic alternative to life in Europe was strengthened in November when Arthur James Balfour, the British foreign secretary, declared his support for the creation of a national homeland for the Jewish people in Palestine.

[82] Franz Kafka, "Vom jüdischen Theater," *Beim Bau der chinesischen Mauer und andere Schriften aus dem Nachlaß*, ed. Hans-Gerd Koch (Frankfurt am Main: Fischer Taschenbuch Verlag, 1994), 137, 139, and 141. An English translation of the theater essay appears in Franz Kafka, *The Blue Octavo Notebooks*, ed. Max Brod, trans. Ernst Kaiser and Eithne Wilkins (Cambridge: Exact Change, 1991).

[83] Kafka, *The Diaries*, 368 and 398.

[84] Ibid., 387.

[85] Ibid., 387, 397.

[86] Ibid., 409.

[87] Ibid., 387.

[88] See Andreas Kilcher, "Kafka, Scholem und die Politik der jüdischen Sprachen," in *Politik und Religion im Judentum*, ed. Christoph Miething (Tübingen: Max Niemeyer, 1999), 84.

Brod's correspondence with Kafka is one of the main sources of information about Kafka's knowledge of Hebrew. It was Brod who mentioned Kafka's progress in teaching himself the language from the second edition of the 1917 *Textbook of the Hebrew Language for School and Self-Study* by Moses Rath.[89] In turn, Kafka expressed praise for Brod's knowledge of the language in a letter from September 21, 1918.[90] Soon after the end of the First World War, Kafka devoted himself "quite seriously" to Hebrew in private lessons with Friedrich Thieberger, son of the Prague rabbi Karl Thieberger.[91] According to a letter to Brod dated April 10, 1920, Kafka was able to engage in a Hebrew conversation during his stay in Meran, however modest he may have been about his ability: "One of the guests, for example, was a Turkish-Jewish rug dealer, with whom I exchanged my scanty words of Hebrew."[92]

In 1921, Kafka joined Felix Weltsch and Miriam Irma Singer for private Hebrew lessons with Jiří Langer.[93] Langer's own recollection of speaking about aviation with Kafka in fluent Hebrew on a Prague tram, awing their fellow passengers with their expressive abilities, seems rather less probable, not because of Kafka's level of knowledge of the language, but rather due to the antisemitism that reemerged in Prague at the war's end.[94] Langer wrote his recollections in Palestine in 1941, and likely glorified and exaggerated the memory in retrospect. Even though Kafka repeatedly interrupted his Hebrew studies for medical and personal reasons, he consistently took them up again. When Puah Ben-Tovim, who had grown up in Palestine with Hebrew as her first language, traveled to Prague in 1922 upon the advice of Hugo Bergmann, Kafka's mother requested that she teach her son.[95] Whether Puah and the contemporary discussions on the authentic Jewish language later served as the model for Josephine and the motif of song and "piping" in Kafka's March 1924 story "Josephine the Singer, or the Mouse Folk" is another matter. It nevertheless seems that, by this point, reading texts in Hebrew—whether the Kabbalah or contemporary Hebrew newspapers and novels such as those of Yosef Haim Brenner—had become part of Kafka's routine.[96] Bergmann and Ben-Tovim, who wrote Kafka (or whom Kafka wrote) in Hebrew, would certainly have agreed.[97] According to Hartmut Binder, Kafka even translated Hebrew letters into German for his friends.[98] Kafka kept up his connection to Hebrew in Berlin, where in good weather he would attend the "Academy for Jewish Studies" twice a week.[99]

At the start of his awakening of interest in Judaism, in a diary entry dated December 25, 1911, Kafka acknowledged his Hebrew name, Anschel, and referenced his pious and learned maternal grandfather and great-grandfather and, through them, the tradition of the book.[100] On Kafka's gravestone, the same Hebrew name is given in a Hebrew inscription → FIG. 212:

> Tuesday, First Day of the Month of Sivan 5684. The above-named, illustrious man, our teacher and master Anschel, blessed be his memory, is the son of the esteemed R. Henoch Kafka, may his light shine. The name of his mother is Yetl. May his soul be bound up in the bond of life.[101]

With the language of the prayers, the inscription on his gravestone, the rituals, the Jewish calendar dating, the Hebrew name, the term "our teacher," referring to Kafka's biblical knowledge, and the final blessing, Kafka's family placed his engagement with Hebrew into the broadest and most final of contexts. In

[89] Max Brod, *Franz Kafka. Eine Biographie* (Frankfurt am Main: S. Fischer, 1963), 173. See also Hartmut Binder, "Kafkas Hebräischstudien. Ein biographisch-interpretatorischer Versuch," *Jahrbuch der deutschen Schillergesellschaft* 11 (1967): 527.

[90] Kafka, *Letters to Friends, Family, and Editors*, 259.

[91] Koch, *Als Kafka mir entgegenkam*, 132–33.

[92] Kafka, *Letters to Friends, Family, and Editors*, 291.

[93] Koch, *Als Kafka mir entgegenkam*, 151–52.

[94] Jiří Langer, "Vzpomínka na Kafku," in Jiří Langer, *Studie, recenze, články, dopisy* (Prague: Sefer, 1995), 139–41.

[95] Koch, *Als Kafka mir entgegenkam*, 177.

[96] Kafka, *Letters to Friends, Family, and Editors*, 482 and 485.

[97] Koch, *Als Kafka mir entgegenkam*, 30 and 178.

[98] Binder, "Kafkas Hebräischstudien," 534.

[99] Franz Kafka to Robert Klopstock, December 19, 1923, and to Max Brod, January 14, 1924, in Kafka, *Letters to Friends, Family, and Editors*, 495, 499. Franz Kafka to Felix Weltsch, January 1924, in Brod and Kafka, *Eine Freundschaft*: Briefwechsel, 515.

[100] Kafka, *The Diaries*, 164.

[101] Reiner Stach, *Is That Kafka? 99 Finds*, trans. Kurt Beals (New York: New Directions, 2016), 278.

212 Josef Sudek, photograph of Franz Kafka's grave at the New Jewish Cemetery, Prague, ca. 1961. Literary Archives of the Museum of Czech Literature, Prague.

Kafka's cubist gravestone by the architect Leopold Ehrmann, the architect who renovated the synagogues in Karlín and Smíchov in a functionalist style, Jewish tradition is joined with modernity.

It will hardly escape notice that, in this final section of my chapter, I have turned greater attention to Yiddish and Hebrew as compared to the once-dominant German and the ascendant Czech languages. I have done so because they were not a matter-of-fact presence in Prague's public space, from which, in fact, they were excluded. Using space as an analytical category, it is worth noting that in contrast to both the German and Czech languages, Kafka did not encounter Yiddish in an established Prague theater but at the Café Savoy. And even if Šaloun's monument to Rabbi Loew implied a fixation in Prague's cityscape of a permanent, if strongly Orientalized, representation of Jewishness,

Kafka's diaries focus more on his fleeting encounters with Orthodox Jewish refugees passing him on their way to evening prayers. The Oriental or Moorish styles of Prague's Spanish (1868) or Jerusalem (1906) synagogues can, in turn, be regarded as the expression of a new pride as much as an indication of an "othered" space, of which the Jewish cemeteries were a part as well. For its part, the historic Prague ghetto, including several of its synagogues, was destroyed in the "slum clearance" → FIG. 213 that started in Prague in the mid-1890s. The same principle was in operation at Austria-Hungary's public schools, where pupils were separated for religious instruction as part of the curriculum. It is nevertheless telling that Kafka learned his modern Hebrew not from any public educational institution but through private study and individual lessons using Rath's textbook.[102]

[102] For a closer look at the Hebrew language and the transition between tradition and modernity, see Alfred Bodenheimer, "A Sign of Sickness and a Symbol of Health: Kafka's Hebrew Notebooks," in *Kafka, Zionism, and Beyond*, ed. Mark H. Gelber (Tübingen: Max Niemeyer, 2004), 259–70.

CONCLUSION

In the end, we can ask ourselves whether, against the background of these differing linguistic and non-linguistic worlds, it makes sense to argue, as the critics and scholars cited at the outset of this chapter did, such as Goldstücker, that Kafka can be understood and interpreted only from the "Prague perspective." A focus on Kafka's Prague contexts undoubtedly makes sense if we look at the ramifications of cultural history, sociology, intertextuality, or discursivity in reading contemporary texts against one another. But it is far less interesting if, as has often been done in the secondary literature, one attempts to solely interpret Kafka's literary texts in direct relationship to his biographical experiences, including his experience of Prague's public space. With regard to Kafka's literary oeuvre, any overly concrete reading of the often highly generalized representations of public space in his fiction is not particularly informative. The sword-wielding goddess, the sword-waving hero, or the gigantic fist each have their own meanings and thus need not necessarily be seen from the "Prague perspective." A similarly unproductive approach has been the one taken by various other interpreters, from authors of historical works on national literatures to figures in contemporary cultural policy, who have attempted to appropriate Kafka exclusively for a single context, national literature, or identity, or with a view to just one of Prague's linguistic-cultural worlds. It is clear that there has never been one single way to read Prague's public space, even if it may sometimes seem that this is possible. Additionally, with regard to Kafka's linguistic and extra-linguistic worlds it is clear that these worlds can never be separated in a metropolis whose essential characteristic was a multilingualism resulting from migration. Instead, it is clear that multilingual actors connect these worlds in their everyday activities and literary translation practices, and that these worlds are constantly changing with respect to the broader (Central European and non-European) contexts. In this sense, the appropriation of Kafka as an "Austrian" author, as for instance on his memorial plaque in Berlin-Steglitz, is paradoxical, and not only because of its location in the German city of Berlin. It is perhaps more appropriate to see Kafka as an author of world literature who, through his work, consciously broke free from the captivity of national literatures.

Standing in opposition to this kind of national and linguistic appropriation of Kafka is the "othering" that Kafka encountered on many levels in his own personal life. It was something that Kafka was confronted with, for instance,

during his stay in Meran, as described in a letter to Max Brod written on April 6–8, 1920:

> So now the thing took its course. After the first few words it came out that I was from Prague. Both of them—the general, who sat opposite me, and the colonel—were acquainted with Prague. Was I Czech? No. So now explain to those true German military eyes what you really are. Someone else suggested "German-Bohemian," someone else "Little Quarter." Then the subject was dropped and people went on eating, but the general, with his sharp ears linguistically schooled in the Austrian army, was not satisfied. After we had eaten, he once more began to wonder about the sound of my German, perhaps more bothered by what he saw than by what he heard. At this point I tried to explain that by my being Jewish. At this his scientific curiosity, to be sure, was satisfied, but not his human feelings.[103]

When Kafka described himself as a "half-German" in a letter to Ottla or wrote to Brod about the language of their "un-German mothers," he accepted—or rather, anticipated—this "othering." It remains an open question whether linguistics or literary criticism should continue to re-inscribe this identity of otherness by recapitulating the idea that Kafka stood apart from the linguistic norms or literary canons of his era. It would seem more fruitful to trace how this difference was staged by Kafka himself in his literary works—in texts such as *The Metamorphosis*, "The Cares of a Family Man," "A Report to an Academy," or "An Old Manuscript." In these stories, Kafka never favored any one of his linguistic or extra-linguistic worlds, instead conveying more universal tales of "othering." As such, an interpretation of Kafka "from the Prague perspective," meaning with a specific knowledge of Kafka's linguistic worlds in Prague, is in fact not really necessary. At best, it is worth pursuing only when it helps us understand how Kafka obscured forms of otherness specific to Prague precisely in order to make them universal.

[103] Kafka, *Letters to Friends, Family, and Editors*, 292. "Little Quarter" is a reference to Prague's Lesser Town (Lesser Quarter).

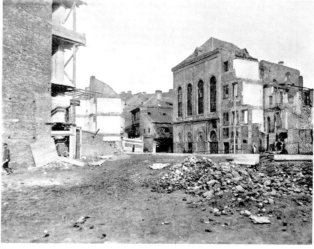

213 Photograph of the demolition of the Jewish Quarter. View of the Fleischmarkt and Grosshof Synagogue, 1905. Prague City Archives.

[Handwritten German text, largely illegible Sütterlin/Kurrent script — partial transcription:]

27. VI 19 Mutter und Schwester in Berlin. Ich werde m[it] Vater abend allein sein. Ich glaube er fürchtet heraufzukommen. Soll ich mit ihm Karten sp[ielen]? (Ich finde die K. häßlich, sie widern mich [an], ich schreibe sie doch, sie müssen für mich sehr ... sein.) Wie sich der Vater verhielt, ... berichte.

———

Zum erstenmal erschien der weiße ... einem Herbstnachmittag in einer großen aber ... belebten Straße der Stadt A. Es trat ... Flur eines Hauses, in dessen Hof ein Spedi[tions]schaft ausgedehnte Lagerräume hatte, wo den ... Gespanne, hie und da auch ein einzelnes ... dem Hausflur geführt werden mußten und ... das weiße Pferd nicht besonders auffiel, hörte aber nicht zum Pf.bestand der Spedi[tion]schaft. Ein Arbeiter, der vor dem Tor die ... einem Warenballen fester zog, bemerkte den ... sah von seiner Arbeit auf, und dann in[s] Hof, ob nicht der Kutscher bald nachk[äme]. Kam niemand, wohl aber besann sich da[s Pferd ?] ... hatte es ... Trottoir betretenhlung paar Fenster an den Pfeiler ...

HETEROCHRONIC MODERNITY IN A HETEROTOPIC PRAGUE

Miroslav Haľák

If time is not linear and space is not limited to three dimensions, why should we hold fast to a strictly chronological sequence of events and a strictly topographical positioning of culture in the broader sense of the word, or of art in the more narrow sense? Without delving into popular interpretations of physics, quantum mechanics, or special relativity, this question can be examined from a foundation of methodological critique of positivistic studies of modernity. Even if we approach individual areas of art history or cultural history from both a synchronic and diachronic perspective, this does not guarantee that we can apprehend the full complexity of historical phenomena. We can view phenomena within their particular chronological contexts (synchrony), or we can approach them as a range of interrelated causalities on a continuous timeline (diachrony), but either way there remain unanswered questions that go beyond hermeneutic, formalistic, or historiographical methods of interpreting a work, style, or epoch. Art that inspires the intellect across generations, that significantly influences formal vocabulary, and that contributes to paradigm changes in many areas of culture is a complex social phenomenon that cannot be analyzed solely from the perspective of the *here* and *now*, or the *there* and *then*.

The art that we consider a part of modernity is not a fixed sum of paintings, sculptures, buildings, furniture, novels, poems, symphonies, plays, films, photographs, or other works. Instead, it constitutes a fluid and thoroughly heterogeneous whole that is shaped by multiple factors and that acts multimedially and transhistorically. Modernity draws from the past in order to reach the future, for it is, in the words of Hans Sedlmayr, a historical "moment" whose temporal and spatial coordinates are difficult or impossible to determine from today's perspective. Writing in 1948, Sedlmayr explains:

> The historical "moment," which from the external conception of time appears only as a non-expanding cross-section between past and future, contains within itself an entangled temporal form encompassing references to future and past. The past is not simply what was at a bygone point in time and thus no longer exists; more primally, it is that which, as an effect of what has been, reaches into the present in a fundamental as well as reinforcing sense and thus itself forms an effective component of this present. Similarly, the future is not simply what is to come at some distant point in time and thus does not yet exist; the future is similarly more primal, it is contained in the present as purpose and objective, as hope and apprehension, and it forms such an integral part of this present that without these future references any bare present cannot be meaningfully described at all.[1]

Philosophical reflections on the function of *time* and *space* within modernity would appear to be a speculative construct that is only possible after in-depth fundamental research. This may be true insofar as one must first collect data and facts before one can confirm any hypotheses, and yet temporality has been a substantial problem for artistic development since the nineteenth century. The word "development" alone captures an essential part of modernity. Process, change, movement, acceleration, speed, and so forth are all relevant for describing the causes and effects of an era in which, for the first time in history, the future was programmatically bound not to eschatological visions or utopian expectations but to the specific projects of a society enlightened by technological progress. At the same time, with its fashion of idealizing historical models such as antiquity or the Middle Ages, the nineteenth century also witnessed a strengthened "effect of what has been."[2] As Sedlmayr emphasizes, this combination of simultaneous currents of thinking had a thoroughly mixed influence on artistic development during modernity.

The ambivalence between, on the one hand, the continued tradition of a history-conscious Europe seeking its identity in an instrumentalized past, and, on the other, a future-oriented Europe's ambitious drive for innovation, has been readily apparent since the romantic era. The accelerated pace by which people move and goods, services, and information are exchanged led to a sense of fascination that was manifested in art in a variety of ways. The philosopher Jean Gebser used the term "aperspectivity" to describe modernity's attempts at holding time fast in the present through art. "From this point of view, all of the attempts by the various 'movements'—expressionism, cubism, surrealism, and even tachism—show as their common trait this struggle to concretize and realize time."[3]

[1] Sedlmayr here makes reference to the existential philosophy of Otto Friedrich Bollnow (*Das Wesen der Stimmungen*, 1941). See Hans Sedlmayr, *Verlust der Mitte: Die bildende Kunst des 19. und 20. Jahrhunderts als Symbol und Symptom der Zeit* (Frankfurt am Main: Ullstein Bücher, 1959), 180–81. The relevant passage is missing from the English translation. Hans Sedlmayr, *Art in Crisis: The Lost Center* (London: Hollis & Carter, 1957).

[2] Sedlmayr, *Verlust der Mitte*, 180.

[3] Jean Gebser, *The Ever-Present Origin*, trans. Noel K. Barstad and Algis Mickunas (Athens, OH: Ohio University Press, 1985), 26. The book was first published in German in 1949.

Gebser identified three stages of temporal perception. The first is the archaic, which he called "unperspectival" and, on the basis of its metaphysical worldview, described as "blind to time."[4] This means that such societies have developed an understanding of space-time that frequently fails to distinguish between what is real and what is not. Starting in the early Middle Ages, the ability to ever more precisely measure time led to a concrete understanding of time, since the widespread use of sundials, water clocks, or candle clocks let it be more easily grasped.[5] Gebser calls this stage "perspectival." Referencing Gebser, Arnulf Rohsmann calls the subsequent "aperspectival" development the "declassing of time." "In the outgoing perspective age, [so Gebser,] the declassing of time to mere 'clock time' [Uhrenzeit] finds its vengeance. In addition to an 'obsession with space' [Raumbesessenheit], there also appear 'time addiction' [Zeitsucht] or 'time anxiety' [Zeitangst]. Time demands to be transformed into space or to be 'beaten to death' [totgeschlagen]."[6] The use of ever more precise technologies for measuring time has also radically changed our perception of time intervals. Instead of deriving the day's intervals from the climatic and lighting characteristics of a particular space, the rhythm of existence came to be calculated with mathematical sobriety and recorded in the numbers on a clock face.

In 1990, the British sociologist Anthony Giddens explained the break in temporal perception by pointing to the establishment of the clock in society:

> The invention of the mechanical clock and its diffusion to virtually all members of the population (a phenomenon which dates at its earliest from the late eighteenth century) were of key significance in the separation of time from space. The clock expressed a uniform dimension of 'empty' time, quantified in such a way as to permit the precise designation of 'zones' of the day (e.g., the 'working day'). Time was still connected with space (and place) until the uniformity of time measurement by the mechanical clock was matched by uniformity in the social organization of time. This shift coincided with the expansion of modernity and was not completed until the current century.[7]

The clock visualized and thus declassed the permanent presence of time. Instead of working with the sum of natural environmental factors, the perception of day and night was reduced to the tiny space within the immediate vicinity of a clock, meaning in view of a time-measuring device. Modern man was suddenly obsessed with punctuality and dependent on technology. The aforementioned concepts of "time addiction," "time anxiety," or "time emptiness" are phenomena initiated by modernity that significantly characterize it to this day.

Nevertheless, this "progression toward rationality,"[8] as Gebser called it, elicited not just approval and fascination (as, for instance, among the positivists and, by extension, the impressionists). Now that the fleeting, ephemeral, transient, and fluid could be captured in the moment by photography and through the exact specification of time, art increasingly attempted to find a balance between the "regression to irrationality"[9] on the one hand and the inhumanly rational on the other. "Only where time emerges as pure present and is no longer divided into its three phases of past, present and future, is it concrete."[10] The historical moment is more than a self-enclosed period

[4] In the original German, the word used is "Zeitblind." Gebser, *The Ever-Present Origin*, 26.

[5] "The first outward signs of a broader perception of time come around 604 A.D., when Pope Sabinian ordered the hourly tolling of bells. But it would not be until 1283 that the first public clock was erected, in the courtyard of Westminster Palace." Arnulf Rohsmann, *Manifestationsmöglichkeiten von Zeit in der bildenden Kunst des 20. Jahrhunderts* (Hildesheim: Georg Olms Verlag, 1984), 4.

[6] Ibid., 7.

[7] Anthony Giddens, *The Consequences of Modernity* (Stanford: Stanford University Press, 1990), 17–18.

[8] Gebser, *The Ever-Present Origin*, 29.

[9] Ibid.

[10] Ibid., 26.

that can be localized in time with a date, for in history there is no convergent concept of time, and thus also of space. In place of an empirically measurable perception of reality, the *here* and *now* is radically relativized in art. One result of this relativization is *myth*. In his *Philosophy of Symbolic Forms* (1923–1929), Ernst Cassirer argues for time's role in myth with a similar view to the latent shift between past, present, and future in favor of new and inspirational forms.[11] Consequently, the directions espoused by the hypotheses in this text could be described using the following chain of causality: Time/Space ↔ Myth ↔ Modernity.

The idea for the present essay, which addresses a particular space-time situation in modern cultural history, arose from a fundamental search for a better understanding of the confluence of factors in the work of Franz Kafka that have caused it to become so globally influential. In order to avoid the trap into which many interpretations of Kafka's art and writing have fallen, I have endeavored to name and contextualize some of these factors with a certain sense of detachment. For if one can resist the temptation to decipher Kafka's world of ideas and thus avoid joining, as Susan Sontag has written, one of the three armies of interpreters who have engaged in Kafka's "mass ravishment,"[12] the possibility arises to understand him as an author of a particular period in art. One is dependent on the other: without authors like Kafka, modernity would not have been as trailblazing for later artistic development; and conversely, without the specific challenges of the time, Kafka's work would not have had the same forcefulness. By concerning ourselves with overarching phenomena such as *space-time* or *myth* we avoid confining Kafka to one particular academic discipline or artistic genre and instead analyze him as a discursive author and an author of formative discourse.

Kafka is perhaps the best example of the asynchronicity and divergence of modernity. Since, however, he was not alone in being aware of the urgent otherness of the era, the following reflections, made from the perspective of the anthropology of art, will consider Kafka as part of a Prague-centric context. Although in the following essay the coordinates of modernity may be defined by the terms "Prague" and "the interwar era," these spatial and temporal parameters ultimately allow us to better illustrate why Franz Kafka is universally considered "modern."

THE GOLEM: MYTH AND TIME

"The essence of myth becomes tangible the moment we relate it to the phenomenon of time. It represents an event as it occurred, *in principio*, at the beginning—meaning at an original and timeless moment within the sacred span of time."[13] Like Ernst Cassirer before him, the Italian philosopher Ernesto Grassi points to the relationship between myth and temporality by raising the concept of origin. This means that a story, in order to be called mythical, must relate to a series of beginnings. Even modern myths, which long ago ceased to depict deities and instead mythologize figures/objects, places, or events, tend to depict an initiation, something never-before-seen, something that begins something new or different. There is no demand for a beginning in the sense of linear time, for a mythical form may be born and a mythical act may occur at any moment in history and can thus reshape the time continuum. Grassi writes: "Myth thus brings together two different

11 Ernst Cassirer, *The Philosophy of Symbolic Forms*, vol. 2, *Mythical Thinking*, trans. Steve G. Lofts (London: Taylor & Francis, 2020), 130.

12 "The work of Kafka, for example, has been subjected to a mass ravishment by no less than three armies of interpreters. Those who read Kafka as a social allegory see case studies of the frustrations and insanity of modern bureaucracy and its ultimate issuance in the totalitarian state. Those who read Kafka as a psychoanalytic allegory see desperate revelations of Kafka's fear of his father, his castration anxieties, his sense of his own impotence, his thralldom to his dreams. Those who read Kafka as a religious allegory explain that K. in *The Castle* is trying to gain access to heaven, that Joseph K. in *The Trial* is being judged by the inexorable and mysterious justice of God." Susan Sontag, "Against Interpretation," in *Against Interpretation and Other Essays* (New York: Dell Publishing, 1969), 18.

13 Ernesto Grassi, *Kunst und Mythos* (Hamburg: Rowohlt, 1957), 83.

HETEROCHRONIC MODERNITY IN A HETEROTOPIC PRAGUE

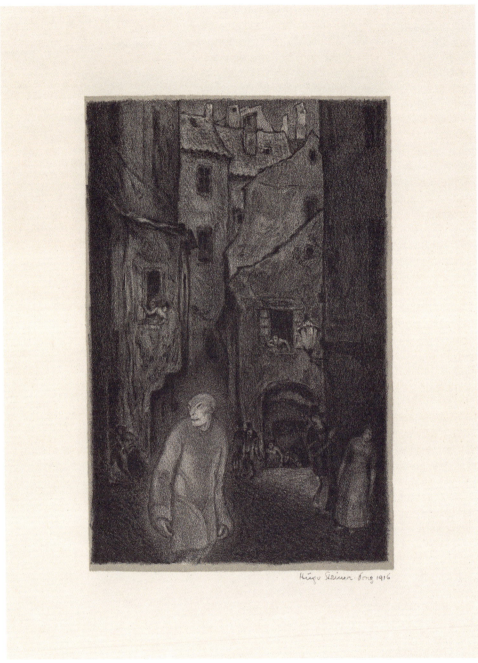

214A

214A, B Hugo Steiner-Prag, from the cycle *The Golem*, 1916. Lithographs, 19×12.3 cm. Gallery of West Bohemia in Pilsen.

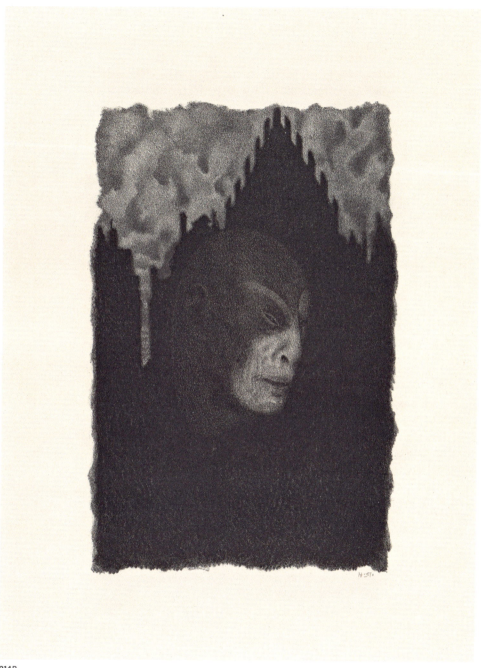

214B

forms of occurrences: firstly, a progression of events within historical time which bears all the hallmarks of a before and after. Myth, however, lifts this progress and the tension that characterizes and sustains it into the realm of the always-presiding, meaning the ever-present."[14] In discussion of this phenomenon, Cassirer turns to Friedrich Schelling, who speaks of "a *moment*," whose duration is constantly updated and whose beginning and end merely signify a kind of eternity.[15]

Modernity as a sociocultural phenomenon marks the turning point in history after which the perception of time has been radically altered because the concept of time has suddenly become a society-wide concern. Precisely because of this "time addiction" or "time anxiety," aperspectival modernity is a perfect place for the emergence of myths. In a constantly accelerating and thus increasingly more fleeting everyday life, the longing for a moment of eternity leads to a worldwide renaissance of metaphysical thinking across a broad artistic spectrum. From the romantic ideal of genius, via occultism, theosophy, anthroposophy, and esotericism, all the way to Far Eastern and animistic forms of spirituality, art since the nineteenth century has been open to spiritual tendencies that are less beholden to empiricism than they are to dreams, the unconscious, utopias, the fantastical, and the transcendental. Even movements and styles that committed themselves to a formal and minimalistic strategy (such as De Stijl, which drew, among other sources, on the ideas of the mathematician and theosophist Mathieu Hubertus Josephus Schoenmaeker) could not escape the creative synthesis of multiple schools of thought. In modern art, programmatic steps were taken to relativize the rigid measurement of time. One artistic means to this end was myth.

In this respect, Prague modernism could build on a rich heritage of medieval and Rudolphine legends. A mixture of religious skepticism (historically conditioned by the suppression of Jan Hus's reforms), Jewish mysticism, and the city's pronounced multiethnic character, combined with the cultivation of alchemy, astrology, geomancy, genethlialogy, gnosis, hermeticism, chiromancy, cosmology, cosmogony, necromancy, numerology, oneiromancy, theurgy, and Kabbalistic practices, left behind a strong influence on the city's atmosphere. One of the best examples for the enduring presence and constant renewal of this type of mythical thinking is the mythical figure of the golem. Itself a product of Kabbalistic creation myths such as the Sefer Yetzirah,[16] the figure of the golem is perfect evidence for an aperspectival concept of time in modernity, which, using a poststructuralist vocabulary, can be described as a heterochronic "break with traditional time."[17]

With its origins in the mythical-rabbinical tradition of the early Middle Ages, the golem as unformed animated matter that subordinates itself to its creator mindlessly and without free will became a projection surface for an entire series of myths, legends, and fantasies, all of which relativize the separation between past, present, and future. At the core of this story lie mystery, the dangerous, and the unknown—all manifested differently in each new retelling. In Gustav Meyrink's novel *The Golem*,[18] the subject of Prague's Jewish ghetto becomes a proclamation of modern myth-building, → **FIG. 214 A, B** a celebration of the unconscious in the nighttime city's eerie, dreamlike atmosphere of horror. → **FIG. 215** The subject itself becomes the stage for a psychological drama in which the search for one's identity symbolizes the existential questions of an entire era. The dust of old rituals is mixed with the smoke of industry, and the alleys of Prague accumulate all these different atmospheres along

14 Ibid., 83–84.

15 Cassirer, *The Philosophy of Symbolic Forms*, 130.

16 "Kabala," in *Lexikon alchymie a hermetických věd*, ed. Claus Priesner and Karin Figala (Prague: Vyšehrad, 2006), 143–46.

17 Michel Foucault, "Of Other Spaces," in *The Visual Culture Reader*, ed. Nicholas Mirzoeff (London: Routledge, 2002), 234.

18 Gustav Meyrink, *Der Golem* (Leipzig: Kurt Wolff Verlag, 1915).

with the various signs of their genesis. The story of the golem, too, meets the criterion that a myth relate to the concept of a "beginning." Not only does it mark the beginning of the life of a foreign substance, but each retelling and revision of the story represents an overlapping of multiple layers of time, from medieval mystery and modern magic all the way to modernist imaginative fantasy. → FIG. 216

Franz Kafka, too, made use of this heterochronic context in order to set the scene for his protagonists. The uncertain, the unexpected, the monstrous, the imperfect, the incomprehensible, the unspeakable, the unconscious, etc. play out before a *timeless* horizon. The shadows of medieval Prague's imperial hierarchies extend over the bureaucratic apparatus of the present and the inhuman machinery of future dystopias.

> The work is conceived historically, not just because it holds a place in history, but also because it opens up history itself; it "makes" history. This it can only do if it conveys a truth that concerns not a particular existence as much as existence as a whole. The "inner" working process (of world and earth) and the "outer" process of the founding of history can be differentiated, at least when the work renews a force that can be experienced as a "push." Put differently: by its mere existence, its mere being, the work can become an event that does away with all that has come before, that breaks conventions, overturns an existing orientation, lets us see with new eyes. In so doing, it opens up a world of previously unknown characteristics, a world that was not before and that will not be created in the future. But just now, it is there. This truth is not the result of a subjective sensation, nor is it a question of experience or reception. It owes a debt to the existence of the work, which does not point to this or that as a sign, does not interpret, but presents its own existence in such a way that the viewer or listener is brought within the sphere of this experience.[19]

[19] Gottfried Boehm, *Die Sichtbarkeit der Zeit: Studien zum Bild in der Moderne* (Munich: Wilhelm Fink Verlag, 2017), 158.

This conception of a work as described by Gottfried Boehm is also found in the literary texts of Franz Kafka. The indeterminate contemporaneousness of his writing produces a sense of permanent presentness. Thanks precisely to the indefinability of temporal factors, the appropriation of the world created in his texts takes on a continuous global dimension.

From Asia and the Arab world all the way to North and South America, Kafka is received and adapted to local conventions. This adaptation is possible because, through his literary protagonists, Kafka has created a mythology that, in each situation and in each context, proceeds from (begins with) a specific problem. The term "beginning" consciously refers to the criterion of myth, namely that it relate to the idea of a beginning. The events in Kafka's works thus not only identify the core of a multitude of social pathologies and societal as well as individual problems; they foresee them. In fact, much in the universe of a "Kafkaesque" situation can be read from the viewpoint of impermanence. Although *The Trial* is about a court proceeding, it plays out over a certain time. Instead of a criminal procedure, the "process" of the title (the German title, *Der Prozess*, can mean both "trial" and "process") can also be understood as the temporal process of losing one's existence—one that

HETEROCHRONIC MODERNITY IN A HETEROTOPIC PRAGUE

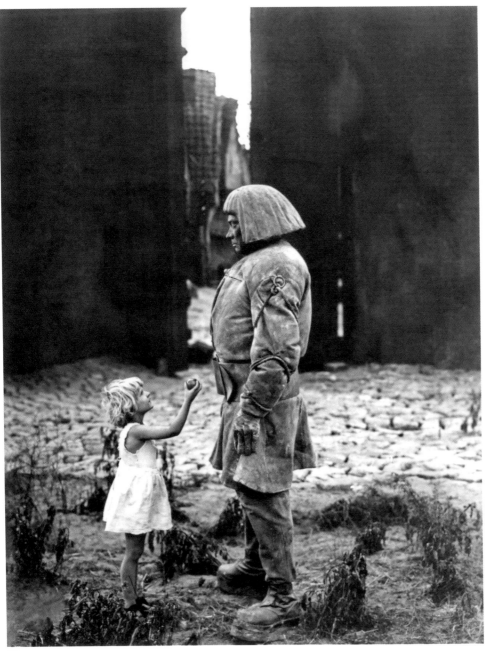

215

215 Scene from the film
Der Golem, wie er in die Welt kam, 1920, directed by Paul Wegener and Carl Boese. Deutsches Filminstitut & Filmmuseum, Frankfurt am Main.

HETEROCHRONIC MODERNITY IN A HETEROTOPIC PRAGUE

always starts from the beginning, can be constantly reactivated, and can be related to a wide range of situations in life.

"Proceedings are underway and you'll learn about everything all in good time."[20] This disturbing sentence describes the main character's loss of control over events in the first chapter of the unfinished novel. The fateful waiting, the maddening uncertainty as to what comes next can be seen as a manifesto of modernity. In Kafka's *The Trial*, "fear of time"—that creative force of modernity—becomes a ruthless weapon to be used against the waiting subject, a means of repression in the hands of the administrative apparatus. This image feels like an indictment from a left-wing pamphlet and only goes to show how this time-mythology equation works. In fact, it is the coincidence of factors such as heterochrony in modernity and modern myth-making that have helped Kafka achieve cult status. And yet, modernity's aperspectival time paradigm is not spaceless, meaning the heterochrony encoded within the substance of such works can only unfold in a corresponding space. As has already been made clear by several of its characteristics, Prague offers the ideal conditions for this to occur.

20 Franz Kafka, *The Trial*, trans. David Wyllie (Mineola, NY: Dover Books, 2009), 2.

216 Josef Wenig, poster for *The Golem*, 1920. Chromolithograph, 126×96 cm. Museum of Decorative Arts in Prague.

209

ŠVEJK: BODY AND SPACE

The Czech linguist and literary critic Pavel Eisner boldly argued that any understanding of Kafka's work is only possible from the Prague perspective.[21] Such a statement would be quite radical if we were to take it literally and decided to identify Prague as the specific site of specific events. But the city appears in Kafka's novels and novellas not as a clearly identifiable place; rather, it is a space defined by a particular state of being. The city's urban space is not real but imagined, though based on a tangible model in the real world. In this regard, the Slovak literary historian Július Pašteka emphasizes the difference between Kafka's Prague and the metropolises of other authors such as Balzac and Paris, Dickens and London, Dostoevsky and St. Petersburg, Joyce and Dublin, Döblin and Berlin, Dos Passos and New York. The settings in Kafka's work, by comparison, are anonymous and universal all at once.[22]

The aforementioned list could be expanded to include Jaroslav Hašek's Prague, except that Hašek's figure Švejk → FIG. 217 and the author's satirical treatment of the absurdity of the First World War contain an interesting personification of Prague. Švejk, who is constantly remembering his time in Prague, sketches a map of the city's urban fabric, a beer- and meat-sated body that resembles the corpulence of the protagonist himself.[23] → FIG. 218 Hašek's city is not anonymous but is very present and thus tangible. Instead of a recollection of specific sites in a living city, Kafka's Prague resembles a malignant organism filled with dark, dangerous, and inscrutable buildings and alleyways.

Analogies between *body/place* and *space* should not have been unfamiliar to Kafka, as evidenced by his acquaintance with several important representatives of the Brentano School, for instance the Swiss philosopher Anton Marty, whose lectures Kafka attended in 1902.[24] Considering the fact that Marty studied under Rudolf Hermann Lotze, it should not come as a surprise that he was concerned with the body and its intentional relationship to the category of space. Like his teacher, Marty was interested in the extent to which the spatial parameters of a real place can be determined through our perception of other bodies—and whether this is even possible at all. In this aesthetic view, the body is considered a purely objective quality and quantity with a coordinate function.[25] Stated simply, this means that, as physical coordinates within space, subjects (meaning us as well) localize this space while also defining it from their own perspective. "Quantity is expressed by the body which fills the space and by the space itself, and in both cases one can speak of size in two senses: one which makes up or constitutes the quantitative difference, and one which measures it."[26] The love scene between the land surveyor K and the barmaid Frieda in the fourth chapter of Kafka's *The Castle* (1922) includes an objectification of the body. In this scene, the characters' bodies become something like organic topographies, meaning places created and made bearers of meaning through mutual seeking and exploration.

> There they lay, although not as absorbed in each other as on their first night together. She was in search of something and so was he, they tried to get at it almost angrily, grimacing, butting each other's breasts with their heads, and their embraces and writhing bodies did not bring oblivion but reminded them of their duty to go on searching. Like dogs desperately scraping

[21] Pavel Eisner, "Franz Kafka a Praha," *Kritický měsíčník* 9, no. 3–4 (1948): 66–82.

[22] Július Pašteka, "Magický prozaik Franz Kafka," *Svet literatúry, literatúra sveta. Analýzy a interpretácie*, vol. 1 (Bratislava: Petrus, 2005), 181.

[23] Jaroslav Hašek, *The Good Soldier Švejk*, trans. Cecil Parrott (London: Penguin, 2005).

[24] Wilhelm Emrich, *Franz Kafka*, second edition (Frankfurt am Main: Athenäum Verlag, 1960), 412.

[25] Franz Brentano, *Grundzüge der Ästhetik* (Hamburg: Felix Meiner Verlag, 1988), 59–60.

[26] Anton Marty, *Raum und Zeit* (Halle: Verlag von Max Niemeyer, 1916), 191.

HETEROCHRONIC MODERNITY IN A HETEROTOPIC PRAGUE

217

218

217 Scenic design by Georg Grosz for Max Brod and Hans Reimann's stage adaptation of Hašek's *Švejk*, directed by Erwin Piscator and Bertolt Brecht for the Piscator-Bühne in Berlin, 1928. Getty Images.

218 V. H. Brunner, poster for the "Restaurant and Café Montmartre," Prague, 1913. Color lithograph, 95×62 cm. Museum of Decorative Arts in Prague.

at the ground, they worked away at one another's body, helplessly disappointed as they tried to retrieve the last of their bliss, sometimes licking each other's faces with their tongues.[27]

Besides the symbolism of the fact that this act involves a protagonist who is a land surveyor, another decisive attribute of this scene is its fateful association with place and thus space. In an indefinite village, on the way to an existentially unattainable goal, in a room at an inn, parallel body-places are explored. This structuring of the novel's spatial components makes the castle a multilayered symbol,[28] a projection surface for the most intimate contents (fears, desires, etc.). In addition to a modernist decomposition of time, with Kafka we also encounter a shifting of the phenomenon of space.

Through its aperspectivity, modernity establishes a perception of time and space that Michel Foucault calls *heterochrony* and *heterotopia*. These most fundamental post-structuralist concepts help to illuminate the art of the interwar period by showing us the relative nature, meaning the untenability, of the traditional concept of time and space in culture since the end of the nineteenth century. "The heterotopia begins to function at full capacity when men arrive at a sort of absolute break with their traditional time."[29] The past two centuries in particular—an era of increasing frustration with time—have produced the preconditions for experimental works which have challenged the limits of space and the linearity of time. Salvador Dalí's melting clock in *The Persistence of Memory* (1931) is just one example of this process. The whole mythology of modernity consists of creating something revolutionarily new and timeless, of exploding the objective three-dimensionality of space.

A far more topical interpretation of the role of space in myth-building, and one not limited to the theory of ancient mythology, may be found with Ernesto Grassi, who draws on the work of Mircea Eliade. The mysterious and inaccessible, which is considered a formal principle of surrealism and the other modernisms that sprang from symbolism and which fundamentally contributes to the atmosphere found in Kafka's work, is based on precisely this aforementioned qualitative criteria for identifying a place. In other words, it is not a real geography with concrete coordinates, but an expression of a superspatial and supertemporal state:

> We are not dealing here with a geometric space whose abstract homogeneity would have to exclude the coexistence of two middle points, but with the sacred space in which a center can be chosen everywhere at the same time. It is not a quantitatively, but a purely qualitatively definable place. The demythicization of a space, however, occurs when it becomes homogeneous and thus measurable.

Grassi then cites Eliade:

> What we have here is a sacred, mythic geography, the only kind effectively *real*, as opposed to … the theoretical construction of a space and a world that we do not live in, and therefore do not *know*. In mythical geography, sacred space is the essentially *real space*, for, as it has lately been shown, in the archaic world the myth alone is real. It tells of manifestations of the only indubitable reality—the *sacred*.[30]

[27] Franz Kafka, *The Castle*, trans. Anthea Bell (Oxford: Oxford University Press, 2009), 44.

[28] "The symbol interests us as what it represents and means, but also as what it simply is for itself, what specifically it places before our eyes, what it tells us and how it presents this concrete narrative, this particular sequence of facts in order to signify something distant and universal." Max Brod, *Über Franz Kafka* (Frankfurt am Main: Fischer, 1966), 170.

[29] Foucault, "Of Other Spaces," 234.

[30] Grassi, *Kunst und Mythos*, 84. See also Mircea Eliade, *Images and Symbols: Studies in Religious Symbolism*, trans. Philip Mairet (New York: Sheed & Ward, 1961), 39–40.

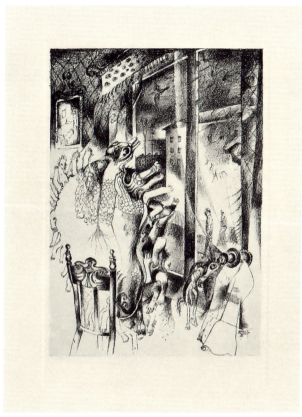

219 Otto Coester, illustration for the Czech edition of Kafka's *The Metamorphosis* (Stará Říše na Moravě: Marta Florianová, 1929). Collotype on paper, 31.5×25 cm. Moravian Gallery in Brno.

31 Franz Kafka, *The Metamorphosis*, trans. Susan Bernofsky (New York: W. W. Norton, 2014).

32 Christa Karpenstein-Eßbach, "Ein moderner Körper – zum Beispiel Gregor Samsa," in *Transfigurationen des Körpers. Spuren der Gewalt in der Geschichte*, ed. Dietmar Kamper and Christoph Wulf (Berlin: Dietrich Reimer Verlag, 1989), 239.

33 Rosario Assunto, *Theorie der Literatur bei Schriftstellern des 20. Jahrhunderts* (Hamburg: Rowohlt, 1975), 32.

34 Ibid.

The polysemantic organization of the material work in modern art *a priori* turns every means of expression into a meaning-forming unit, no matter how trivial and simple it may appear. With the point, the line, and the most sterile surface as a starting point, compositions are created whose interpretations far transcend their visual possibilities. All objects can be transformed into bodies whose dialogic quality determines the narrativity of the work as a whole. That the division between the subjective and the objective and between the human and non-human body is indistinguishable is among other things borne out by the transformation of Gregor Samsa in Kafka's *The Metamorphosis*.[31] → **FIG. 219** "The modern body possesses a specific ability to resist any signification, a resilience that constantly reasserts itself against the violence and subjugation implicit in circumscriptions, delimitations, incursions. In modernity, the body becomes seemingly impossible to comprehend through interpretation and discourse; it becomes illegible."[32] Since the idealism of the nineteenth century at the latest, the incomprehensible has become an integral vehicle for the body as symbol, the body as coordinator of space, and the body as determinant of space. The ensuing myths are therefore, like their ancient predecessors, pre-programmed with inaccessibility; they build on what is taboo. The spatial situations of such mythical practices in which we encounter inaccessible places, untouchable beings, impenetrable formal structures (abstract tendencies in art come to mind), and so on are of a symbolic nature. They are "charged with a tension force"[33] capable of stretching the spatially determined into the mythically "boundless."[34]

Michel Foucault refers to such situations as "crisis heterotopias."[35] He, too, uses the concept of the sacred, which—especially with Kafka, but with other sociocritical modernist authors as well—should be understood in a positive spiritual sense. Rather, these crisis heterotopias are a mental construct designed to demonstrate how non-spatially (in the sense of a single concrete place on a clearly defined timeline) many ritual, religious, and traditional practices function. The groundbreaking contribution of modern social criticism rests in recognizing—within hierarchical forms of organization, bureaucracy, compulsory military service, state structures, and all repressive institutions of any sociopolitical structure—the patterns of an archaic strategy for the mythicizing of specific places (offices, institutions, schools, organizations, clubs, companies, etc.). The sacrality of the heterotopias that form the setting for Kafka's protagonists symbolizes the transformation of the sacred into the demonic. The *castle* as an always distant objective becomes the archetype of the individual and collective failure of a non-human organism. The starting point from which the land surveyor K seeks to reach the castle is thus forever frozen in the past. At this break with traditional time, when the target vision of the future cannot be achieved at any point in time, when the here and now cannot be defined, a "non-place" is constructed that to this day remains inspiring across modern media, -isms, movements, genres, and styles.

K: THE MYTH OF "MODERNITY" AND THE LOGOS OF "THE MODERN"

The decision to avoid engaging in an explicit interpretation of Kafka's work and to instead focus on a specific question of modernity from which to derive contextual points of reference for this exceptional Prague author has proved productive. Working with the concepts of *time* and *space*, it is possible to learn something about an era-specific initiative on the part of many authors across all the arts. We are talking here about the modernist initiative of giving the construct of time and space more room while also helping the subject within this construct acquire more freedom. A rejection of the dictates of the rational-empirical Enlightenment, which significantly determined everyday life in countries affected by the industrial revolution, has been present across all media and disciplines since the nineteenth century. Idealism and the romantic liberation of the subject[36] have accelerated a countermovement to the "progression toward rationality," to once more cite Gebser.[37] This regression has more than one face and has started more than the one consistent tradition that could be described as transcendental. It is a reaction to the imposition of the space-time that modern societies increasingly committed themselves to. The resulting time and space anxieties are manifested within sociocritical art movements ranging from realism all the way to existentialist tendencies. Philosophers, writers, painters, sculptors, designers, architects, filmmakers, actors, dancers, and others have managed to break out of the space capsule and to confuse the clockwork in a number of different ways. Some break with tradition by liberating form from mimesis and, as in non-representational abstraction, conferring upon it an autonomous quality. Others flee into the unconscious, from which they draw associations that defy all laws of classical logic. The thus-programmed reactivity of art continues to shape us via modernity all the way to today's (so far) insurmountable postmodernity.

35 Foucault, "Of Other Spaces," 232.

36 Miroslav Haľák, "Paradigmatischer Baum Hölderlins. Projektion, Symbol und Prozess als Wurzel der Moderne," in *Hölderlins frag-würdige Aktualität. Ein Dichter zwischen cooler Verabschiedung und heilig-nüchterner Epiphanie*, ed. Lisa Wolfson and Sophie Reyer (Würzburg: Königshausen & Neumann, 2022), 101–8.

37 Gebser, *The Ever-Present Origin*, 29.

220 Franz Kafka, diary entry from May 27, 1914, with distinctive Ks in the text. "I find Ks ugly, almost repugnant, and yet I keep on writing them; they must be very characteristic of myself …" The Bodleian Libraries, University of Oxford.

27.V.14 Mutter und Schwester in Berlin. Ich werde mit dem Vater abend allein sein. Ich glaube er fürchtet sich heraufzukommen. Soll ich mit ihm Karten spielen? (Ich finde die K häßlich, sie widern mich fast an und ich schreibe sie doch, sie müssen für mich sehr charakteristisch sein.) Wie sich der Vater verhielt, als ich F. berichtete.

———

Zum erstenmal erschien das weiße Pferd an einem Herbstnachmittag in einer großen aber nicht sehr belebten Straße der Stadt A. Es trat aus dem Flur eines Hauses, in dessen Hof ein Speditionsgeschäft angedehnte Lagerräume hatte, so daß öfters Gespanne, hie und da auch ein einzelnes Pferd aus dem Hausflur geführt werden mußten und infolgedessen das weiße Pferd nicht besonders auffiel. Es gehörte aber nicht zum Pferdestand des Speditionsgeschäftes. Ein Arbeiter, der vor dem Tor die Stricke an einem Warenballen fester zog, bemerkte das Pferd, sah von seiner Arbeit auf, und dann in den Hof, ob nicht der Kutscher bald nachkomme. Es kam niemand, wohl aber bequemte sich das Pferd, kaum hatte es das Trottoir betreten, kräftig auf schlug paar Funken aus dem Pflaster, vor einem

In the process, new phenomena are made visible that play an important role in the emergence of these artistic strategies. As we have seen in the first part of this essay, one of these phenomena is *myth*. Myth is a functional means for destabilizing quasilinear time, for it challenges continuity by discontinually setting the beginning of an unusual narrative and thus enabling a shift in time: in a myth, *now* is identical with *then*. Franz Kafka makes use of this destabilization of time and frequently places the characters of his stories in a temporal vacuum where the waiting is endless but the grim future is inevitable. His protagonists involuntarily become myths of a dystopian society, myths that can be deployed anytime and anywhere and thus produce ever newer discontinuities.[38] "K" achieves cult status, regardless of whether we mean the bank administrator, the land surveyor, or the creator of both—the author. → **FIG. 220** Encoded in their fate are the crises that have plagued modern societies for more than a hundred years. In Kafka's works, individualism, anonymity, alienation, and dehumanization acquire a supertemporal and superspatial dimension by which they become new myths. This absurd tragedy and banal fatefulness are what make Kafka the ultimate example of existentialist thinking. Even here, it must be noted that this so-called proto-existentialist attitude, meaning this beginning-with-something, makes the author himself a myth.

The second observation has been that although the perception of space and the conception of the body in modernity have functioned in a meaningful manner, they are highly inconsistent. Like undefinable time, space, too, offers no fixed quantity. When the reckoning with traditional time contributes to myth-building, space is not the given essence of the matter, of logos, but—as already addressed in Plato's *Phaedrus*[39]—a dialogic partner. This dialectic produces a fascinating picture of modernity. As a stage, it is a heterochronic whole enabling the occurrence of the most diverse phenomena, which it then allows to swing wildly back and forth along a timeline. Modernity even dispenses with the concept of a timeline; it does away with it in order to be able to justify creations such as Malevich's black square, which is attributed with new and progressive forces in art even though these forces are founded on an older tradition (in Malevich's case, orthodox image theology). In this way, the bank administrator K becomes both the victim of an archaic-diabolical conspiracy and a contemporary symbol of bureaucratic absurdity. The land surveyor K is on the way to a castle in a village, but he is also lost in a confusion of incomprehensible layers, structures, and a panopticon of obstacles—in other words, a crisis heterotopia.

Prague is indispensable as a stage for Kafka's modernity. Without its historical background and idea-laden identity, the anonymous settings of Kafka's stories would be mere bodies without any function. But Prague is a complex organism, a body full of folds[40] that perfectly illustrates the post-structuralist issues of an advanced understanding of space and time. With Kafka, it is possible to identify the decisive factor that makes his work so timelessly modernist within modernity—the insight it offers into the acute issues of the era in which he lived, an era in which, unfortunately, myths were mixed with facts to produce the greatest tragedy of the twentieth century. The right to work with myths should be reserved for art, so that politics will never again make the fatal mistake of using made-up stories to pave the path toward inhuman totalitarianism.

[38] Pašteka, "Magický prozaik Franz Kafka," 206–7.

[39] Kurt Hildebrandt, "Einleitung zur Übersetzung," in Plato, *Phaidros oder Vom Schönen* (Stuttgart: Reclam, 1998), 10–13.

[40] Gilles Deleuze, *The Fold: Leibniz and the Baroque*, trans. Tom Conley (London: The Athlone Press, 1988)

INDEX OF NAMES

This index includes the names of all the individuals mentioned in the book's chapters, footnotes, and image captions. It does not include mythological or literary figures; names contained in works of art or referring to monuments; personal names referenced in the names of buildings; city districts; institutions; companies (including publishers); or names contained in subsequently cited copyright information. For the authors of works cited in footnotes, we give only the page number of the name's first appearance in each chapter of the book; any other occurrences are not included. Understandably, the index does not include the name Franz Kafka.

Aleichem Sholem 80
Aleš Mikoláš 178
Alt Peter-André 174, 175, 191
Anderson Mark 191
Arendt Hannah 16
Asch Sholem 80
Ascher Ernst 31, 60, 84, 89, 103
Ascher Zikmund 89
Asklöf Louise 110
Assunto Rosario 213
Aue Hartmann von 185

Bach Friedrich Teja 14
Bach Ulrich 31
Bachhofer Ludwig 41
Bailly Louise 187
Balfour Arthur James 193
Balint Benjamin 125
Balzac Honoré de 210
Bärsch Claus-Ekkehard 80
Barstad Noel K. 201
Bárta Josef 43
Basilius Harold 136
Bassermann Albert 58
Bauer Felice 21, 29, 39, 58, 78, 89, 90, 92, 114, 116, 133, 135, 169
Baum Oskar 185
Baxa Martin 9
Beals Kurt 122
Beardsley Aubrey 29
Beck Evelyn 31
Beethoven Ludwig van 178
Bell Anthea 175, 212
Ben-Dov Ya'acov 79, 96
Ben-Tovim Puah 194
Beneš Vincenc 20, 62, 67, 86, 133
Benjamin Ross 15, 29, 134, 176

Benjamin Walter 16, 41
Bergmann Hugo 185, 194
Bernofsky Susan 213
Bie Oscar 32, 46
Bílek František 78, 91, 182–184
Bílek Petr A. 171
Binder Hartmut 14, 21, 28, 40, 62, 63, 90, 110, 122, 134, 169, 187, 188, 194
Blank Herbert 188
Blei Franz 28, 29, 31, 32, 67
Blom August 49, 65
Bodenheimer Alfred 196
Boehm Gottfried 207
Boehm Philip 79, 185
Boese Carl 208
Bokhove Niels 122
Bollnow Otto Friedrich 201
Born Jürgen 21, 32, 114, 133, 183
Borový František 79
Bourdelle Antoine 64
Braque Georges 64, 125, 155
Braunerová Zdenka 43
Brecht Bertolt 211
Brenner Yosef Haim 194
Brentano Franz 28, 185, 210
Brod Max 8, 9, 17, 20, 21, 28, 29, 32, 39, 41, 43, 49, 55, 60, 61, 63, 64, 67, 78–80, 82, 84, 89, 110, 122, 123, 125, 132–135, 147, 148, 150, 152, 155, 159, 168, 174, 175, 178, 183–185, 188, 191–194, 197, 211, 212
Brod Otto 55
Brömse August 44, 60, 100
Bruce Iris 80, 132
Bruder Anton 80, 82, 101

Brunner Marie Vera 27, 32
Brunner Vratislav Hugo 69, 211
Buber Martin 132, 192, 193
Bugsch Irene 21
Burger Hannelore 110

Čapek Josef 16, 67, 79, 87
Čapek Karel 188
Carter Karen 155
Cassirer Ernst 203, 206
Čermák Josef 16, 76, 90, 166, 169
Cernuschi Claude 148
Čeřovský František 60
Cézanne Paul 125
Chaplin Charlie 16
Chrobák Ondřej 148
Chudy Tomáš 16
Citroen Paul 67
Clarke Jay 155
Coester Otto 94, 213
Conley Tom 216
Corngold Stanley 174

Daemgen Anke 67
Dalí Salvador 212
David Claude 16
David Josef 177
Degas Edgar 61, 63, 125
Deleuze Gilles 14–17, 79, 84, 169, 216
Demetz Petr 170
Derain André 38
Detter Ferdinand 185
Diamant Dora 177, 178
Dickens Charles 210
Dickson Rachel 133
Döblin Alfred 210
Dorst Marijke van 122
Dos Passos John 210

Dostoevsky Fyodor Mikhailovich 79, 93, 210
Duchková Zuzana 89, 133
Duckworth Elisabeth 21, 114, 133
Duras Mary 80
Duttlinger Carolin 14, 16, 176
Dutz Elisabeth 135

Eduardova Yevgenya (Eugenie) 59
Ehm Josef 169, 182
Ehrlich Hans 27
Ehrmann Leopold 195
Eilittä Leena 14
Eisner Minze 21
Eisner Pavel 166, 168, 169, 171, 210
Eliade Mircea 212
Elsner Lotte 169
Emrich Wilhelm 210

Fanta Berta 21
Fechner Gustav Theodor 61
Fedrová Stanislava 16
Feigl Ernst 89
Feigl Friedrich 20–23, 25, 60, 61, 64, 67, 71, 79, 80, 84, 89, 90, 92, 94, 97, 105, 133, 134, 136, 138, 140, 145
Feigl Margarete 89
Fellner Friederike 122
Ficker Adolf 111
Figala Karin 206
Filipová Marta 125
Filla Emil 20, 23, 60, 61, 64, 67, 74, 85, 86, 131, 133, 155, 157
Fink František 182

INDEX OF NAMES

Fischer Otto 41
Fischer Sabine 90
Fleischmann Ingrid 111
Florian Josef 90, 94
Formánek Václav 89
Foucault Michel 206, 212, 214
Frank Anton 112
Freund Ela 67
Freund Ida 21, 26, 40, 67, 80, 135, 147
Frimmel Johannes 31
Frynta Emanuel 169
Fuchs Rudolf 185, 188, 193

Gandelman Claude 122
Garbagni Paul 63, 77
Gauguin Paul 16, 61, 125
Gebser Jean 201, 202, 214
Gelber Mark H. 80, 132, 196
Gellner František 150, 152
Gerstenberg Heinrich Wilhelm von 185
Giddens Anthony 202
Gillespie Susan 14, 178
Gilman Sander L. 31
Glatzer Nahum N. 94
Gleizes Albert 64
Gobard Henri 15, 28, 79
Goebel Rolf J. 41
Goethe Johann Wolfgang von 15, 32, 39, 47, 61, 183
Gogh Vincent van 16, 61, 75, 125, 155
Goldfaden Abraham 191
Goldstücker Eduard 16, 43, 166, 168, 169, 196
Goll Jaroslav 183
Gordin Jacob 98
Gordon Donald E. 134
Gottsmann Andreas 110
Goya Francisco 32
Graetz Heinrich 191
Grandauer Josef 113, 115
Grassi Ernesto 203, 212
Greenberg Martin 84
Greule Albrecht 111
Gris Juan 64
Grosz George 16, 211
Gruša Jiří 169
Gschwind Emil 112
Guattari Félix 14–17, 79, 84, 169
Gütersloh Albert Paris 27, 30
Gutfreund Otto 64, 83

Haas Miroslav 134
Haas Willy 185
Habán Ivo 82
Habánová Anna 82
Halák Miroslav 7, 9, 16, 200, 214
Harlas František Xaver 60
Harlfinger-Zakucka Fanny 27, 33–35
Hašek Jaroslav 188, 210, 211

Haug Christine 31
Hawes James 29
Heine Thomas Theodor 32, 150
Hejná (Wettenglová) Růžena 173
Heller Erich 21, 114, 133
Herbart Friedrich 113
Hermsdorf Klaus 187
Hildebrandt Kurt 216
Hiroshige Utagawa 40, 41, 55
Hodin J. P. 61, 90, 125, 133, 134, 136
Hoffe Ilse Esther 125
Hofman Vlastislav 79, 93
Hofmann Ludwig von 18, 20
Höhne Steffen 8, 59, 169
Hokusai Katsushika 40
Horb Felix 39
Horb Max 20, 39, 40, 60, 61, 64, 71, 84, 89, 126, 130, 132–134, 147, 148
Horovitz Luise 27
Hume Naomi 159
Hus Jan 206

Iggers Wilma A. 21

Jakesch Alexander 43
Jamison Anne 188
Janáček Leoš 188, 191
Janáčová Eva 133
Janák Pavel 115
Janouch Gustav 16, 67, 122, 123, 166
Jansa Václav 43
Jaques-Dalcroze Émile 21
Jedličková Alice 16
Jeiteles Berthold 193
Jesenská Milena 39, 45, 79, 185, 188, 189
John of Nepomuk (Saint) 174
Johnson Julie Marie 28
Jordaens Jacob 63
Joyce James 210
Juncker Axel 60
Jürgens Zuzana 9, 110

Kafka Elli (Gabriele, married name Hermann) 134, 187
Kafka Hermann (also Henoch Kafka) 187, 188, 192, 194
Kafka Jacob 188
Kafka Julie (also Yetl) 136, 184, 187, 194
Kafka Ottla (Ottilie, married name David) 95, 134, 135, 177, 183, 185, 187, 197
Kafka Valli (Valerie, married name Pollak) 134
Kafka Vladimír 166
Kaiser Ernst 135, 188, 193
Kalvach Rudolf 27, 30

Kamper Dietmar 213
Karner Stefan Benedik 21
Karpenstein-Eßbach Christa 213
Kars Georg 64, 67, 81, 82
Kašková Gabriela 80
Kautman František 166, 169
Kaznelson Siegmund 80, 193
Kieval Hillel 28
Kilcher Andreas 8, 9, 14, 21, 41, 114, 122, 125, 132, 135, 146, 193
Kisch Egon Erwin 39, 178, 185
Kisch Paul 21, 39, 178, 185
Klauss Jochen 39
Klee Alexander 7, 9, 14, 110, 113, 135
Klee Paul 94, 134
Klein-Diepold Leo 61
Klimt Gustav 27–29
Klínková Hana 9, 80, 110
Klopstock Robert 21, 194
Koch Hans-Gerd 15, 21, 61, 171, 173, 174, 177, 192, 193
Koeltzsch Ines 49, 178
Kokoschka Oskar 16
Kolig Anton 37
Konečný Lubomír 132
König Lucie 59
Konůpek Jan 62
Kopf Maxim 80, 101
Koschmal Walter 169
Kotalík Jiří 14, 155
Koula Jan 175
Kramář Vincenc 67
Kratochvíl Zdeněk 91, 159, 162
Krattner Karl 132
Kraus Karl 191
Kraus Wolfgang 173
Kresh Joseph 84
Krings Marcel 171
Krolop Kurt 14, 43, 171, 173
Kroupa Jiří 132
Kroutvor Josef 15, 171, 173
Kubin Alfred 29, 44, 60, 82, 84, 94, 102, 128, 134, 184
Kubín Otakar 20, 60, 63, 67, 70, 73, 133
Kubišta Bohumil 20, 23, 24, 28, 44, 60, 61, 63, 64, 67, 70, 74, 75, 85, 87, 126, 133, 140, 145, 155, 159, 161, 162
Kubišta František 60, 61
Kubišta Oldřich 60

Lacan Jacques 16, 92
Ladendorf Heinz 14
Lahoda Vojtěch 67, 134
Lamač Miroslav 63, 125, 132
Langer František 76
Langer Jiří Mordechai 193, 194
Lasker-Schüler Else 21
Latteiner Joseph 191

Layton Jean 169
Lemaire Gérard-Georges 84, 134
Leppin Paul 40, 51, 148
Leupold-Löwenthal Harald 39
Liebermann Max 61
Lindner Gustav Adolf 144
Liška Pavel 125
Lofts Steve G. 203
Lotze Rudolf Hermann 210
Löwy Yitzhak 80, 98, 191–193
Lucbert Françoise 64
Lucian 29, 43
Lukas Jan 169

MacDougall Sarah 133
Mack Max 58
Mahen Jiří 49
Mairet Philip 212
Malevich Kazimir 216
Manet Édouard 61
Mantegna Andrea 63
Mareš Michal 16, 166
Mars Mella 59
Martini Simone 63
Marty Anton 210
Mařatka Josef 17
Matějček Antonín 28
Matisse Henri 125
Medková Emila 94
Meidner Ludwig 94, 106
Meier-Graefe Julius 155
Meng Weiyan 41
Mercereau Alexandre 67
Měšťan Antonín 59
Meyer Georg Heinrich 89, 94
Meyrink Gustav 206
Mickunas Algis 201
Miething Christoph 193
Miller Jacques-Alain 16
Mirzoeff Nicholas 206
Mitchell Breon 31
Monet Claude 63, 125
Mráz K. D. 43
Muir Edwin 49, 95, 170, 171
Muir Willa 49, 95, 171
Müller Michael 15
Müller Richard 16
Munch Edvard 20, 61, 124, 125, 133, 155, 156
Musil Roman 9
Myslbek Josef Václav 180, 182, 183

Nanobashvili Nino 113
Naske Alois 111
Natter Tobias G. 27, 28
Naumann Gerhard 14
Nechleba Vratislav 38
Neilan Marshall 49
Nekula Marek 7, 9, 14, 17, 78, 79, 80, 111, 166, 169, 173, 188
Nešlehová Mahulena 61, 79, 133

220

INDEX OF NAMES

Neumann Stanislav Kostka 79
Nicholas II 152
Nicolai Ralf R. 41
Niklová Pavla 9
Nowak Willi 20, 60, 61, 67, 74, 84, 89, 92, 104, 127, 131, 133, 134, 136
Nünning Ansgar 16
Nünning Vera 16

Odstrčil Bedřich 187
Odys Gusti 59, 68
Oeser brothers 49
Oppenheimer Max 45, 60, 72
Orlik Emil 18, 40, 41, 54, 55, 124, 132, 136, 138
Orlíková Jana 80

Pachinger Anton Max 29
Padrta Jiří 132
Parrott Cecil 210
Pascin Jules 32, 46
Pasley Malcolm 15, 63, 67, 155, 175, 183
Pašteka Július 210, 216
Pastor František 94
Paul Bruno 150, 152
Peretz Isaac-Leib 80, 98
Pestalozzi Johann Heinrich 113
Pfeiffer Julius 82, 102
Pfemfert Franz 188
Picasso Pablo 16, 64, 67, 78, 125
Pichler Wolfram 14
Pick Otto 185, 188
Pickford Mary 49
Pietsch Jost 80, 82, 101
Pinès Meyer Isser 191
Pinski David 80
Piscator Erwin 211
Pittermann Longen Emil Artur 20, 60, 64, 76, 88, 98, 133
Placák Jan 94
Plachta Bodo 61, 155
Plato 216
Podhajská Minka 27, 33, 35
Polan Dana 14, 169
Pollak Hilde 80, 99
Pollak Oskar 39, 40, 178, 184
Pollak-Karlin Richard 80
Pomajzlová Alena 134
Pouzarová Anna 187
Pravdová Anna 64
Preisler Jan 18, 124
Priesner Claus 206
Procházka Antonín 20, 60–62, 73, 86, 133

Raabe Paul 32
Rakušanová Marie 5, 7, 9, 14, 60, 61, 89, 94, 132–134, 147, 155

Rath Moses 194, 196
Rees Goronwy 16, 122
Reimann Hans 211
Reimann Paul 166
Renoir Auguste 63, 125
Reyer Sophie 214
Rhein Philip 134
Richter Ludwig 39
Rilke Rainer Maria 132, 136, 138
Robert Marthe 16, 169
Roberts G. Humphreys 29
Rodin Auguste 17, 18, 125
Rodlauer Hannelore 63, 67, 155, 183
Rogall Joachim 169
Rohsmann Arnulf 202
Rops Félicien 29
Rosenberg Adolf 62, 76
Rosický Václav 187
Roth Claudia 9
Rothe Wolfgang 90
Rousová Hana 15
Rubens Peter Paul 63
Ryan Michael P. 41

Sabinian (Pope) 202
Šalda František Xaver 125
Šaloun Ladislav 17, 179, 180, 183, 184, 195
Sauer August 185
Sawicki Nicholas 5, 7, 9, 14, 21, 41, 60, 61, 67, 89, 94, 114, 122, 125, 132, 133, 155
Scheithauerová-Procházková Linka 20, 24, 133
Schiele Egon 27–29, 36, 42, 72
Schmidt Gilya 132
Schmidt Pavel 21, 147
Schmidt-Dengler Wendelin 14
Schoenmaekers Mathieu Hubert Joseph 206
Scholem Gershom 193
Schopenhauer Arthur 61
Schöttker Detlev 14, 63, 64
Schulz Josef 176
Schwind Moritz von 82, 184
Sedlmayr Hans 201
Šeferisová Loudová Michaela 132
Sekal Zbyněk 94
Sekyrka Tomáš 132
Sheridan Alan 16
Siebenschein Hugo 170
Šimůnek Karel 56
Singer Miriam Irma 194
Sontag Susan 203
Sova Antonín 79
Spector Scott 132, 169
Šrámek Fráňa 79
Srp Karel 134
Stach Reiner 8, 14, 21, 41, 125, 194

Staeger Ferdinand 43
Staegr see Staeger Ferdinand
Štáfl Otakar 68
Starke Ottomar 94, 107
Stašková Alice 59
Steiner Hugo 40, 51, 132
Steiner Rudolf 80
Steiner-Prag Hugo 53, 204
Sterk Elvire 187
Stern James 21, 114, 133
Stretti Viktor 43
Sucharda Stanislav 17, 180, 182, 183
Sudaka-Bénazéraf Jacqueline 14, 63, 122
Sudek Josef 195
Švestka Jiří 67
Sychra Vladimír 16
Szilard Rósza 21

Teige Karel 79
Teschner Richard 40, 51, 52, 129, 134, 148
Teutenberg Tobias 113
Thieberger Friedrich 177, 178, 194
Thieberger Karl 194
Thoma Hans 39, 48
Thorsen Kristine A. 191
Tintoretto 63
Titian 63
Toulouse-Lautrec Henri de 63
Třebízský Václav Beneš 183
Trummer Thomas 27
Tuckerová Veronika 122, 169

Uhrová Olga 67
Urban Otto M. 89, 134
Urbanitsch Peter 110
Urzidil Johannes 79, 136
Utamaro Kitagawa 40, 55
Utitz Emil 20, 21, 27, 28, 61, 170, 178

Valenta Jindřich 187
Vančura Vladislav 188
Vašata Rudolf 59
Velázquez Diego 63
Vinci Leonardo da 62, 76
Vlček Tomáš 67, 79, 125
Vlnas Vít 15
Vogel Anke 31
Vojnović Ivo 178
Vojta Tomáš 179
Votlučka Karel 90
Vrána Ludvík 94
Vrchlický Jaroslav 178

Wagenbach Klaus 21, 90, 110, 166, 176
Wagner Benno 187
Walden Herwarth 67
Waller Susan 155

Webber Andrew J. 176
Weber Hans von 82
Wegener Paul 208
Weiler Hedwig 60, 133, 176
Weinberg Manfred 8, 169
Weiß Ernst 185
Weltsch Felix 21, 175, 185, 192, 194
Wenig Josef 209
Werfel Franz 185, 193
Wernerová Marie 187
Wessel Wilhelm 90, 94, 107
Whitlark James 31
Wiegele Franz 27
Wiener Oskar 43
Wierer Alois 40
Wilke Karl Alexander 153
Wilkins Eithne 135, 188, 193
Winkler Norbert 173
Winston Clara 17, 95, 133, 176, 177
Winston Richard 17, 29, 95, 133, 176, 177
Winter Tomáš 148
Wittlich Petr 125, 134
Wodyński Józef 159
Wolf Werner 16
Wolff Kurt 76, 94
Wolfson Lisa 214
Wulf Christoph 213
Wünsche Isabel 134
Wyllie David 209

Ženíšek František 178
Zilcosky John 41
Zimmermann Hans Dieter 14, 171
Zischler Hanns 8, 14, 49, 58, 79, 178
Zítek Josef 176
Zohn Harry 16
Zrzavý Jan 79, 92
Županský Vladimír 18

THE FOLLOWING INSTITUTIONS HAVE GENEROUSLY PROVIDED
ILLUSTRATIONS AND PERMISSIONS FOR REPRODUCTION:

Albertina, Vienna; Aleš South Bohemian Gallery; Archiv Kritische Kafka-Ausgabe;
Arthouse Hejtmánek; Belvedere, Vienna; Bildarchiv Klaus Wagenbach; British Museum;
The Bodleian Libraries, University of Oxford; COLLETT Prague | Munich;
Czech Office for Surveying, Mapping and Cadastre (ČÚZK); Deutsches Literaturarchiv
Marbach; DFF – Deutsches Filminstitut & Filmmuseum; The Digital Journal Archive,
Czech Literary Bibliography, Institute for Czech Literature at the Czech Academy
of Sciences, https://clb.ucl.cas.cz (ORJ code: 90243); Gallery of Fine Art in Ostrava;
GASK – Gallery of the Central Bohemian Region; Gallery of West Bohemia in Pilsen;
Getty Images; Jewish Museum in Prague; Kunstforum Ostdeutsche Galerie Regensburg;
Kunstsammlung und Archiv der Universität für angewandte Kunst Wien;
Leopold Museum, Vienna; Liberec Regional Gallery; Moravian Gallery in Brno;
Munchmuseet, Oslo; Museum of Czech Literature; Museum of Decorative Arts in Prague;
National Archives (Prague); National Gallery Prague; National Library of Israel;
National Library of the Czech Republic; National Museum (Prague);
New York Public Library, Dorot Jewish Division; Olomouc Museum of Art; Prague City Archives;
Prague City Gallery; Regional Gallery of Fine Arts in Zlín; Kolín Regional Museum; Retro Gallery;
Stockholm University Art Collections; T. G. Masaryk Library, Masaryk Institute and Archives of
the Czech Academy of Sciences; Velvary Municipal Museum; Wien Museum;
Ztichlá klika Gallery; and private collections (Christie's Images/Bridgeman Images: Fig. 26;
Erich Lessing/Art Resource, NY: Fig. 27).

ADDITIONAL REFERENCE IMAGES ARE CITED FROM THE FOLLOWING BOOKS:

Tobias G. Natter et al., *Fantastisch! Rudolf Kalvach: Wien und Triest um 1900*
 (Vienna: Leopold Museum – Silvana Editoriale, 2012): Fig. 20, 30.
Minka Podhajská (Prague: Arthouse Hejtmánek, 2021): Fig. 21, 22.
Stadt der Frauen. Künstlerinnen in Wien 1900–1938
 (Munich – Vienna: Prestel – Belvedere, 2019): Fig. 23.
Marie Rakušanová, *Kubišta – Filla. Zakladatelé moderního českého umění
 v poli kulturní produkce* (Brno: B & P, 2019): Fig. 32.
Jochen Klauss, ed., *Goethe als Sammler* (Zürich – Weinheim: Offizin, 1998): Fig. 42.
Sigmund Freud Museum (Vienna: Verlag Christian Brandstätter, 1994): Fig. 43.
Hanns Zischler, *Kafka geht ins Kino* (Berlin, Galiano, 2017): Fig. 67, 71, 72.
 DVD released as a supplement to this book: Fig. 69, 93, 111.
Hugo Siebenschein (ed.), *Franz Kafka a Praha: Vzpomínky, úvahy, dokumenty*
 (Prague: V. Žikeš, 1947): Fig. 134, 197a–b.
Jiří Švestka and Tomáš Vlček (eds.), *Český kubismus 1909–1925*
 (Prague: Modernista, 2007): Fig. 139.
Antonín Matějček, *Národní divadlo a jeho výtvarníci* (Prague: SNKLU, 1954): Fig. 201.
Vojtěch Volavka, *Josef Václav Myslbek* (Prague: V. Neubert a synové, 1942): Fig. 204.

© Albert Paris Gütersloh, Alfred Kubin, Linka Scheithauerová-Procházková,
Max Oppenheimer/OOA-S 2024: Fig. 12, 17, 82, 123, 124, 152; Jean-Baptiste Beranger: Fig. 154;
Birgit und Peter Kainz: Fig. 28, 33; Ota Palán: Fig. 11, 106, 125, 132; Ludwig Meidner-Archiv,
Jüdisches Museum der Stadt Frankfurt am Main: Fig. 130; 2024 Jan Zrzavý, National Gallery
Prague: Fig. 109

All rights reserved. No parts of this book may be reproduced or copied in any form or using
any technological or electronic means without the prior written consent of the publisher.

THROUGH THE EYES OF FRANZ KAFKA: BETWEEN IMAGE AND LANGUAGE

Marie Rakušanová and Nicholas Sawicki, eds.

ZČ/G

Published on the occasion of the exhibition Through the Eyes of Franz Kafka: Between Image and Language, held at the Masné krámy exhibition hall, Gallery of West Bohemia in Pilsen, from 5 June to 28 October 2024.

The exhibition was organized by the Gallery of West Bohemia in Pilsen and the Adalbert Stifter Verein, in collaboration with the Jewish Museum in Prague, as part of the Kafka 2024 and Kafka 100 projects.

Exhibition concept: Marie Rakušanová
Exhibition curator: Ivana Skálová

Book concept: Marie Rakušanová
Editors: Marie Rakušanová, Nicholas Sawicki
Contributing authors: Miroslav Haľák, Zuzana Jürgens, Alexander Klee, Roman Musil, Marek Nekula, Marie Rakušanová, Nicholas Sawicki
Graphic design: Robert V. Novák
Technical support: Tomáš Brichcín
Translations: Stephan von Pohl, Martin Tharp
Copyediting: Eva Hrubá, Stephan von Pohl
Proofreading: Megan Bedell
Index of names: Eva Hrubá
Printed by: Tiskárna Protisk, s.r.o., České Budějovice

The book is published with the support of the Ministry of Culture of the Czech Republic, State Culture Fund of the Czech Republic and Deutsch-Tschechischer Zukunftsfonds.

Published by KANT – Karel Kerlický and the Gallery of West Bohemia in Pilsen, 2024.
ISBN: 978-80-7437-426-5

Partners:

Main media partner: Media partner: